THE LIBRARY OF AMERICAN ART

NORMAN ROCKWELL

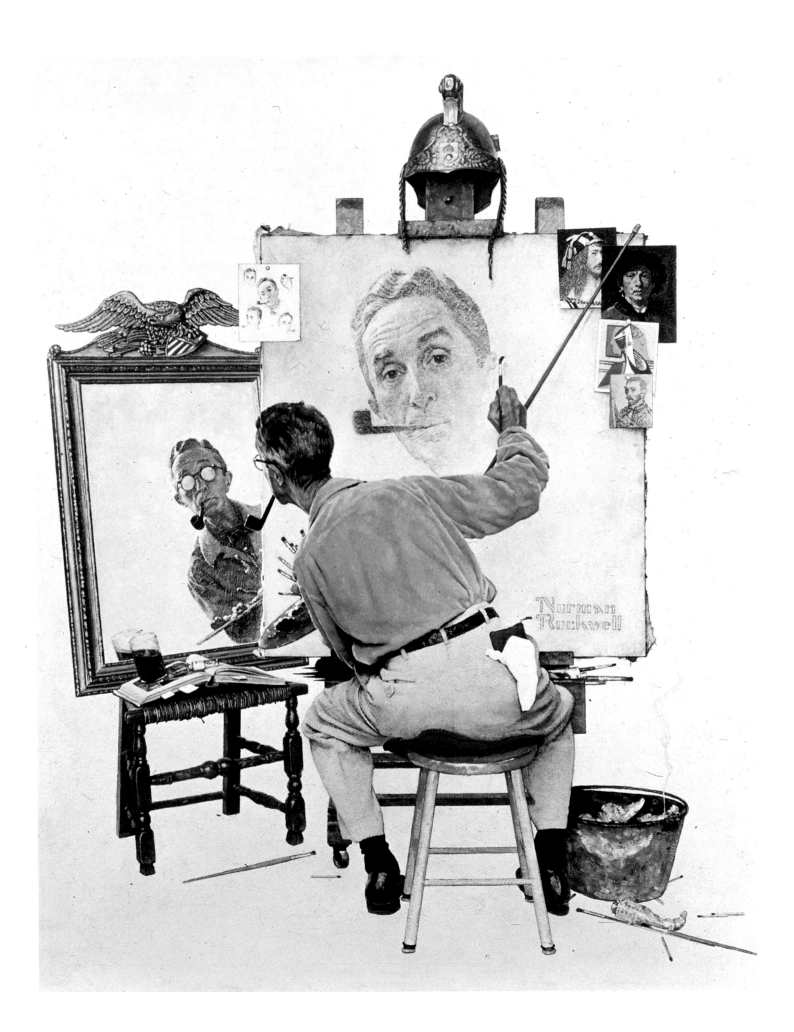

Norman Rockwell

KARAL ANN MARLING

Harry N. Abrams, Inc., Publishers

IN ASSOCIATION WITH

The National Museum of American Art, Smithsonian Institution

Series Director: Margaret L. Kaplan
Editor: Eric Himmel
Designer: Robert McKee
Photo Editor: Uta Hoffmann

Library of Congress Cataloging-in-Publication Data

Marling, Karal Ann.
 Norman Rockwell / Karal Ann Marling.
 p. cm.— (The library of American art)
 Includes bibliographical references and index.
 ISBN 0–8109–3794–8
 1. Rockwell, Norman, 1894–1978—Criticism and interpretation.
 2. United States—In art. 3. Civil rights in art. I. Title.
 II. Series: Library of American art (Harry N. Abrams, Inc.)
N6537.R576M37 1997
759.13—dc21 97–7635

Frontispiece: *Triple Self-Portrait*
 1960. Oil on canvas, 44½ x 34¼″ (113 x
 87 cm). The Norman Rockwell Museum at Stock-
 bridge, Massachusetts. (*Saturday Evening Post* cover,
 February 13, 1960)
 During the 1950s and 1960s, Rockwell was trying to
 resolve to his own satisfaction, the question of where he
 belonged in the grand scheme of American art—or if
 he belonged there at all. This self-portrait, which appeared
 on the Post *cover advertising his autobiography in serial*
 form, complicates the question with an endless series of
 non-resemblances. The face on the easel, for example, is not
 the Rockwell in the mirror. Nor is it one of the Rockwells
 on the sketchbook sheet attached to the easel. Has the artist
 painted himself—or some idea of what an artist ought to
 be? Rockwell lines up his models on the right side of the
 easel: self-portraits by Dürer, Rembrandt, and van Gogh.
 And a Picasso self-portrait is hidden behind a portrait
 of a woman.

Printed and bound in Japan

Harry N. Abrams, Inc.
100 Fifth Avenue
New York, N.Y. 10011
www.abramsbooks.com

Contents

Preface

Norman Rockwell is the most popular American artist of this century. The themes of his work define a turbulent period that opened with barefoot boys lazing away summer afternoons in the countryside and ended with their sons stepping cautiously onto the surface of the moon. He chronicled our times: the change from parental paddling to Freudian psychology, from sleepy storefronts to offices in mighty skyscrapers, from storybooks to TV sets. He showed his fellow citizens two great world wars, the Cold War, the failures and triumphs of the civil rights movement. Every major political figure from F.D.R. to the Carters. Movie stars, moms, cute kids, foxy grandpas, and Boy Scouts. New suburbs. Old cities. Small-town places left behind in the march of progress. Ordinary, everyday places beatified by light and by the artist's scrupulous attention to their angles and corners and timeworn surfaces.

Rockwell was born in 1894, the year of the great Pullman strike, when Labor Day, ironically, became a national holiday. But he shunned unpleasant, controversial subjects for most of his long life. Rockwell's Americans worked hard—and sometimes daydreamed on the job—yet they rarely got themselves in any real trouble. Rockwell didn't paint strikes. Nonetheless, his own art was an industrial product, like Pullman's railroad cars. The *New York World* began printing comic strips in color in the year of Norman Rockwell's birth; he would later go to work for the new mass-market magazines that sold themselves to passing customers through the visual appeal of the color cover. Rockwell would never paint pictures for museums. He was not the classical starving artist in a garret, expressing himself as he wished for the admiration, perhaps, of the enlightened few. He worked instead in a blatantly commercial setting: his subject matter was often dictated and edited by others, and his paintings were only one step in a complicated industrial process that led to a finished ad, an illustration, or a cover.

In all, Norman Rockwell did 324 covers for the *Saturday Evening Post* alone. By conservative estimates, four million people saw each *Post* cover as it first appeared. Faithful readers became caught up in a Dickensian serial of American life that began in 1916 with the story of an embarrassed little boy, forced to dress up and walk the baby while his friends played baseball, and petered out in 1962 as a museum guard opened his lunchpail for a midnight snack under the censorious gaze of a stuffed horse that carried a medieval knight in full armor. Following Rockwell's saga, month after month, year after year, his fans saw an edited version of their own lives, rarely marked by dramatic incident or great tragedy, but lives of decency, sweetness, and perseverance. It was a vision of our common life, in the heart of this century, as we might wish to have lived it.

Cover art was throwaway stuff, of course—yesterday's trash, like most other consumer products. It was popular art that pandered to the masses with sentimental boy-and-his-dog themes and a style premised on painstaking verisimili-

tude. The man in the street had a hankering for anecdote and affirmation, nostalgia and myth: true connoisseurship in this corner of the marketplace meant chuckling over cunning details missed on first inspection (like the bandage almost always wrapped around the toe of the barefoot kid). So Rockwell never commanded much respect in the realm of high art. He was a journalist, doling out information in pictorial form. Or an entertainer, a raconteur. A craftsman, a maker of Christmas cards and Valentines. But not an artist. Not really. During his lifetime, there were only a handful of museum exhibitions of his work, despite rising auction prices and a mounting demand for old Rockwell covers, reproductions, prints, and collectibles. Nobody wrote about him, either, except as an example of bad taste—the Lawrence Welk of American art—or as an American character, a sort of stereotype: the skinny New Englander with a pipe who seemed to have stepped out of a picture by Norman Rockwell.

When Rockwell died in 1978, his eulogists included art critics who had clearly been assigned to the story against their collective wills. John Russell, writing for the *New York Times,* called him an "amiable anachronism." Rockwell "will not live in the history of art," Russell concluded, "but as a witness to a certain view of America . . . he was the right man in the right place at the right time." Robert Hughes of *Time* dubbed the deceased "the Rembrandt of Punkin Crick." He was a picture-maker, Hughes argued, who supplied pre-electronic America with an endless store of images framed in the "depthless narrative clarity" of the TV set. He painted "visual bromides," said *Newsweek.* Editors who mourned Norman Rockwell—editors of the lowbrow journals for which he once worked—steered clear of the experts. Instead, they asked celebrities to comment on his passing, reasoning that movie stars and politicians were amateurs, just like the average reader. And it came as no surprise at all that John Wayne and Ronald Reagan, Doris Day, Mary Tyler Moore, and Lucille Ball all loved Norman Rockwell. They cited favorite pictures with an ease bred of long familiarity. Everybody knew the one with the cop and the runaway kid. The little girl with the black eye. The father saying goodbye to his college-bound son at the depot. The old lady and her grandson saying grace in a grubby trackside diner. Recollected with genuine pleasure, Rockwell's pictures were an intimate part of other people's lives, as precious to them as their own memories.

In recent years, the art world has not changed its collective mind about Rockwell: he is still a nonperson. In the public domain, however, Rockwell has taken on a distinctly conservative coloration. Ronald Reagan, while still in the White House, pronounced him "wonderful" and agreed to chair a fund-raising drive for the new Norman Rockwell Museum in Stockbridge, Massachusetts. Ross Perot often poses for the camera in front of his Rockwells, as if to connect his biography and political values to their content. There is Rockwell the mythmaker, too, from whose pictures filmmaker Steven Spielberg (another Rockwell Museum supporter) derived the old-fashioned, apple-pie, front-porch Americana of movies like *ET* and *Jaws:* it is the snug rightness of the Norman Rockwell settings that makes the incursion of Spielberg's alien forces so terrifying. Rockwell, in the 1990s, stands for something timeless and true, but something always

on the verge of destruction—a vision of America that becomes harder and harder to reconcile with rampant crime, urban chaos, and the impersonal age of the computer. To cherish Rockwell can be an act of defiance, a willful retreat into nostalgia and should-have-beens.

Gradually, however, and from other quarters, a new understanding of Rockwell has begun to emerge, innocent of both ideology and futile regret. Novelist John Updike, in an important 1990 essay, confessed to looking daily for years at Rockwell's *Shuffleton's Barbershop* (page 130), a 1950 *Post* cover mounted over the toilet in his office. What he discovered was that there was always something else to notice in the picture, an "avid particularizing," a plenitude, a generosity of vision that intensified the experience of place. Rockwell, he wrote, consistently provided "a little more than the occasion strictly demanded." Although despised by the critical establishment, Norman Rockwell's sheer obsessive perfectionism had crossed the line from mere commercial work to an art for art's sake perilously close to high art.

The composition raises further questions. In *Shuffleton's Barbershop,* the glass surface of the window is identical in shape and dimension to the picture plane. The lighted doorway within and the windows on the back wall of the store mirror that rectangular form and set up a tense dialogue between the painted and the real, the transparent and the opaque, the near and the far. There is more here than poignant yesterdays in small-town Vermont. The barbershop is also a painting. William Sidney Mount + Mark Rothko = Norman Rockwell.

But to hold Rockwell to standards set by the avant-garde is, in the end, to deny the possibility that there is art beyond the margins of modernism. Dave Hickey, in a provocative 1995 *Art Issues* study, observes that Willem de Kooning and Andy Warhol both loved Rockwell's work. Yet he judges Rockwell according to a different yardstick, a measure of memory calibrated to his own recollections in which particularity, sentiment, and desire all matter. "Rockwell taught me how to remember," he confesses. "I clung to the ordinary eccentricity, the clothes, the good-heartedness, the names of things, the comic incongruities, and the oddities of arrangement and light"—and so did Rockwell. Because Norman Rockwell's pictures lived in this world of ordinary things, amid a million other things, they had to select and define, as memory does. They had to accept and cherish. They affirmed precisely what modernism programmatically questions and rejects.

Rockwell's is not a perfect world, Hickey notes. Little girls have fights at school. Bankers are puzzled by Jackson Pollock paintings. Salesmen struggle with expense accounts and languish in lonely hotel rooms. But life goes on, in the subtle self-contained rhythms of the compositions. Shoes echo the shapes of lamps. The printed fabric of a slipcover tells a story of its own. And, because these things have been chosen, examined, ordered, and well remembered, we seem to remember them, too. Life goes on and Norman Rockwell is a part of it.

Norman Rockwell is a big part of my life. In 1970, when I was in the middle of a doctoral program in art history, my grandmother gave me Thomas S. Buechner's *Norman Rockwell, Artist and Illustrator* for Christmas. It is a huge volume,

easily the size of the average coffee table, with beautiful color plates: a memorable gift! Because it was so massive (11 pounds), so lavish (614 illustrations), and so expensive ($45), the publication of the book was an event in its own right. There was not much discussion of Rockwell's merit as an artist: under the headline, "If we all like it, is it art?" Buechner himself conceded, in the pages of *Life*, that his compilation was meant for the faithful who didn't care what the art world thought. But there I was, ready to join that establishment, and suddenly confronted with the sheer pleasure of looking at Norman Rockwell again. When I was a little girl, come for long Sunday afternoon visits, my grandmother and I often sat side by side on her living room sofa and looked at the pictures in that week's crop of magazines together. We were indiscriminate. We looked at covers, ads, photographs, the artwork that went with the stories. *Life. Look. McCall's. Good Housekeeping. The Saturday Evening Post.* John Falter, Mead Schaeffer, Al Parker, Jon Whitcomb. And Norman Rockwell. The great big Christmas book made me remember those Sundays and those pictures. But the fledgling art historian had to wonder now if the pictures, the memories, and the joy of looking could possibly be legitimate. "If we all like it, is it art?"

The question is all but moot, twenty-five years later. Today, Rockwell fits readily into the grand continuum of realist masters that stretches from Thomas Eakins to Richard Estes. Memory and pleasure, stories and feelings, things and their peculiar auras have all found their places in a postmodern aesthetic more voracious and forgiving than the modernist orthodoxy of Buechner's time. Today, I can say that Norman Rockwell is the most popular American artist of this century—an artist, that is: a *real* artist, a great artist. And I am delighted to be able to do so in this book. I am pleased that Elizabeth Broun, Director of the National Museum of American Art, Smithsonian Institution, and Margaret Kaplan, Senior Vice President of Harry N. Abrams, Inc., have given me the chance to remember a childhood full of Sunday afternoons with my grandmother and Norman Rockwell. And to think about how those happy times have shaped the sensibilities of a grown-up art historian.

Karal Ann Marling
Minneapolis

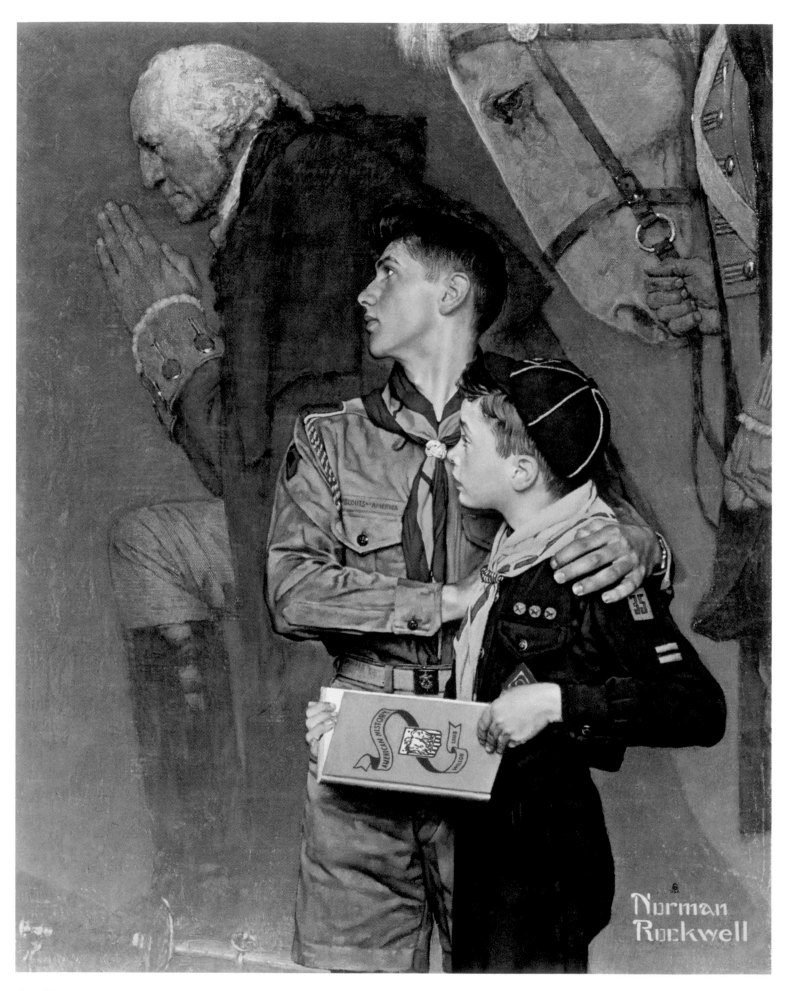

Our Heritage

1. Becoming an Illustrator

The first edition of Norman Rockwell's autobiography appeared in 1960. Serialized in eight installments in the *Saturday Evening Post*, the book still seems remarkably candid today. Although the style is informal and breezy—instead of writing down his story, Rockwell had reminisced aloud to his son, Tom—*My Adventures as an Illustrator* touches on any number of uncomfortable personal matters. Rockwell's first, loveless marriage and subsequent divorce. His self-doubts and depressions. And a somewhat distant relationship with his parents.

"Potty"—his genteel father, J. Waring Rockwell—came from a well-to-do family of New York City coal merchants and rug manufacturers. But by the time Norman was born in 1894, "in the back bedroom of a shabby brownstone front on 103rd Street and Amsterdam Avenue," Potty, "Baba" (Norman's mother, Nancy Hill Rockwell), and elder brother Jarvis were living in pinched circumstances. The handsome J. Waring worked, as he would all his life, for a textile firm, slowly rising from office boy to manager of the New York operation. In the evenings, when he came home from the office, he would tell his family every word the boss had said that day. Sometimes, after supper, he would read Dickens aloud to the boys, in an even, colorless voice, "the book laid flat before him to catch the full light of the lamp." Sometimes, he copied engraved illustrations from magazines with pen and ink in the fine, spidery hand of one more accustomed to ledger books.

Baba's father, Howard Hill, was a down-at-the-heels painter. Arriving in the United States after the Civil War with high hopes of winning fame and fortune as a portraitist, he wound up instead cranking out portraits of pets to support his twelve children. When the trade in dogs and prize pigs was slow, he would put the whole family to work manufacturing potboilers showing Indian maidens, grieving mothers, or homebound clipper ships. The senior Hill did the hard parts—the beautiful Indian and her canoe. Then, one child would paint the lake, another the trees, a third the moon, and so forth, assembly-line fashion. He was said to have had a remarkable eye for detail, but he never made much at his craft and turned to drink. Nancy Hill Rockwell despised him for both failings.

J. Waring and Nancy were religious; they packed their children off to sing in various church choirs and forbade Sunday funny papers. According to his autobiography, Norman Rockwell never felt close to either of them. Father was quiet and remote. Mother (who lived to be eighty-five!) was an invalid by choice, given

Our Heritage

1950. Oil on canvas, 42 x 32" (106.7 x 81.3 cm). Art from the Archives of Brown & Bigelow, Inc., and with permission from the Boy Scouts of America. (Boys Scouts of America calendar for 1950)

In this picture Rockwell pays tribute to another great American illustrator: J. C. Leyendecker, who had been responsible for many of the Saturday Evening Post's *special holiday covers. One of his Washington's Birthday covers depicted the legend of George Washington, praying on his knees in the snows of Valley Forge. The cycle of patriotic festival days—Thanksgiving, Independence Day, Lincoln's Birthday, Washington's Birthday—was another powerful tool for forging a national identity in an age of mass culture and alienation.*

In this cover, the Leyendecker Washington inspires two young scouts. This was a convention that Rockwell used frequently, but here it also seems to assert Rockwell's superiority over his predecessors. Leyendecker's work fades into the background. Rockwell's very different aesthetic, marked by minute detail and odd angles of vision, takes the foreground. Throughout his life, Rockwell worried about his profession, his standing in it, and the relationship between illustration and "high" art.

The artistic talent was supposed to be on his mother's side of the family, but Norman Rockwell's father liked to copy illustrations that caught his eye. The practice demonstrates the importance and ubiquity of the illustrator's craft at the turn of the century. The subject matter—a colonial scene, with Longfellow's Puritan maiden—is a reminder of the important role the illustrator played in picturing American history for new Americans and thereby helping to confirm a common culture.

As an art student, Norman Rockwell experimented with ways of creating a distinctive signature for his work: all the great illustrators had such trademark methods of signing their names. Norman's father seems to have had the same idea.

to lying in darkened rooms with a cold compress on her forehead. "I remember very little about my parents," their skinny, awkward second son later wrote.

Because the Rockwells were determined to raise their offspring in respectable surroundings, they moved to better addresses whenever circumstances permitted. Norman remembered trolley trips from a railroad flat on 152nd Street into the countryside on warm evenings—and whole summers in rural boardinghouses. When he was nine or ten, the Rockwell family moved first to suburban Mamaroneck, in Westchester County; then back to New York, to a boardinghouse, so poor sick Nancy would not have to attend to household chores; and finally to a succession of such establishments in New Rochelle, New York, where the famous illustrators of the day had settled in numbers: Frederic Remington (1861–1909), Coles Phillips (1880–1927), Charles Dana Gibson (1867–1944), and J. C. Leyendecker (1874–1951). The teenage Norman had a foot in both worlds. From Westchester, he had already begun to commute to the city by day to enroll at the famous Chase School of Fine and Applied Art and to copy plaster casts at the National Academy School.

The aspiring illustrator was not enchanted with the city, however. The vagueness of his memory of his parents stands out in startling contrast to his vivid recollection of New York as a place of sheer horror. He remembered, for example, "a vacant lot in the cold yellow light of late afternoon, the wind rustling in the dry grass and a scrap of newspaper rolling slowly across the patches of dirty snow. And a drunken woman in filthy gray rags following a man and beating him

over the head with an umbrella." Summers in the country, on the other hand, were pure bliss. Freed from the hard work of a real farm boy, the city visitor lived out an idealized, Booth Tarkington version of small-town America at the turning of the century, beautiful and serene.

It was Rockwell's belief that those summer idylls determined the iconography of his later work. He had created, in his own memory, a shining alternative to the city and to everything that was wrong with his own childhood years. "Maybe as I grew up . . . I unconsciously decided that, even if it wasn't an ideal world, it should be and so painted only the ideal aspects of it—pictures in which there were no drunken slatterns or self-centered mothers, in which on the contrary, there were only Foxy Grandpas who played baseball with the kids and boys fished from logs and got up circuses in the back yard."

If his formative years left Norman Rockwell prone to nostalgia and make-believe, they also left him rootless in some fundamental way, a boardinghouse boy without a real home, shuttling between an imagined farmscape and an urban scene he both mistrusted and despised. Yet place was to be a strong determining factor in American art between 1908 and the end of the Great Depression. In 1908, when Rockwell made up his mind to be an illustrator someday, the so-called Eight, led by Robert Henri (1865–1929), mounted their first group exhibition at the Macbeth Galleries on Fifth Avenue. There is no evidence that Rockwell attended. On the contrary, two years later he fled in pious horror after mistakenly spending a day among the hard-boiled, streetwise avant-garde in one of Henri's classes. He was fleeing the art of the city.

Henri and his friends in the Macbeth show were urban realists, dubbed the "Ashcan School" for their interest in precisely the scenes that so shocked young Norman; his description of the terrible drunken woman in the vacant lot could just as easily have characterized a painting by George Luks. While Rockwell was turning his back on the city, however, Henri and his circle were embracing it and exploring it, crossing the barriers of class and respectability to see the metropolis afresh in all its sordid splendor.

Urban realism in art was paralleled by a similar phenomenon in American literature. Theodore Dreiser's *The "Genius"* (1915), for instance, chronicled the career of illustrator Eugene Witla as he tried to make his name in the cutthroat commercial milieu of the big city. Ironically, it may have been books like Dreiser's, steeped in Darwinian conflict and the harsh realities of the city's ethnic and economic strife, that would help to kill off the art of illustration in young Rockwell's lifetime. Unlike the beautiful girls of Harrison Fisher (1875–1934) and Charles Dana Gibson, unlike Howard Pyle's (1853–1911) knights in shining armor, the scenes described in such stories seemed too common, seedy, and mean to merit artistic treatment. The Ashcan School painted denizens of the Bowery and washlines in backyards in Greenwich Village and rainy nights on the Staten Island ferry, but the true illustrator, like Howard Pyle, was above all that. He was a shining ideal, a demigod too good for mere boardinghouses and shabby brownstones at 103rd and Amsterdam. Howard Pyle was Norman Rockwell's hero.

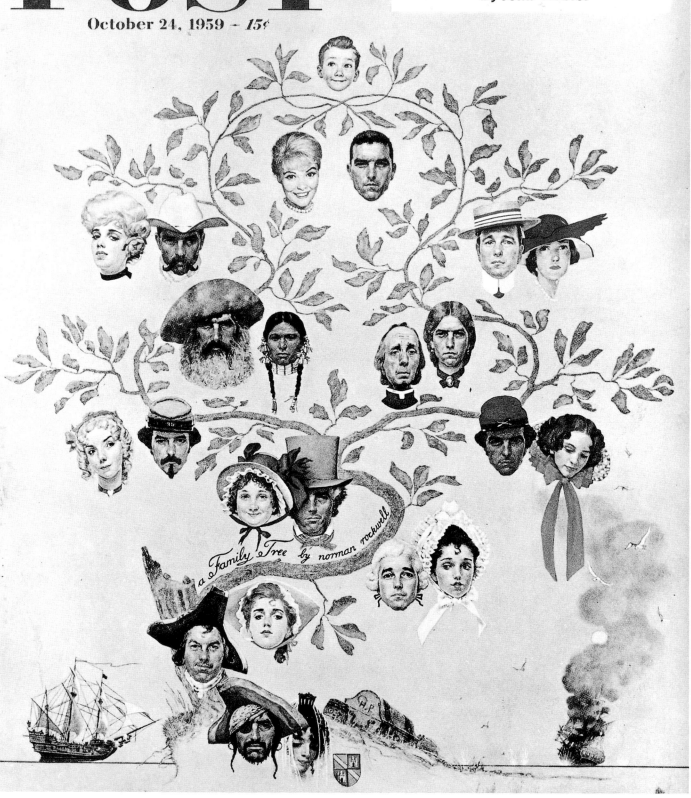

The Saturday Evening

POST

October 24, 1959 – 15¢

a Family Tree by norman rockwell

Family Tree

George Bridgman taught Rockwell anatomy at the Art Students League. A rumpled figure who swore, smoked cigars, and was seldom entirely sober, Bridgman revered the heroes of the Golden Age of Illustration and used their work liberally in his course. After school, late on Friday afternoons, he'd have a beer with the students and fill their heads with stories of Pyle and Edwin Austin Abbey (1852–1911) and the great days past. The students, in turn, pursued models known to have posed for the titans. How did Pyle begin a painting? they asked. Did he make drawings first? What kind of paints did he use? On the day Pyle died, in 1911, Bridgman turned up at class tipsier than usual, with tears in his eyes. The Golden Age was over. If not that day—when he was only seventeen—then shortly thereafter, Rockwell later wrote. In the Golden Age, illustration had been a noble profession. Nobody talked about money. The editors' offices at the top magazines looked like living rooms in nice homes. But soon— poof!—it was all gone. Filing cabinets. Typewriters. Strictly business. Pyle had been an artist, a historian with a brush, in the mainstream of fine art. But could Pyle or his followers sell soup? Could pirates and castles and brave men and beautiful maidens compete with photographs of washing machines and sleek cars?

It is telling that Rockwell should have ended *My Adventures as an Illustrator* with excerpts from a diary, kept over a three-month period in the summer of 1959, chronicling his fitful work on a *Post* cover called *Family Tree*. The picture is an overt tribute to Howard Pyle and the Golden Age of Illustration. The theme—how one family finds its place in American history—is his effort to resolve the conflicts of the life story just unfolded in the previous pages. Pictorially, Norman Rockwell invents a new lineage for himself, stolen straight from the collected works of Howard Pyle. The patriarch is a swarthy pirate with earrings, pigtails, and an eyepatch. The matriarch is a titled Spanish beauty, part of his plunder. And on the chestful of treasure just behind her—on the side of the painting where the burning Spanish galleon falls victim to a final volley from the pirate frigate in *his* half of the canvas—Rockwell emblazoned the initials "H.P." (Rockwell himself roosts in a branch halfway up the trunk, disguised as a preacher, in a sly reference to his art-school nickname: "The Deacon.")

He lifted that galleon from Pyle, too, Rockwell later admitted; whereas N. C. Wyeth (1882–1945), Pyle's student and follower, would have painted his own romantic pipe dream of galleon-ness, Pyle always researched the genuine article. Howard Pyle had been committed to historical accuracy, the use of models, seizing the dramatic moment, and employing, wherever feasible, authentic American subject matter. And so was Norman Rockwell, Pyle's only true heir. The perky little red-haired boy at the top of the *Family Tree* is pure Rockwell, however: cheerful, bursting with life, and wholly mythical, like the made-up genealogy itself. Read from top to bottom, the picture is the daydream of a little boy like Norman, imagining a more exciting lineage for himself. Read from the piratical roots upward, it is a melting-pot history of a nation without any strife between races, sexes, and generations. An ideal America created out of the specifics of pirate chests and colonial wigs.

Family Tree

Saturday Evening Post cover, October 24, 1959

In this mature work, Rockwell pays tribute to his first hero, illustrator Howard Pyle, who was best known for romantic historical themes. Pirates and galleons were Pyle's trademarks and the initials "H.P." appear on the lid of the treasure chest at the foot of the tree. Family Tree also recalls the historical subject matter in vogue during Rockwell's youth. He collected colonial costumes and made something of a specialty, early in his career, of Pilgrims, Puritans, and merry Christmas revelers who looked as though they had stepped right out of the pages of Dickens. Throughout his life, Rockwell continued to try—often in a humorous way—to show the influence of history on today's Americans.

The pirate in *Family Tree* is a measure of Rockwell's insecurity about his profession. Although he was a famous and beloved artist of mature years when he began the cover painting, Norman Rockwell never really trusted his own judgment. Perhaps that was the lot of the illustrator, the commercial artist always subject to the whims of the client or the vagaries of the text. Pyle had often argued that the illustration was a self-sufficient entity—an independent, autonomous work of art. But when psychologist Erik Erikson, one of Rockwell's neighbors and closest friends, raised questions about the propriety of having the typical American family spring from the loins of a cutthroat, Norman killed off Pyle's pirate (for a day or two, anyway) without a moment's hesitation.

Thomas Fogarty (1873–1938) taught the illustration course at the Art Students League. In his class, the approach was more practical than in Bridgman's. Illustration was made-to-order art and students were given hypothetical assignments for real magazines. They read the stories, paid attention to the author's words, and translated them into paint with great exactitude through a judicious selection of costumes, models, and props. Authenticity was the watchword: if a writer made a character sit down in a Windsor chair, then the pupil was expected to go to the Metropolitan Museum and find one. And to ask why he was sitting down in the first place and how those reasons might be expressed in posture, facial expression, and supporting detail. Fogarty taught Norman Rockwell the nuts and bolts of illustrating, the secrets of creating the anecdotal scenes from daily life that were, increasingly, what the marketplace demanded for ads and for snappy new stories about real people in true-to-life situations—stories like those the movies purveyed. Fogarty admired Howard Pyle as much as Bridgman did, but he was also willing to admit that the days of pirates and perukes were probably over.

Just before Rockwell quit high school to go to art school, the widening gap between art and illustration was mapped out in a celebrated incident involving Fogarty's work. In 1907, pressure was brought on the Metropolitan Museum by illustrators and their publishers to establish formal illustration galleries, in keeping with that institution's mission to elevate the public taste and thereby improve the design of manufactured products. In any case, a recent piece by Fogarty entitled *Wee Annie* was duly submitted as the first such work for the collection. And promptly rejected by painting curator Roger Fry, who argued that the work had to be considered on its own merits as a drawing, apart from its value as an accompaniment to a given text. On those grounds, Fry found the pencil drawing lacking. The gallery project collapsed. Whereas it might have been possible to paper over distinctions between the self-directed genius and the illustrator in the heyday of Howard Pyle (whose historical views of old Philadelphia were much admired by Vincent van Gogh)—when themes were exalted and stories noble—the illusion was harder to sustain at the high tide of mass culture, with ads for oatmeal and light bulbs an important part of every new illustrator's stock-in-trade. Art was created for art's sake. Illustration paid the bills and greased the wheels of commerce.

Illustration also made young men join the Marines. Despite the bleak mood

at the Art Students League, the Golden Age did not actually end with Pyle's passing in 1911. Top illustrators continued to command huge annual salaries. Their beautiful wives and splendid apartments were splashed across the pages of the Sunday supplements. They dined with presidents and kings. Although the art world was primly drawing its skirts away from the mud of commerce, illustration actually reached a pinnacle of public prominence during World War I, thanks to the volunteer efforts of the fraternity.

In 1917, James Montgomery Flagg (1877–1960), a notorious bohemian whose prewar works were synonymous with urban sophistication and pretty city girls, donated his famous pointing patriot—"*I Want You for U.S. Army*"—to the war effort. Named official artist of New York State for the duration, he turned out forty-six other splendid war posters and, bored with that, went into show business, reproducing his best-known images at huge scale on a scaffold high above Times Square as the crowds below pointed and gaped. To sell Liberty Bonds, he also gave chalk-talks on the steps of the New York Public Library in the company of famous movie stars while his rival, Charles Dana Gibson, head of the U.S. government's official Division of Pictorial Publicity, rallied his followers less noisily at Keene's Chop House nearby. Howard Chandler Christy (1873–1952) spent the war years doing dream girls who showed raw recruits just what they were fighting for. His favorite wartime model, whom he married in 1919, was Nancy Palmer of the jewel-like blue eyes and the pink-and-white complexion; Norman Rockwell once said that she looked like a burlesque queen of the 1890s—the kind that tempted young fellows to their ruin.

So Rockwell entered the profession, and formed his views about it, at an odd point in time. Illustrators were celebrities who lived like movie stars in special enclaves around New Rochelle and Westport, Connecticut. As printing techniques improved and circulation figures mounted, their work was in increasing demand by editors and the new ad agencies. Art students, like Norman Rockwell, looked on them as gods. Growing up in faraway New Ulm, Minnesota, in the years just before Rockwell enrolled at the League, printmaker and children's illustrator Wanda Gág (1893–1946) and her friends knew the names of all the greats—Harrison Fisher, Flagg, Christy—and awaited each week's fresh crop of magazines in a fever of anticipation. By 1913, when she had moved to the Twin Cities to go to art school, Gág had grown more critical of her heroes, however. "We talked of Harrison Fisher . . . who had sacrificed The Better Art to The Art That The Public Demands," she told her diary, and pledged always to stick to the Good Stuff. To Rockwell and his friends, "illustration was an ennobling profession. That's part of the reason I went into illustration," he recalled. "It was a profession with a great tradition, a profession I could be proud of." But Gág's indictment lingered: was it The Better Art?

Artists or not, the illustrators of the generation just before Rockwell's had helped to create a national pictorial identity that transcended the competing immigrant groups who crowded the cities. With her great cloud of hair, her proud profile, and her willingness to best a beau at almost any outdoor sport, the Gibson Girl—she also appeared on wallpaper and souvenir spoons—was the

new century's ideal of American womanhood. J. C. Leyendecker's Arrow shirt man was her male counterpart, chiseled of chin, self-contained, urbane, and smooth. If neither one of them challenged prevailing Victorian mores, they were, nonetheless, mildly modern: fashionable, clean-limbed, and forward-looking. They were also Caucasian, Anglo-Saxon, young, and beautiful.

One of young Rockwell's first setbacks in his quest to emulate Leyendecker, Gibson, and the other mainstays of the Society of Illustrators was his singular inability to paint such creatures. Cartoonist Clyde Forsythe, who shared Frederic Remington's old studio in New Rochelle with Rockwell shortly after he left the League, used to laugh at Norman's pathetic attempts to depict beautiful women. "C-R-U-D," he'd say. "Hopeless. . . . She looks like a tomboy who's been scrubbed up with a rough washcloth and pinned into a new dress by her mother. Give it up." Forsythe advised his roommate to stick to kids and oldsters. A decade afterward, invited to contribute some personal insights into the formative years of the *Saturday Evening Post*'s new star, Forsythe noted that Norman never had "a period of brilliance." He just plugged away at his own work and studied the work of his illustrious predecessors, like Howard Pyle. And painted little boys, dogs, and nice old men in the meantime.

Realizing that his student was having a hard time of it, Thomas Fogarty had started to find Rockwell little jobs even before he left school. The result was that Norman Rockwell, while still a teenager himself, became the art director (and principal artist) for *Boy's Life* and so began a lifelong association with organized American boyhood. From 1923 onward (he somehow missed 1928 and 1930) he also designed the official Boy Scout calendar issued annually by Brown & Bigelow, a Saint Paul, Minnesota, greeting card and calendar company. Calendar art was a major outlet for commercial artists of the period. Beginning in the 1880s, pictorial calendars served as important means of advertising. They were often large, showy affairs, with a picture affixed to a cardboard sheet that also held a pad with removable sheets for months or days and a prominent indication of the donor's name and address. Businessmen hung calendars in their offices: outdoor scenes and pictures of saucy girls were equally appreciated. For the kitchen, dogs and kids were deemed especially suitable.

Calendar art began to fade from the national scene after Word War II. Photographs replaced artwork. With many competing sources of imagery available, the old illustrated wall calendar lost its appeal. An exception was the scout calendar. Loyalty to the organization was one reason for displaying it. The fact that it always offered a brand-new Rockwell surely helped. *Our Heritage* (page 10), the 1950 calendar picture, is another image in which Rockwell seems to wrestle with the problems of being an illustrator and with his own limitations as a working professional.

The setup was one that Rockwell used frequently, especially in studies of children and students: an earnest young man—or two, in the case of *Our Heritage*: a Boy Scout and a Cub Scout—thinks about a historical episode, and suddenly it materializes in the blank space behind him, like a guiding vision. This is the format of the 1932 scout calendar, for example, in which George Wash-

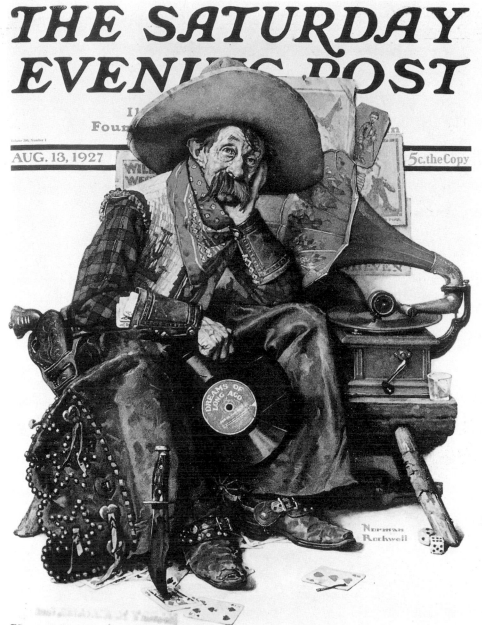

THE SATURDAY EVENING POST

Foun

AUG. 13, 1927 5c. the Copy

Norman Rockwell

Charles Francis Coe—Horatio Winslow—Richard Connell—Floyd W. Parsons
Eleanor Mercein—Thomas McMorrow—Day Edgar—Joseph Cummings Chase

Dreams of Long Ago

Saturday Evening Post cover, August 13, 1927

If the Boy Scouts are dreaming of Wash-ington, after reading about him in their textbook, this armchair cowboy is dream-ing of bygone days with the Wild West Show. The episode comes from a real-life encounter Rockwell had with one of his favorite models, the diminutive James K. Van Brunt. Calling on him one after-noon, Rockwell found Van Brunt lost in memories of his past while playing the gramophone.

Costume plays a key role in telling the story. Good illustrators spent a great deal of time running down the proper cos-tumes for a given situation. They were casting directors of sorts, setting the stage, and choosing the proper costumes, props, and models. Van Brunt was always easy to spot in Rockwell's work because of his huge mustache ("This mustache, sir, is eight full inches wide from tip to tip. The ladies, sir, make much of it.").

ington appears to point the way into the future to a dazzled scout. But in *Our Heritage,* Washington is no mere apparition. Although Rockwell, in conversation with his unsentimental friend John Atherton, described the background as "a cloudy vision of George Washington kneeling and praying in the snow at Valley Forge" (Atherton gagged at the thought!), this Washington is actually a paint-ing—an adaptation of a 1935 *Saturday Evening Post* cover by J. C. Leyendecker.

Leyendecker—who died a year after *Our Heritage* was completed—and his brother Frank (1877–1922) were friends and idols to Rockwell, much as George Washington is the inspiration of the two scouts in the calendar picture. Leyen-decker's original praying figure had been designed as a Washington's Birthday

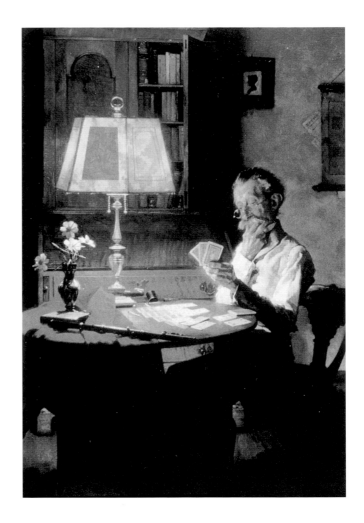

Man Playing Cards by Lamplight

c. 1925. Oil on canvas, 36 x 24" (91.5 x 61 cm).
General Electric Company, Cleveland, Ohio.
(Unused advertisement for Edison Mazda)

When editors and art directors complained that Rockwell was using Van Brunt too much, he had his model try to cover the telltale mustache with his hand. The old man may have reminded Norman of his own father. He described J. Waring Rockwell sitting just like this in the evenings, erect at a table, with his book laid flat within a pool of lamplight.

cover piece: after his collar man, Joe Leyendecker was best known for defining the iconography of the American festival cycle on the covers of the *Post*. His was the New Year's baby, for instance, a versatile figure who could double as a cupid on Valentine's Day. This pattern of recurring imagery, to which Rockwell also contributed with his Santas and April Fool's Day covers, was not confined to magazines. A common vocabulary of Americanism, a kind of American psalter of works and days, it also turned up in ads, cookbooks, greeting cards, and schoolroom decorations.

The scout—the kid, the fresh-faced youngster—is a similar kind of American symbol especially associated with the period before World War I, when Leyendecker was at the top of his form. The comics in the newspapers were full of mischievous kids alive with the vitality of the slums from which they came. Robert Henri specialized in child portraits executed in a slapdash brushwork that suggested the same frenetic energy. The child was America's shining future. In Rockwell's inspiration pictures, the boy always lays claim to the foreground, to tomorrow, while the historical figure melts away into the background and the past. In this picture, Joe's work stands for the past, leaving the future to Norman.

Thus Rockwell subtly subordinates Leyendecker's art to his own. Leyendecker's forms are generalized and idealized: his George Washington never knelt at Valley Forge. But Rockwell's scouts are rendered in hyperbolic detail,

every button and badge studied from life. It is not so much that Rockwell seems to announce the end of the old, traditional costume piece. Every practicing illustrator worth his salt used to collect period coats and boots. It was part of the mystique of the profession and Rockwell collected them, too, until they were all destroyed in a studio fire in 1943. In *Our Heritage*, he seems instead to be saying that the important costumes are those of today—that the present is as deserving of close attention as the heroic past. So even as he continued to wrestle with the legacy of Leyendecker and Pyle, Norman Rockwell hinted at the primacy of a new sensibility that was wholly Rockwellian.

In the early years of his career, however, historic costume—fancy dress—was often the key ingredient in a Rockwell cover. The magazine cover represented the height of the illustrator's ambition in the years between the wars. But it was a difficult assignment. The story illustrator had a narrative to follow. Cover artists did not; journals like the *Saturday Evening Post* rarely linked the cover art and the editorial content of a given issue. Except for the holiday covers, of which Joe Leyendecker was the reigning virtuoso, anything went—within limits, of course: Rockwell once told his son that George Horace Lorimer, the *Post*'s editor when he began his long association with the magazine, instructed him "never to show colored people except as servants" on the front of the magazine. Editors and art directors signaled their displeasure at certain themes by consistently rejecting them or calling for modifications. But within those strictures, cover art still offered the illustrator as much freedom as he was liable to want. In essence, Norman Rockwell was called upon to write his own story—and then to illustrate it in such a way that his audience could read the unwritten text.

The agonies of finding an idea form a recurring theme in *My Adventures as an Illustrator*, and over the years the artist developed certain surefire strategies for coming up with new covers. Sometimes, he brooded and fussed. Sometimes, he drew a lamppost and then imagined something going on around it, on the street corner. Early in his career, Rockwell often took his inspiration from costumes, props, and interesting models. *Dreams of Long Ago* (page 19), which appeared on the *Post* on August 13, 1927, could almost be entitled "What to Do with a Terrific Cowboy Outfit"—chaps, boots, spurs, bandanna, leather wrist guards, flannel shirt, quill vest, and all. The humor of the scene, intermingled with a touch of pathos, comes from the sight of the diminutive figure of an old man in full western regalia thinking about his heroic youth as he listens to cowboy songs on the gramophone. But the details—the meticulously rendered objects scattered around the old man—flesh out the story. He wasn't a cowboy; what he is remembering are his days in the Wild West Show, among the dance-hall beauties who display their ankles in the faded posters behind him. The old man poses among his own show business props, much as an illustrator might arrange a costumed model among suitable theatrical properties to create a cover.

Silhouetted against white paper, the tableau vivant is perfectly constructed, down to the sad droop of the old cowpoke's shoulders, matched by the sag of his mustache. That luxuriant growth identifies the model as James K. Van Brunt, who turned up at young Rockwell's New Rochelle studio one hot June afternoon

in the 1920s, ready for work. Van Brunt was a model's model: he rehearsed his poses in the mirror until they were perfect. He was part of a vanishing cadre of professional models who followed the illustrators to the suburbs. For the most part, Rockwell thought them a sad lot, failures in other callings, reduced to furnished rooms, occasional jobs, and a lonely old age lived out in the afterglow of some Golden Age. Van Brunt was perkier than most—"Five feet two inches tall, sir. The exact height of Napoleon Bonaparte!"—and full of tales of glory as a soldier at Antietam, in the Indian Wars, and Cuba. He loved to march in Fourth of July parades festooned in epaulets and braid. One day Rockwell called at his rooming house to make an appointment for posing and came upon Van Brunt listening to his gramophone in a tiny room filled with souvenirs of days gone by. Kernels of popcorn bought at the Chicago Fair of 1893, heaped under a little glass dome. The butt of a cigar smoked by Ulysses Grant. A seashell brought back from a trip to Atlantic City with his dear late wife, years before. Van Brunt's biography, in slightly altered form, is the story Rockwell gives his old cowboy.

James Van Brunt seemed to bring his own cover stories with him. He was, therefore, an excellent model for a beginner, so much so that Lorimer and some of Rockwell's other clients began to complain of seeing him far too often. He is the lively old gentleman playing solitaire by lamplight in a 1925 ad for Edison Mazda: the theme of loneliness persists but the old man's erect posture and neat business dress also recall Rockwell's memories of his own father in the evenings after work, reading Dickens by the light of a lamp. In the ad, Van Brunt covers the telltale mustache with one hand, but when that ruse failed, Rockwell paid him $10 to shave it off. The eight-inch whiskers never grew back properly, much to Van Brunt's regret. But Rockwell continued to use him so frequently that more radical methods of disguise had to be adopted. In *Gossips* of 1929 he played three old ladies, busily assassinating the characters of their neighbors. Van Brunt threw himself into the spirit of the masquerade. Rockwell described "the way he pranced around the studio in the old maid's costume, lifting the long skirt and curtsying, a flossy little hat tilted rakishly over one eye, his pipe sending up clouds of smoke from its perch behind the mustache."

The cover hints at some of the drawbacks of Rockwell's early methods. He later said that he had used Van Brunt because he "couldn't find any old ladies who were funny-looking enough." In this case, then, the idea came first—a stereotype, really—and the artist sought out the means to bring it to life. The need to hide Van Brunt led to a tightly grouped composition, suggesting the covert nature of gossip. But Rockwell's real affection is lavished on the costumes, especially the sheen of the taffeta skirt in the foreground and the nap of the velveteen jacket at the left. Clothing and props could swamp a good story or temporarily disguise the weakness in a bad one. Rockwell used to haunt a costume rental firm behind the Metropolitan Opera House and, like Pyle and Edwin Austin Abbey, gradually began to acquire a stock of uniforms, hats, and stuffs whose beauty he admired for its own sake. When he bought a real colonial suit in embroidered velvet and satin, it was the talk of his circle, a mark of an established illustrator. Eventually, Rockwell took the outfit to the Metropolitan Muse-

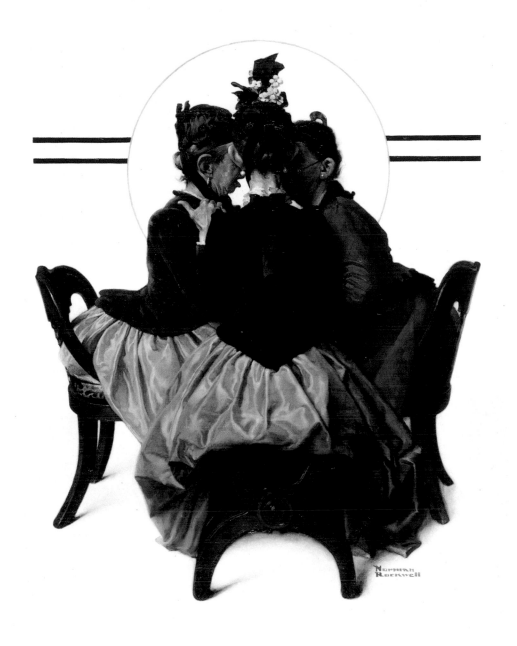

um for authentication. The suit never came back but he later received a certificate thanking him for his gift to the museum. That costume was the only Rockwell in the collection for many years to come.

As the professional model passed from the scene, illustrators resorted to amateurs. In general, Rockwell's covers took on a more contemporary flavor as the oldsters were replaced by a variegated cast of characters. He liked New Rochelle because he had access to an unlimited supply of kids, kept still by a pile of shiny nickels stacked just out of reach. But he also cajoled local residents into posing when a particular idea seemed to demand a particular physical type. The shift to untrained models led some artists to use photographs, still anathema to most of the trade (or a dirty little secret, carefully hidden from one's peers). To

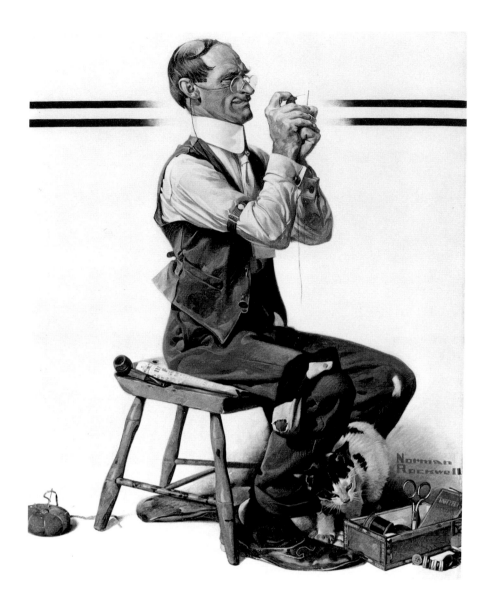

Threading a Needle

1922. Oil on canvas, 25¼ x 20" (64 x 51 cm). Private collection. (*Saturday Evening Post* cover, April 8, 1922)

For this cover, Rockwell posed a Pelham, New York, businessman as a bachelor darning his own sock. Increasingly, as the old professional models from the Golden Age of Illustration died off, amateurs took their places. This had the effect of pushing illustration toward more contemporary subject matter; because amateurs found it hard to hold poses for long periods of time, some artists even resorted to photography (although they generally kept the fact a secret). The tall, thin figure with his tongue sticking out is the comic element in the work. But the deeper content is embedded in the props and costume: the cigar box full of sewing apparatus, the backless kitchen chair, the kitten, the old but elegant slippers, and the pipe and paper waiting to reward the amateur tailor when his labors are done.

others, however, the man-in-the-street model, even if he fidgeted and twitched, was worth the effort because the amateur was a guarantee of emotional authenticity. However contrived the situation, the inclusion of a dentist, a fireman, a relative meant that the picture was true.

As early as 1923, Norman Rockwell was denying that he consorted with professional models. "The very human characters that he loves to portray are all real persons," wrote an approving correspondent for *International Studio*. Rockwell, he continued, was a portrait painter, but instead of painting millionaires who paid to be flattered, he could paint the honest truth "for millions to see and enjoy rather than for the occasional visitor in a stately drawing room." A 1930 article about his models included several cute anecdotes about Van Brunt yet still maintained that "Rockwell never uses professional models. . . . For fifteen years Rockwell has painted people as they really are, and never has there been a false note in the grin of a red-headed kid nor in the drooping shoulders of a Western bad man, dreaming of his youth."

Dave Campion was one of Rockwell's "real" models. Owner of a prosperous news and stationery business in nearby Pelham, Campion was tall, thin, and solemn—the perfect model for a whole range of characters whom Rockwell saw that way in his mind's eye. Campion could make a wonderful sheriff, he thought, or a farmer. There was something vaguely Dickensian about Dave, perhaps in his long, exaggerated proportions. Along with his wife and son, he took a madcap spin in the family Ford on a 1920 *Post* cover. In *Threading a Needle* of 1922, Campion's lean form anchors a sparse but affecting still life descriptive of the bachelor household. Some female once collected the needle book, the pincushion, the spools of thread, and the string of mismatched buttons in the old cigar box at his feet. But now Dave sits alone on a backless kitchen chair, darning his own left sock. His vest is missing a button, too, and his trousers are thin at the knee. All he has for company is the cat, but the bachelor is jaunty and brave, nonetheless, his back straight, his collar clean, his hair combed carefully over an incipient bald spot. It is a domestic scene, however bare: the evening's pipe and newspaper are at the ready.

The picture builds its story, detail by detail, out of real things, assembled with care and closely observed. The least convincing object in the composition may be Dave, too cute by half with his tongue sticking out of the corner of his mouth in overemphatic effort. Dave's pronounced tallness and thinness—he seems more like the idea of a tall man than a real person—may, in fact, have invited the gesture that strikes the false note of stereotype. But his too-long slippers are marvelous, plausible in every stitch and wrinkle, and keep the figure of Dave Campion from slipping over the line into outright sentimental make-believe. Rockwell is a portraitist not just of his models (who sometimes seem like caricatures of themselves) but of everything they wear and touch and see. The illustrator worries over every last facet of the little world within the cover. The face and the slipper and the cigar box. The cat and the chair. His whole professional stock-in-trade: models, props, and costumes.

Profiled in the *New Yorker* in 1945, Norman Rockwell returned over and over again to the matter of what the illustrator did and how—or if—the illustrator was different from the painter. He was a little touchy on the subject. Since he finished art school and set up shop in the second decade of the century, since he painted James Van Brunt and Dave Campion as old ladies and gallant bachelors, the commercial artist had slipped down the ladder of prestige. It was no longer a matter of artists and illustrators. It was artists—and the others, who weren't artists. "If I had my choice between an original Rembrandt and a good Howard Pyle," he told his interrogator defensively, "I would take Pyle every time."

He was an illustrator, like Pyle. *And* an artist: "The critics say that any proper picture should not tell a story but should be primarily a series of technical problems of light, shadow, proportion, color, and voids. I say that if you can tell a story in a picture, and if a reasonable number of people like your work, it is art. Maybe it isn't the highest form of art, but it's art . . . and it's what I love to do."

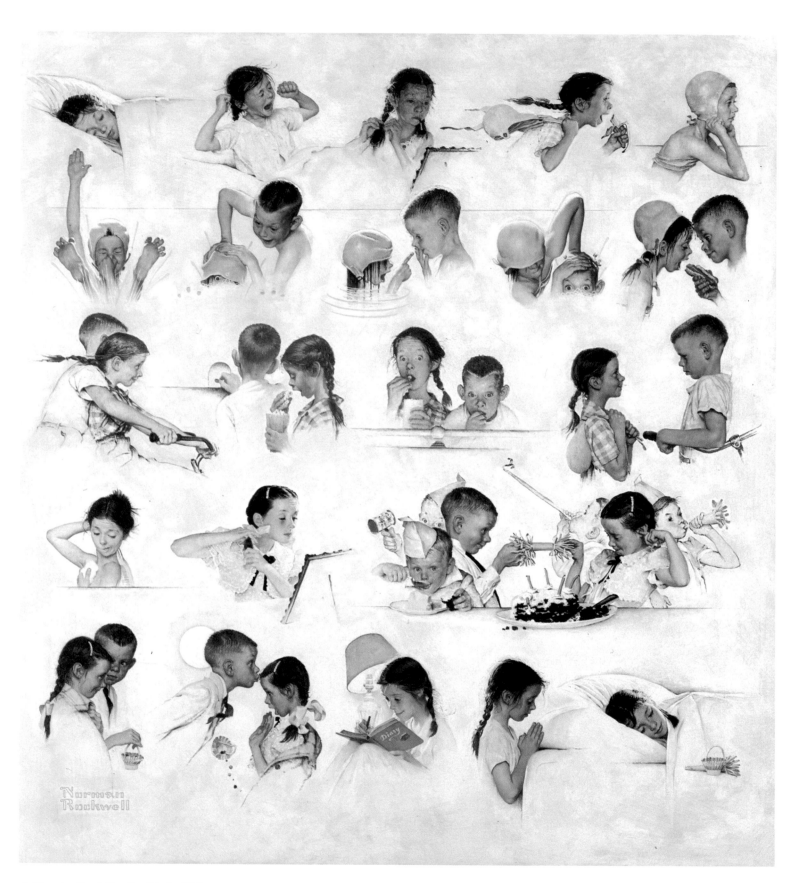

A Day in the Life of a Little Girl

2. Kid Stuff

From 1915, when he found a studio in New Rochelle and set up shop as an illustrator, until 1923, when, as a married man and an established cover man for the *Saturday Evening Post,* he went to Europe to commune with great art, Norman Rockwell painted kids. Fat kids, kids with glasses, kids with freckles, and kids with dogs—boys, mostly. If John Held, Jr., specialized in flappers and sheiks, if Maxfield Parrish went in for decorative reveries, if the Brandywine group purveyed chivalry and derring-do, then Norman Rockwell was the clear choice when the occasion demanded a rapscallion with a cowlick.

Every businessman needed a gimmick. Kids were Rockwell's trademark. He would someday find the situation limiting, but for a young fellow just starting out, Rockwell's early work for the Boy Scouts and the children's press had won him an enviable niche in the marketplace. Forty-one of his first fifty *Post* covers would have juvenile subjects. The vogue for boys made perfect sense to Norman: after all, every grown-up in a business suit used to be one! Besides, a crusty old editor at *Life* had told him that he would never go hungry if he stuck to his guns. The most popular subjects for covers were, in descending order, beautiful women, cute kids, and dogs.

Norman's boys could have been New York street urchins. Backyard circuses and ball games were universal childhood occupations; swimming holes had their urban equivalent in the murky East River, as Ashcan School painter George Bellows (1882–1925) had shown in a famous 1907 canvas entitled *Forty-Two Kids.* But Rockwell's kids were not from the city and he made a point of saying so. Like Tom Sawyer and Huck Finn (although Rockwell had not yet read Mark Twain), they were farm boys and small-town boys. Or the boy Norman Rockwell wished he had been. "I always wanted to be a country boy!" he told a journalist in 1960. Rockwell the artist could make that dream come true.

A series of covers created for *Country Gentleman* between 1917 and 1922 shows how thoroughly Rockwell had fleshed out his dream of an idyllic country boyhood. Some of the covers exist as pairs and others as single images, but the earliest pictures all revolve around a story line Rockwell made up, presented to the readers of the magazine, and then spun out over a period of months. The first five covers introduce the cast of characters in pencil sketches: Rusty and Tubby Doolittle, Chuck Peterkin and his black-eyed mutt, Patsy—and the Doolittles' sissy cousin from the city, Master Reginald Claude Fitzhugh. Thereafter, Cousin Reginald is the butt of everybody's jokes. He can't fish or swim, ice-skate or tumble. He walks the plank when the gang plays pirates. And the Thanksgiving turkey chases him! He excels only in repugnant or unimportant matters:

A Day in the Life of a Little Girl

1952. Oil on canvas, 45 x 42" (114.5 x 106.5 cm). The Norman Rockwell Museum at Stockbridge, Massachusetts. (*Saturday Evening Post* cover, August 30, 1952)

The girl is often the enemy in a Rockwellian boyhood. But in this series of vignettes arranged like the frames of a movie, she gets her due. The work is a companion piece to an earlier Post *cover about a typical little boy's day. The artist thought the masculine version was more popular because boys did more interesting things, but his own chronicle of the doings of little Mary Whalen, an Arlington, Vermont, youngster, is full of fun: the swimming hole, the movies, a party, a little chaste romance, sweet dreams.*

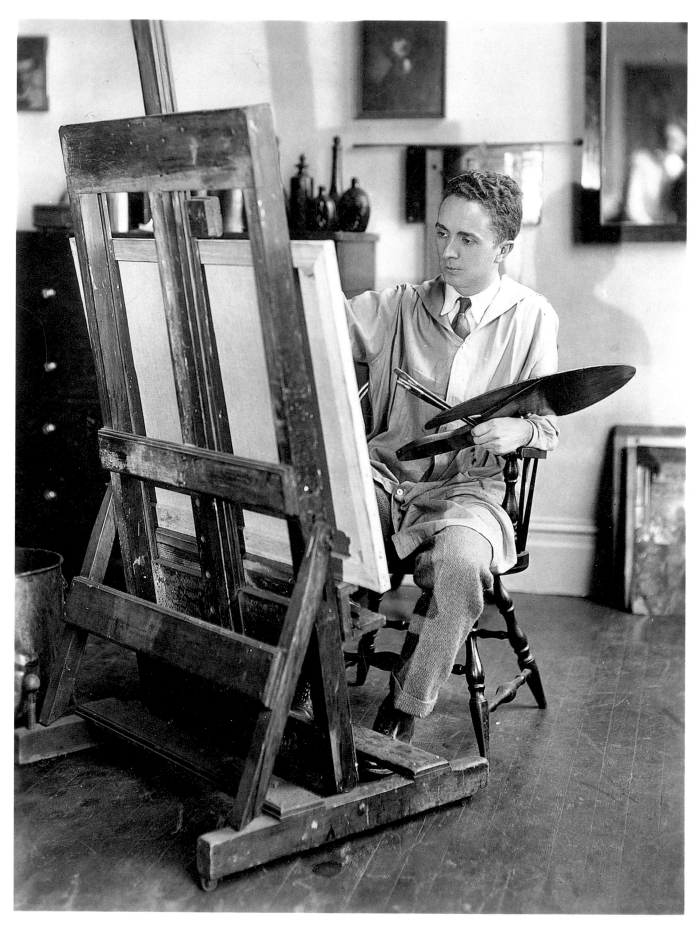

Photograph of Norman Rockwell

spelling bees and wooing girls under the mistletoe, for instance. Yet the viewer is meant to sympathize with the barefoot yokels, however cruel their pranks.

The skinny city kid with the nice clothes and the glasses—Norman Rockwell a few years before—is a figure of fun. The city boy is always bested by the unspoiled children of nature with their tattered straw hats and uncombed hair. At this stage in his life, Rockwell looked at exurban America the way Eugène Delacroix once looked at Morocco, the way other artists thought of Paris: it was heaven, paradise on earth. Like the Regionalists of the 1930s, he attributed special qualities to those unspoiled by city ways. The elderly, most children, and "small town folks are the best characters to use in telling a human story in pictures," Rockwell said, "because in real life they express their emotions naturally."

One of the great social debates of the era erupted just as the *Country Life* material appeared. It concerned the relative merits of country and city. Norman Rockwell's naval service during World War I took him no farther than Charleston, from which he continued his civilian career without missing an assignment. But the war swept millions of other young men of draft age out of rural America into the armed forces, and they never went home again. The war began a great demographic shift from country to city—"How ya gonna keep 'em down on the farm, after they've seen Pair-ee?" asked the lyrics of the popular song—and with it, a searching reappraisal of the way of life to which Rockwell aspired in his pictures of a make-believe boyhood past. Kansas editor William Allen White, of the *Emporia Gazette,* spoke for the heartland and against big-city sophistication: "Surely all joy, all happiness, all permanent delight that restores the soul of man does not come from the wine, women, and song, which Kansas frowns upon." Novelists like Sinclair Lewis took the other side of the case. Lewis's *Main Street* (1920) was a bitter exposé of the narrowness and cruelty of small-town life in the Midwest.

While their conclusions about America's Main Streets could not have been more different—Rockwell for, Lewis emphatically against—the methods employed by the writer and the illustrator are remarkably similar. Lewis is usually credited with having a good ear for the cadence of regional speech but he has an even better eye for artifactual detail. He conjures up not only a typical Main Street house but the character of its inhabitants through a devastating inventory of the parlor wall, plastered with "'hand painted' pictures . . . of birchtrees, newsboys, puppies, and church steeples on Christmas Eve; with a plaque depicting the Exposition Building in Minneapolis [c. 1886], burnt-wood portraits of Indian chiefs of no tribe in particular, a pansy-decked poetic motto, a Yard of Roses." Rockwell brings the same pointed specificity to his Cousin Reginald series, using shoelaces (neatly tied), stockings (trim and smooth), and scraps of scenery (the mirrors and blackboards of feminized places) to tell his audience that the priggish, citified Reginald deserves whatever he gets. Only on the casual cruelties of country life do Rockwell and Sinclair Lewis find themselves in complete agreement.

Rockwell's world differs from Lewis's in one fundamental respect. The characters in *Main Street* work. They are doctors, merchants, teachers; the most trou-

Photograph of Norman Rockwell

Photograph by Paul Hesse, c. 1919. At age 25, he was already a successful young illustrator.

. . . But Wait 'til Next Week!

Many of the young Rockwell's "kid" covers rely on stock props and situations—barefoot boys, straw hats, cute mutts, illicit pranks—but still seem fresher than similar work by other illustrators. His admirers thought the difference was that he used neighborhood youngsters as models and copied them faithfully. Rockwell's kids were real, despite the predictable and sometimes sentimental scenes in which they appeared.

Retribution!

This is a sequel to the previous cover, showing that the wages of sin are a tummy ache and a headache. Many of Rockwell's Country Gentleman *covers illustrated an ongoing narrative constructed by the artist himself about the misadventures of a prissy city boy among his country cousins. So the covers resembled popular serial novels for boys that unfolded their adventures over the course of several volumes. The storytelling drive was strong in all of Norman Rockwell's juvenile magazine work, even in covers like these two that were not, strictly speaking, part of a designated series.*

bled souls are those who, like his heroine, have nothing to do. But Norman Rockwell's kids are too young to have jobs. They are supposed to go to school, of course—but real boys hate school. Although there is a scattering of bored clerks and Babbitts sneaking off to play golf in his early work, most of the Rockwell covers of the period show a society of blissful idleness, or the opposite of the nine-to-five grind of the modern business world. King Vidor's moving silent film *The Crowd* (1928) shows an ordinary young couple trying to survive the pressures of life in New York City, symbolized by giant offices that swallow young men whole at daybreak and spew them back into the streets by night in a well-digested mass. That is not Norman Rockwell's view of the good life.

Rockwell understood the pressure of deadlines. He took his business very seriously. But perhaps because the freelance commercial artist worked alone and set his own schedule, his interest in routine jobs was slow in developing. For many years, there were no offices or factories or mechanized farms in Rockwell-land. The most unrealistic thing about his Edenic country pictures is the almost total absence of labor. Old folks no longer need jobs. Kids haven't yet been caught up in the daily grind. And neither has anyone else. As a rule, the countryside is not a workplace. It is a place of the heart and the memory, an imaginary place without the plows and the reapers the Regionalist painters would shortly find there. Heaven is not a place for baling hay.

Retribution!

Salutation

But Rockwell's countryside is not a place you could find on a map, either. The cover layout of most of the journals Rockwell worked for in the teens and twenties was fairly uniform: a logo at the top, a list of this week's articles at the bottom, and in between, a blank space. *Country Gentleman* framed the artist's reserved block. *Literary Digest* did not. The *Saturday Evening Post* left the matter of a framing or vignetting device up to the cover illustrator. What all the journals had in common, however, was a sea of empty white paper on which the illustration floated. Occasionally, the artist filled the void with a wall, indicating that the space was to be understood as the expanse of a room. But most often, it was the illustrator's challenge to indicate the setting of the scene through a few well-chosen details. In the case of Rockwell's bachelor with the sock, the sewing kit in the foreground suffices to establish a domestic context: in general, the early *Post* covers, before World War II, lack developed background scenery.

In most of the Reginald covers, a slice of earth (or ice) in the foreground is the only hint at geographic location. So just as the young Rockwell was a rootless person, yearning for the security of an imaginary country boyhood from a precarious toehold in a succession of apartments, boardinghouses, and rented studios, his characters too exist in a kind of blank white no-man's-land of the imagination. In the 1920s, Thomas Hart Benton, the father of the Regionalist movement in art, took to the back roads in search of the authentic America. What he found was a whole array of pungent places, each one with its own strong local flavor. The Southern hills were alive with forests of twisting, whispering trees. The plains of west Texas boiled with the energy hidden beneath swarms of gyrating oil wells. The people counted—their folkways, their downright peculiarities—but so did the valleys and prairies where they made their homes, the streets they wandered, the levees where they lazed in the sun. Benton, Grant Wood, and John Steuart Curry made a fetish out of real American places. But unlike the peripatetic environmentalists of his day, Norman Rockwell preferred places that existed in his mind's eye.

A variation on the Cousin Reginald series consisted of an abbreviated narrative dispatched in two successive issues. The first of one such pair features a bully (from the city!) menacing a smaller, barefoot boy. The following week, the little kid levels his tormentor. Twin covers for *Country Gentleman* (pages 30 and 31) in May 1920 invite the reader to stay tuned for further developments. The first picture shows two kids, a Doolittle and a Peterkin, having an illicit smoke, while Patsy looks on through a fence. The title contains a warning: *...But Wait 'til Next Week!* Sure enough. Next week's cover is called *Retribution!* One little miscreant has a headache, the other is sick to his stomach, and the dog, like the viewer, seems both amused and sympathetic. Boys will be boys! If the place is a nondescript, mythic no-place with a few blades of grass and a fence (like the spots where the irrepressible hero and his bad little friends hide to smoke bits of wicker porch furniture in Booth Tarkington's 1914 novel, *Penrod),* the situation is fully developed and wrung dry of narrative potential. Nostalgia, humor, a little pathos: verging on stereotype, the twinned pictures invite a chuckle of recognition, either because we have seen these tableaux in real life or because we wish we had done so.

Salutation

1916. Oil on canvas, 20¾ x 18½' (53 x 47 cm). The Norman Rockwell Museum at Stockbridge, Massachusetts. *(Saturday Evening Post* cover, May 20, 1916)

This was Rockwell's first cover for the Post. *He had labored in vain over pictures of society swells and pretty girls until a friend advised him to show the* Post *what he did best: kids. Editor George Horace Lorimer bought two covers on the spot and approved three more sketches for future covers. The theme was vintage Rockwell: the humiliation of a "real boy" all dressed up by his mother and forced to wheel the baby buggy, while his friends play ball. The artist used red in the picture to draw attention to the crucial narrative elements: the baby's foot, the baseball uniforms, the flower in big brother's buttonhole.*

In 1936, in an editorial written for *The American Magazine* as he was working on an illustrated edition of *Tom Sawyer*, Rockwell spoke of visiting small towns, like those he had idolized and fictionalized for so long. He had recently gone to Hannibal, Missouri, in connection with the Twain project. In 1939, he would move to Arlington, Vermont, abandoning cities and suburbs for good. Now, however, he was surprised at the depth of discontent he found in rural America. "The farm family so often looks with envious eyes upon the town," he noted, "the town upon the cities." But artists and writers were moving in the opposite direction. "They are discovering the things we have seen all our lives, and overlooked." Rockwell wanted to be part of that movement, reassessing—as he had for all *his* life—"the commonplaces of America. . . . Boys batting flies on vacant lots; little girls playing jacks on the front steps." Norman Rockwell's kids.

In 1916, despite his success, Norman Rockwell didn't think he was getting anywhere: it was kids, kids, and more kids. Billy Paine, Eddie Carson, and the other neighborhood youngsters hung around the studio, pulling pranks between stints on the modeling stand. His career seemed like one long issue of *Boy's Life*. Cartoonist Clyde Forsythe, with whom he was sharing work space, urged Norman to try a cover for the *Saturday Evening Post*—the "Satevpost," as the guys in the trade called America's favorite magazine. Norman was terrified. The *Post* was the top of the heap. They wouldn't want boys and dogs. He'd have to do something completely different.

His first try at a *Post* cover was a study in high-society suavity: a Gibson man in tails, as Rockwell described it, bending over to kiss a gorgeous Gibson girl in full evening dress. His second effort—very French, very Edgar Degas—pictured a ballerina curtsying in a spotlight. The only trouble with the sketches was that they were awful. He didn't have a knack for hoity-toity, artsy themes. Forsythe pointed out that all Norman's glamour girls looked like tomboys. "Do what you're best at," he urged. "Kids. . . . You're a terrible Gibson, but a pretty good Rockwell. You do 'kid' stuff." So Norman called in Billy Paine and got down to work. He dashed off two finished designs in black, white, and red (the only colors the *Post* used until 1926) and three sketches and got busy bundling them up for the trip to Philadelphia.

Then he remembered how often he had fumbled around with parcels and string in editors' offices. And eager to make a good impression this time, he ordered a new suit, a new hat, and a bizarre piece of luggage to hold the artwork. A New Rochelle harness maker produced a huge black contrivance so large that he couldn't get it into the subway. Irvin S. Cobb, the famous writer, spied Rockwell and his amazing case waiting, that cold March afternoon, in an outer office at Curtis Publishing Company and asked him if he had a body inside. Profoundly embarrassed, Norman abandoned the offending object and fled. But not before he had sold both sketches and all three ideas to editor George Horace Lorimer at $75 apiece. At age twenty-two, barely more than a kid himself, Norman Rockwell had arrived.

His first *Post* cover, *Salutation* (page 32), appeared on May 20, 1916. The title is ironic. An eleven-year-old boy (Billy Paine) in his Sunday suit—hard collar

No Swimming

1921. Oil on canvas, 25¼ x 22¼" (64 x 56.5 cm). The Norman Rockwell Museum at Stockbridge, Massachusetts. (*Saturday Evening Post* cover, June 4, 1921)

This is the most painterly cover picture Norman Rockwell executed for the next thirty years. The usual Rockwell illustration of the period was an outline drawing or cartoon filled in with local color. Here, the movement of the visible brushstrokes lends an added element of speed to the youngsters' headlong flight, but the broken color—blue and orange patches in the legs of the central figure—is also savored for its own sake. By framing the boys in a box composed of heavy lines, Rockwell accelerates their motion: the lead boy is running so fast that he has scampered out of the frame!

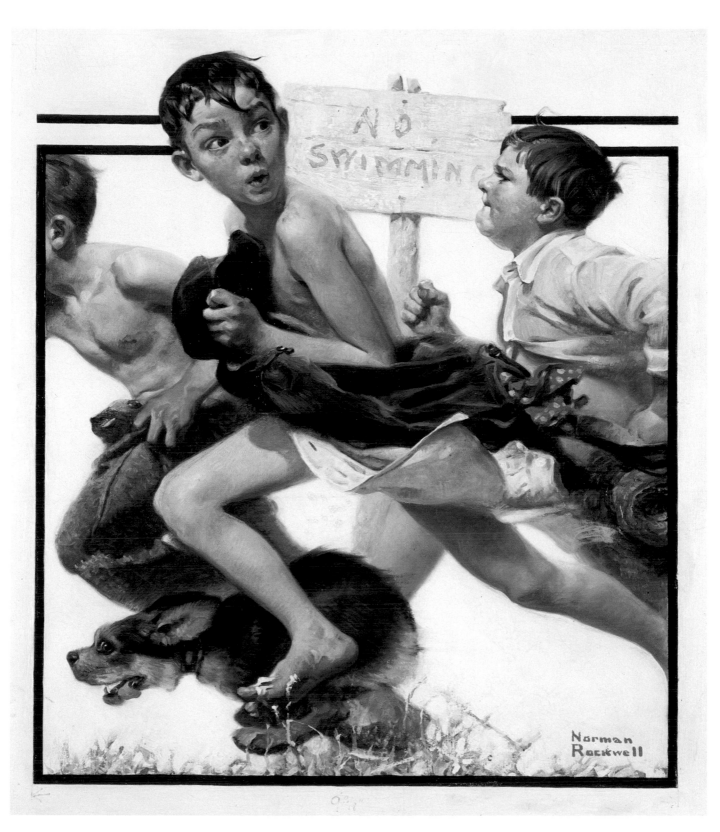

No Swimming

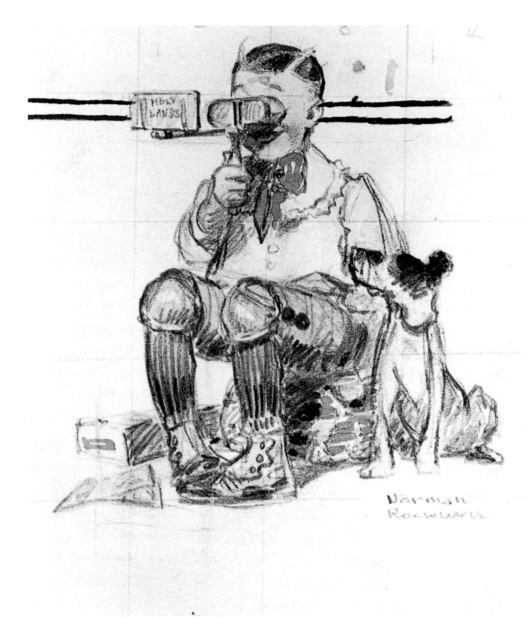

Boy with Stereoscope
or *"The Sphinx"*

Study for *Saturday Evening Post* cover, January 14, 1922. Pencil and watercolor on paper, 4 x 3¼" (10 x 8 cm). The Norman Rockwell Museum at Stockbridge, Massachusetts

This tiny sketch shows how fully developed the typical Rockwell cover was from the outset. All the most important narrative details are already in place: the bow tie, the ruffled shirt, the deflated hassock, and a stereo card entitled "The Sphinx" in the viewer. In the finished version, the boy is fatter and thus even more rooted in his own parlor, far from the Wonders of Egypt. Otherwise, everything is just the same.

and tie, bowler hat, gloves, and a boutonnicrc—is pushing a baby carriage against his will: his expression registers a disgust beyond mere abhorrence. To make matters worse, however, he is greeted by two pals in baseball uniforms (more Billy Paines), one of whom raises his cap in mock greeting. *Salutation*, indeed. The gag requires no advance preparation, no introduction of the characters. Rockwell presumes that any red-blooded male passerby will understand the plight of one forced to do women's work. "The best part of the gag," he later confessed, "was the baby's bottle in the boy's pocket. I received lots of letters about his humiliation."

The emphatic facial expressions help to tell the story quickly but so does a simple but effective composition. Rockwell interrupts the double bars of the *Post* title line only twice: once for the black bowler hat and again for the red-billed baseball cap, thus highlighting the mocking salute delivered and received. He uses the few reds in the picture to good effect, too, picking out the "sissy" buttonhole flower, the necktie, the baby's bootie, and the trim on the baseball uniforms—or all the essential parts of the story. Rockwell gave part of the credit to young Billy Paine, a scamp and a daredevil who would appear in fifteen of Norman's covers for the *Saturday Evening Post* and who died in a fall at the age of thirteen, fooling around like the kind of boy who would have hated pushing a baby buggy while his friends played ball.

Billy's is a masculine world, defined by those activities that are properly female and therefore beyond the pale of male self-respect. Gender lines are firmly drawn in most of Rockwell's juvenile covers. Although the intent is humorous, there is a measure of anxiety inherent in reiterations of the theme for the benefit of an adult audience. Boys ought to do this. Girls ought to do that. In this respect—and in the kinds of adventures they portray—Rockwell's kid pictures parallel the course of serial fiction for children. Norman Rockwell and his boyhood friends, he recalled, devoured Horatio Alger and the Rover Boys. Begun in 1899, the Rover Boys series included thirty volumes by 1926 and had sold more than thirty million copies. The Rover Boys books were published by Edward Stratemeyer (he had written some of the Alger books) and featured heroes like Billy Paine and the Doolittles, whose worst moments came when their mothers or teachers intruded upon a masculine world of adventure. Rockwell's *Salutation* describes a milieu in which nervous male defenders are barely holding the forces of femininity at bay.

Salutation, when it appeared in 1916, competed for national attention with the militant phase of the women's suffrage movement. In March of that year, Woodrow Wilson finally announced his support for a woman's right to vote. Margaret Sanger, jailed briefly for opening a birth control clinic, was back on the hustings, agitating for women's reproductive rights. In November, Jeannette Rankin of Montana became the first woman elected to the House of Representatives. Like the Rover Boys, Norman Rockwell's boys represent a last-ditch effort to hold back the tide of change. In 1930, Stratemeyer himself would capitulate to the demands of the marketplace and issue the first volume in the popular Nancy Drew series, for girls.

Breaking Home Ties

When Rockwell took up the theme of feminine adventures, in the 1952 *A Day in the Life of a Little Girl* (page 26), the results were predictably charming. She gets up in the morning, rushes off to the swimmin' hole (where she dunks the boy who dunks her, without a qualm), goes to the movies with her erstwhile tormenter, puts on her best dress, attends a birthday party, gets kissed on the way home, tells her diary all about it—and goes to bed. The format, which Rockwell seldom used, was an effective one: a series of keyhole views strung together like the frames of a comic strip (or the volumes in a series of books for children) to create an anthology of images, a continuous filmic narrative which, like his early kid covers for the *Post*, has no background.

In the 1940s and early 1950s, Rockwell recruited his Vermont neighbors and family members—son Peter is the Cub Scout in *Our Heritage*—to serve as models: he met little Mary Whalen over a Coke at a high school basketball game. "She was the best model I ever had," he said. She "could look sad one minute, jolly the next, and raise her eyebrows until they almost jumped over her head." Yet in the tiny vignettes that tell her story, Mary's face is less important than her body movements. Her characteristic pose is an energetic one, elbows akimbo, heedless of ladylike proprieties.

Rockwell also wondered if he should include the young man's mother. In the end, he removed her to sharpen the impact of the composition. But in the final painting, her presence is felt in the pack of sandwiches in the boy's lap, tied with a tender pink bow.

On his last *Post* cover before this one (for May 24, 1952), Norman Rockwell had looked in on *A Day in the Life of a Little Boy*. Chuck Marsh, son of a local schoolteacher, was the hero of the piece and Rockwell chose him for his devilish face. Again, however, pose counts more heavily than facial expression, as Chuckie reads the funnies, wrestles with a day at school, plays ball, takes a girl out for a soda, eats dinner, watches a little TV, and goes to bed, with his faithful black-eyed dog. His movements are compact and restrained. His arms reach in, toward his head and body, while Mary's reach out into the blank space around her. On formal grounds alone, she is the more aggressive, open, and dynamic character. Yet the artist was disappointed with the Mary Whalen version of the conceit. "It wasn't as good or as popular, I guess because a little boy leads a more active and varied life than a little girl," he speculated wrongly. Clearly, Rockwell's audience preferred the good old days, when boys were Rockwell boys and little girls were seldom seen.

Boys were supposed to break the rules. *No Swimming* (page 35) of 1921, one of Rockwell's best early *Post* covers and a work that shows an uncommon command of the artist's painterly resources, celebrates a minor instance of boys-will-be-boys lawlessness. The sign in the center background says "NO SWIMMING."

But three boys have been apprehended doing just that and flee in great disorder, half-dressed or, in the case of the central figure, naked as a New Year's baby. By surrounding the scene with thick black lines, Rockwell makes the act of transgression clear: as the boys run in headlong terror of the law, they are cut off by the edges of the frame, reinforcing their speed and pell-mell flight. The lead boy's face has disappeared behind this frame but the expressions of the other two betray an emotional stress commensurate with their physical effort to elude pursuit.

The running pose was nearly impossible to hold. The model, the obliging Franklin Lischke, son of Rockwell's New Rochelle landlord, did his best, his bare feet propped up on stacks of art books, half sitting on a stool under the north window his father had installed for Norman in the second story of an old barn at 40 Prospect Street. It was difficult poses like this that drove Rockwell to call in a photographer for the first time in 1921, perhaps for *No Swimming*. When he wasn't posing for Rockwell—or the never-to-be-mentioned camera—Franklin ran errands, swept the floor, and rounded up props. But some pictures could be ruined by too many clever accessories. The rag tied around Franklin's big toe in *No Swimming* comes dangerously close to being too cute. The dog huffing and puffing across the foreground is simply redundant.

There are better means of showing speed. Rockwell's brush moves quickly over the scene with the broken touch of an Impressionist. The legs of the youngster in the middle are made up of crosshatches of complementary blue and orange. The shirt he clutches trails off into thin white squiggles. So quickly do the boys dart past the viewer, so fast does the brush flicker across the surface, that the clothing of the last boy in line is an unreadable blur. Rockwell's other covers of the 1920s rely, for the most part, on a crisp definition of firmly bounded forms, filled in with color rather than created by it. *No Swimming* is the exception to a cartoonish style rarely so supple or so subtle.

Rockwell's pencil and watercolor study for *Boy with Stereoscope* or *"The Sphinx"* (page 36) of 1922 has some of the same sprightliness and dash, despite the sedentary theme of a chubby boy passing a Sunday afternoon in the parlor looking at the wonders of the world through an old-fashioned viewing device. The use of the stereoscope suggests that Rockwell may have been doing a period piece, a variation on his usual subject picture. The boy's amazed countenance seems too startled for a 1922-vintage Rockwell kid, but perhaps the real joke is that the great stone face of the Sphinx, by contrast, never registers emotion. The child wears a blouse with fussy ruffles at collar and cuffs and a floral scarf tied in a big tabby bow. Like Cousin Reginald, he has been dressed by a mother or an aunt in clothes best never seen outside that parlor. One of his models, Rockwell told a reporter in 1921, agreed to pose in a sailor suit but was teased so unmercifully by his pals when the cover hit the newsstands that "he has never consented to play the part of a 'sissy' again. He will die first."

Rockwell's interest in illustrating deluxe editions of *Tom Sawyer* (1936) and *Huckleberry Finn* (1940) may have been sparked by the affinities between Twain's characters and his own all-American boys. His kids, too, resented being made to

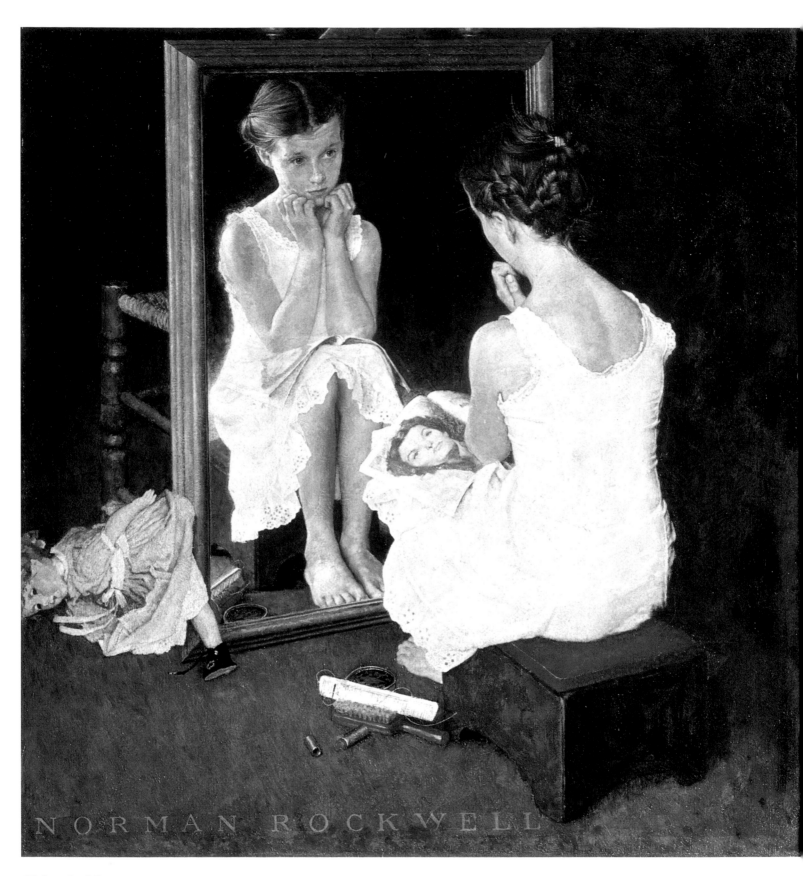

Girl at the Mirror

wash and dress up: their sworn enemies were the "widders" of the world, the Aunt Pollys and the Miss Watsons. Mark Twain's protagonists would have sympathized with the plight of the overdressed boy with the stereoscope; the worst thing that ever happened to Huck Finn was having to dress up like a girl. In fact, several of the Heritage Press color plates actually derived from magazine covers or, with minor changes, doubled as typical Rockwells on the front of the *Saturday Evening Post*. A scene of Huck teaching Tom and Joe to smoke comes directly from *Retribution!* of 1920, for example: the boy on the right side is virtually identical in both pictures. The looser, more expressive paint handling is all that separates cover from classic. In the company of great literature, Rockwell felt freer to let his artistic means show. The scene of Aunt Polly dosing Tom with medicine became the *Post*'s *Spring Tonic* in 1936 by the simple expedient of lightening up the scene. The *Post* was relentlessly cheerful. Despite the false belief in many quarters that Mark Twain wrote pleasant stories for children, *Tom Sawyer* was not that.

As the years passed, Rockwell's view of the all-American boy deepened and changed. No longer the cartoon figure whose antics roused sentimental longings for the good old days, when boys were boys, the young man in *Breaking Home Ties* (page 38) of 1954 is that fresh-faced Rockwell kid all grown up and bound for college. This is the last chapter in a long story, and the sweet sadness is vested not in a half-imaginary child anymore but in the knowing, aging adult, who must stay behind.

The title and the subject both come from an 1890 genre painting in the collection of the Philadelphia Museum of Art by the Irish-American artist Thomas Hovenden (1840–1895). In the prototype, a mother bids her son goodbye. His father carries his bag, an old woman by the fireplace holds his home-packed lunch and his umbrella, a younger brother peers sorrowfully from the shadows, and even the family dog adopts a mournful expression. The kind of subject picture popular in the British Isles during the potato famines and the colonization of Australia, the original *Breaking Home Ties* was full of incident and touching detail. It was Rockwell's task to unclutter the composition not only for the sake of the narrative clarity required of a magazine cover but also to achieve the sharper emotional bite demanded by the conclusion of a story that had been unfolding for more than thirty years. His *Breaking Home Ties* documents the coming-of-age of the Rockwell kid.

The picture held personal meaning for Norman Rockwell, too: his eldest son, Jerry, had just joined the Air Force, and the younger boys, Tom and Peter, had gone away to school. There was another crisis in the household as well. His second wife, Mary, the mother of his children, had been undergoing treatment for alcoholism and related problems at a psychiatric hospital in Stockbridge, Massachusetts. Between the time he started his two great studies of the end of childhood—*Breaking Home Ties* and *Girl at the Mirror* (1954)—and finished them, Rockwell abruptly uprooted his household from Vermont and moved to Massachusetts, to be closer to the Austen Riggs Center. The period was one of turmoil, sadness, and goodbyes.

Girl at the Mirror

1954. Oil on canvas, 31½ x 29½" (80 x 75 cm). The Norman Rockwell Museum at Stockbridge, Massachusetts. (*Saturday Evening Post* cover, March 6, 1954)

All of Rockwell's little girls come of age in this one poignant image. Am I a woman yet? How do I look in makeup? Is my hair right? Am I pretty enough? I'm a little scared. Will everything be all right?

The genesis of *Breaking Home Ties* was, accordingly, slow and painful. In the pencil and charcoal studies that preceded the oil, a mother comes and goes. The principals first move closer to the picture plane and then edge back, toward the middle distance. But Rockwell's biggest problem was the background, the setting. Once a non-place constructed of white paper and a few props, the locale suddenly becomes a crucial element in the meaning of the piece. Before the boy can feel the pain of leaving home—before the *Saturday Evening Post*'s readers can understand the mingled joys and sorrows of growing up—the audience must recognize the place from which he is departing on his journey toward adulthood. If he is leaving home, then home must be achingly real, down to the last weed and railroad tie. Rockwell moves his figures from a waiting room to the station platform to the running board of the father's old truck to achieve a more intimate sense of place. A station could be anywhere. The sort of flag stop where it is more comfortable to wait in the truck, alongside the track, must be a very tiny place indeed. Besides, the battered running board brings the sunburned rancher and his son closer together, for the last time.

The details are masterfully handled: the truck, of course, the ties and the single rail in the foreground, the steamer trunk that holds the signal flag and lantern (and carries Rockwell's signature). The boy is his father's son; the same long, broad feet, the same calloused hands, the same white band of skin around the forehead, where the hatbrim shades the face. The father is holding two hats—his old one, junior's new one—one on top of the other, as if the family history could be summed up in a beat-up Stetson covered by a nice, clean model. The father wears denims. The son is in his Sunday clothes: a suit, an awful tie, argyle socks, a ticket in his breast pocket. From the pocket of the old man's shirt dangles a white paper disk, the tag for a key, dead center in the picture. The key to the trunk that he once took with him, when he waited at the same depot years before? Or the key to his heart? The boy holds a package of sandwiches in his lap, tied up in a pink ribbon evoking the absent mother; his dog is too miserable to sniff at the parcel and beg. His textbooks already have bookmarks poking out of their tops. The "State U" pennant glued to his cardboard suitcase looks brand-new. And suddenly, he sits up straight because he's heard the engine in the distance.

Also painted for the *Post*, *Girl at the Mirror* (page 42) is the feminine counterpart to *Breaking Home Ties*. Rockwell seats Mary Whalen on a low stool before the mirror. Her doll has been tossed aside: she is finished with childish toys. On the floor by her feet are a comb and brush, a lipstick, and a box of powder. The solemn little face in the mirror, under the wispy chignon with the erratic center part, bears traces of artificial color. On her lap is a picture of Jane Russell, Hollywood's latest sex bombshell. Rockwell copied Russell's likeness faithfully from the cover of *Movie Spotlights* but later regretted it. "I should not have added the photograph of the movie star," he remarked. "The little girl is not wondering if she looks like the star but just trying to estimate her own charms." But she is also trying to see if she is almost grown up yet. For purposes of that determination, the mature charms of Miss Russell provide an excellent yardstick.

Like *Breaking Home Ties,* this canvas was begun in Arlington, Vermont, and finished in Stockbridge, Massachusetts. During that long period of gestation, an indecisive Rockwell photographed several girls besides Mary in a search for the essential pose. In one of them, the child is wistful, even exasperated at her poor efforts with the makeup kit. In another, she presses her hands to her cheeks in mock despair. But Mary's is the only pose to seem apprehensive, as if she understands that womanhood is upon her and fears that she is not quite ready. That Mary Whalen, whose gestures were so expansive in *A Day in the Life of a Little Girl,* should pull her arms in toward her chest for self-protection, aware of the woman's breasts to come, is the most poignant detail of all.

The setting shows what can be conjured up with the slightest of means. There are vague indications of flowered wallpaper in the darkness to the right of the figure and behind the mirror. Mary is intent on her self-scrutiny. She has taken that mirror down from the wall and propped it up against the back of a spool-turned chair—and then dragged the little stool into position. The disordered contents of the room help to show how important this still, fragile moment is to the budding child in the slip whose eyes we see in reflection, peering back anxiously at a face visible to us only through the artist's good graces. His name reads large across the fresh green carpet at her feet. Norman Rockwell. Clown prince of kids. And poet of childhood.

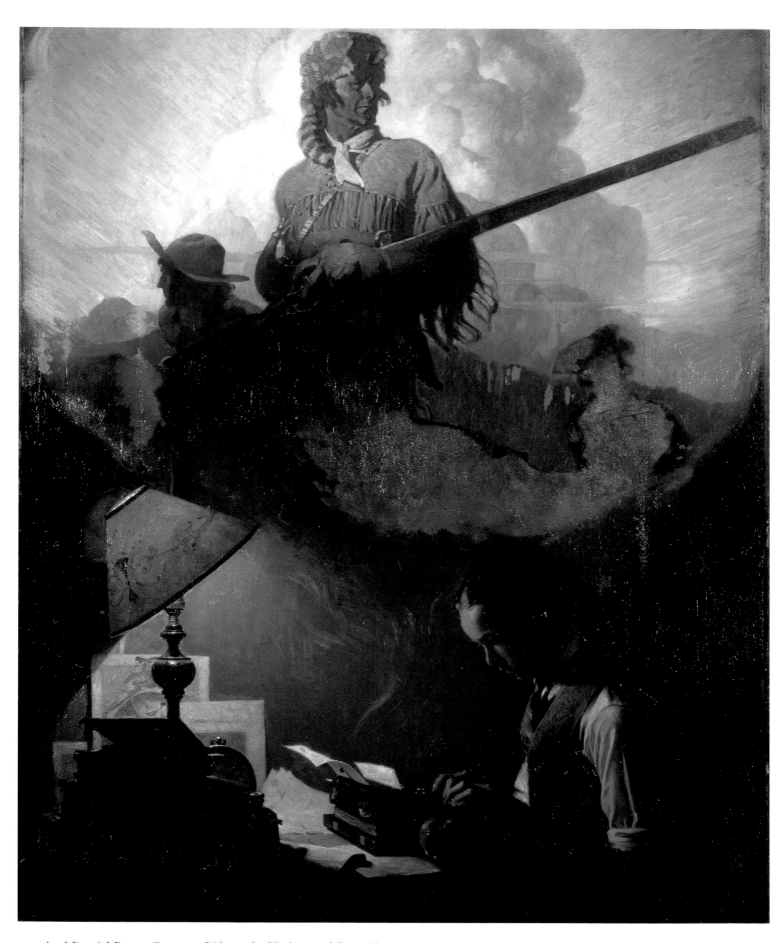

. . . And Daniel Boone Comes to Life on the Underwood Portable

3. Norman Rockwell's Colonial Revival

Right after Rockwell sold his first cover to the *Saturday Evening Post,* he rushed to a phone and proposed marriage to Miss Irene O'Connor, a schoolteacher he met and courted at his parents' current boardinghouse. The match was not a success. A year after the wedding, Norman enlisted in the Navy, and when he came home, he threw himself into his work. In the 1920s, he also dove into the mad social whirlpool of the suburbs—golf, cocktails, and fancy cars—with the desperation of a character in a novel by F. Scott Fitzgerald: he was, by his own admission, a cartoon version of the madcap, Jazz Age fool.

He went to Europe, several times, never with his wife. Plagued by loneliness and insecurity, he enrolled in art school in Paris and dabbled in the latest aesthetic crazes, until the *Post* caught him up short by rejecting a cover idea. "I don't know much about this modern art," Mr. Lorimer lectured, "but I know it's not your kind of art. Your kind is what you've been doing all along. Stick with that." Norman took a room by himself at the Salmagundi Club in New York and rented a studio nearby. He had a breakdown. Irene brought him back to New Rochelle. But the marriage failed. She filed for divorce in Reno, Nevada, at the end of 1929. "Mrs. Rockwell charged that her husband declared he and she were unsuited to each other and that he was absorbed in his work," the *New York Times* reported. He kept the house on Lord Kitchener Road.

Rockwell's new, two-story colonial had already been built when he acquired the property in 1926. Dean Parmelee, the original architect, agreed to design a white brick and clapboard addition to shelter the garage and a studio. The fancy studio wing, with its walk-in fireplace and (fake) balcony so captivated the imaginations of decorators and home improvement experts that it became the subject of no fewer than three major magazine stories in its own right. The first of them appeared in *Good Housekeeping* in February 1929. And nowhere is a Mrs. Rockwell mentioned. The decisions about the house in New Rochelle were all Norman's, and the taste it expressed was his own.

To be sure, the white colonial house with green shutters was the fashionable choice in the late twenties. Architect Parmelee, who went to Europe with Norman in 1927, was a revivalist by trade. At the height of the great antiques craze of the day, he toured New England with Rockwell in search of $23,000-worth of authentic bric-a-brac for the all-important studio wing. His prime model, Rockwell said, was the Wayside Inn, in South Sudbury, Massachusetts, restored and refurbished by automaker Henry Ford, beginning in 1923. Legend had it that here, in 1862, poet Henry Wadsworth Longfellow had written *Tales of a Wayside Inn,* with its breathless evocation of the midnight ride of Paul Revere. Ford had made it a working hostelry again, a mecca for celebrities and decorators.

. . . And Daniel Boone Comes to Life on the Underwood Portable

1923. Oil on canvas, 28 x 36" (71 x 91.5 cm). Private collection. (Advertisement for Underwood typewriters)

The Colonial Revival was part of a general preoccupation with the American past that began in the 1920s and reached a climax in the 1930s. The past offered a snug place of safety in a world buffeted by the social upheaval of the Jazz Age and the calamity of the Great Depression. Rockwell often shows the events of the past—historical ones, like the adventures of Daniel Boone, or personal recollections—as a positive influence upon the present. Here, a thoroughly modern boy with a typewriter, slicked-down hair, and a spiffy Joe College–style sweater is inspired by the heroic deeds of American history.

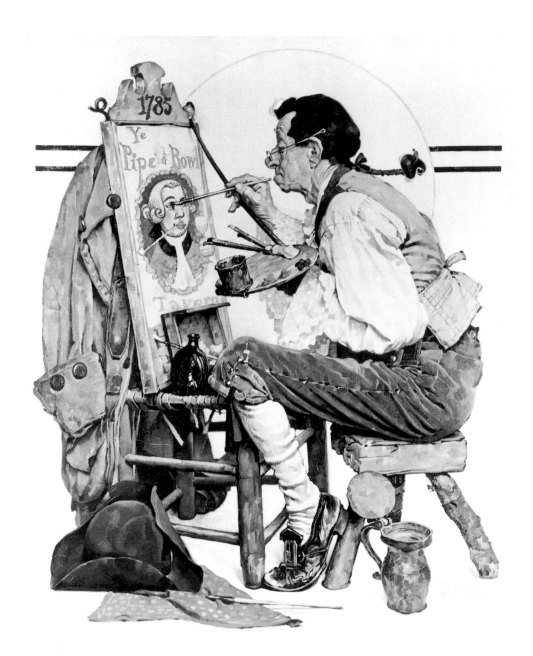

Sign Painter

1926. Oil on canvas, 26½ x 21¾" (67 x 55 cm).
Private collection. (*Saturday Evening Post* cover,
February 6, 1926)

*Editor George Horace Lorimer selected
Norman Rockwell to design the* Post's
*first full-color cover. And Rockwell used
the opportunity to consider the commer-
cial artist's lot. The model was his
favorite: James K. Van Brunt, without
his trademark mustache. But the real
subject was Norman Rockwell and his
artistic heritage. His own Colonial
Revival house in New Rochelle was
strewn with artifacts like those scattered
around his ancestor in art.*

The Wayside Inn was famous for its fireplaces, old-time inconveniences now cherished for their warmth and charm by a generation more accustomed to the modern furnace and the thermostat. Guests were seated at fireside tables and served with hearty fare prepared in the colonial manner, on spits and toasting racks. But the infrastructure of the place was as advanced as a new Ford automobile. The guest bedrooms had electric lights, indoor plumbing, spacious closets—and central heating. Ford had, at one point, demanded that the state move a modern, paved stretch of the Boston Post Road away from the inn so that the noise of the passing cars wouldn't spoil the atmosphere. And atmosphere was what President and Mrs. Coolidge, Emily Post, and Norman Rockwell came looking for, amidst the litter of real and faux antiques, period reproductions, and outright frauds on proud display—including, in the latter category, a heart-shaped piece of the cherry tree young George Washington is supposed to have chopped down.

Rockwell's studio looked like one of the more cluttered public rooms of Henry Ford's New England hotel. There were Windsor chairs, a grandfather clock, sturdy tables of maple and pine, quill pens, pewter flagons, and steer horns. A wagonwheel chandelier with electric candles. A Revolutionary War musket over the mantelpiece. The fireplace, *Good Housekeeping* gushed, recalled "one in the Wayside Inn, furnished with antique andirons and fire tongs, bellows and iron pots, similar to those used in the old tavern." Despite the carefully contrived atmosphere—there was an imitation bread oven in the fireplace—it was simple, tasteful, and irresistibly friendly, the writer thought. Real and American, just like Norman Rockwell, "the studio goes back to an earlier type, with the solid timbers exposed, as in the cottages of our forefathers."

With the artist's working tools carefully concealed from view (except for the big studio window in the north wall), the room could have been the setting for one of Rockwell's illustrations of bygone times, with every object chosen and placed for best effect. A 1940 article on his technique in *American Artist* was introduced with a large photograph taken in the studio that year. Not an ornament is out of place. Not a detail has changed. But the hearth and the balcony serve as a passable setting for a historical story by Howard Fast: dressed in her long gown and bonnet and holding a musket, the model seems right at home in the colonial scenery. "Rockwell's studio at New Rochelle is a large timbered structure with trusses of hand-hewn beams supporting the high-pitched roof," noted the journalist. "An enormous stone fireplace provides a focal point of interest and a few relics of Revolutionary days garnish the scene with the romance of ancient Americana."

Rockwell liked his studio, despite the exorbitant price tag. He considered it "extremely up-to-date in an antique way." Rockwell's phrase is, in fact, a good working definition of the Colonial Revival of the 1920s. Columnist Walter Lippmann, struggling in 1926 to explain the appeal of the laconic Yankee-bred Calvin Coolidge, hit upon a clever phrase to describe a culture devoted simultaneously to wretched excess and to the imagined asceticism of colonial New England. "We have attained a Puritanism de luxe," wrote Lippmann, "in which

The New Tavern Sign

Study for *Saturday Evening Post* illustration, February 22, 1936. Oil on board, 15 x 25¾″ (38.5 x 65.5 cm). Center Art Galleries, Hawaii

Painted for the Washington's Birthday issue a decade later, Rockwell's second attempt at the subject shows the viewer why the new sign was needed. The year is 1776. George III is out. George Washington is in. Using tavern signs to show the passage of time was a trick Rockwell borrowed from John Quidor, a nineteenth-century genre painter who specialized in pictures that illustrated the stories of Washington Irving. By 1936, Rockwell's interest in the Colonial Revival had gone beyond good taste and current fashion: he was also captivated by American literature, art, and costume. In 1938, he won the annual "High Hat" award from Judge *magazine "for having kept alive the affectionate interest of America by his re-creation of figures of the late eighteenth and early nineteenth centuries."*

it is possible to praise the classic virtues, while continuing to enjoy all the modern conveniences." In a world run mad with easy credit, fast living, and constant change, the colonial style offered some hope of stability, a reminder that basic values persisted, or ought to persist, whatever the craze of the moment.

As the repository of virtue, a refuge from the whirl of commerce, the home was the ideal focus for the Colonial Revival, which was, first and foremost, a domestic phenomenon. While a few neocolonial office suites and roadside restaurants were carried along on the high tide of the movement, shutters, beams, and fireplaces were signs of home. It is telling, therefore, that Rockwell should have decorated his studio in the manner of an ancestral house. His work was his life. His studio, when *Good Housekeeping* came to call, was his real home.

In the 1920s, colonial gewgaws were foils for modernity. In the 1930s, with the onset of the Great Depression, the Colonial Revival also became a spiritual anchor in the stormy seas of despair—a "usable past." As novelist John Dos Passos put it, "we need to know what kind of firm ground other men, belonging to generations before us, have found to stand on." With doomsayers predicting the end of the republic, history offered a kind of reassurance that survival was possible. The nation had weathered calamity before. It would surely do so again. The Revolutionary era—in stories and historical novels, in pictures, in films like

Ichabod Crane

c. 1937. Oil on canvas, 49½ x 24½" (125.5 x 62 cm). The Norman Rockwell Museum at Stockbridge, Massachusetts

This portrait of the stringbean school-master described in Washington Irving's famous tale of the headless horseman was intended to be the first in a series of important figures in American literature. But Ichabod is disappointing. He is timid and static, despite Rockwell's vigorous brushwork.

Ichabod Crane

c. 1937. Oil on canvas, 38 x 24" (96.5 x 61 cm).
The Norman Rockwell Museum at
Stockbridge, Massachusetts

Despite a view from above that diminishes his gawky height, this is a better Ichabod Crane. He prowls the classroom, a book in one hand, and a switch in the other, the lead actor in his own story.

Other characters proposed for the series on beloved American authors—Little Lord Fauntleroy, and Captain Ahab from Melville's Moby-Dick—*reflect Rockwell's idiosyncratic view of American literature. A 1930 edition of* Moby-Dick *designed by left-wing artist/illustrator Rockwell Kent was highly praised and may have given Rockwell the idea for his literary pictures; much to the amusement of both men, they often got one another's mail. But many "fine" artists without previous experience turned to illustration in the 1930s. Grant Wood, Reginald Marsh, and Thomas Hart Benton all illustrated American classics. The artistic ideology of the Depression held that book illustration was a democratic art, accessible to the masses in a way that oil paintings were not.*

John Ford's *Drums Along the Mohawk* (1939)—was of special interest to the 1930s because of the string of anniversaries that stretched across the decade, from the bicentennial of Washington's birth in 1932 to the 150th anniversary of his inauguration in 1939. In both versions of the Colonial Revival—the domestic edition of the 1920s and the public one of the 1930s—Norman Rockwell played important roles.

In keeping with the home-and-hearth character of revivalism, many of Norman Rockwell's most fully developed colonial works were executed not for the *Post* but for the *Ladies' Home Journal*. Although the *Journal* called upon him to illustrate fiction, like the 1939 Howard Fast short story about Dolley Madison that drew attention to the colonialized interior of his studio, often Rockwell's pictures seem to have been painted simply because the artist wanted to. Full of romance and precise delineation of furniture, costume, carpets, and accessories, these independent compositions reflected his own interest in the accoutrements of the Colonial Revival.

His storyless illustrations were accompanied by bits of text either found or created for the occasion. A scene of two late-eighteenth- or early-nineteenth-century gents toasting the season in a wayside tavern, for example, was printed in the Christmas issue, alongside an excerpt from Charles Dickens's *Pickwick Papers*. A silhouette cutter taking the likeness of an eighteenth-century American girl topped an explanatory paragraph discussing the origins of the term and the popularity of black paper silhouettes during the Revolutionary War. A picture of the young George Washington courting a New York heiress in an elegant

interior was justified by a quiz in the same issue on "Forgotten Facts About Washington." All created between 1930 and 1932, these early efforts matched the tone and content of the *Ladies' Home Journal*. They were the kind of pictures readers clipped and framed for their bedroom walls, where they hung among the silhouettes of colonial worthies that were a decorating "must" of the period.

The earliest of Rockwell's colonial efforts is also one of the most significant. In 1926, George Horace Lorimer decided to drop the old red-and-black cover format of the *Post* in favor of color. Norman Rockwell was chosen to do the first full-color cover in the long history of a magazine that claimed to have been founded by Benjamin Franklin. Perhaps a sense of historical import influenced Rockwell's choice of subject: a somewhat elongated and rejuvenated James K. Van Brunt in knee britches and a scruffy queue, painting a sign for "Ye Pipe and Bowl Tavern" in 1785. The cover (page 48) is not a complete success. Even without his mustache, the model is just as distinctive as he had been before, and Rockwell caricatures his features further, adding a broad comic touch to the work but undercutting its real seriousness. For the picture is a self-portrait of sorts, a study of the commercial artist at work—one of a large number of such self-referential exercises with which Norman Rockwell would punctuate his career.

Van Brunt, his surrogate, was his favorite model and if, at the age of thirty-two, the tall, gawky Rockwell ever looked like a tiny old man, it was in this picture. Like Rockwell in his New Rochelle studio, the sign painter works in a space crammed with colonial stuff: hats, coats, and a flagon. Like Rockwell, he paints to order. If the sign with its conventional portrait of a colonial gentleman is a kind of mirror of the painter's grotesque face, positioned directly before it, then the commercial artist also prettifies the often unpretty world around him. Rockwell/Van Brunt is a rawboned craftsman with a mug of beer—but in the mirror of art, he has become a smooth-faced aristocrat with a glass of wine. Art improves upon nature.

Rockwell revisited the subject in 1936, in a double-page illustration for the inside of the magazine. *The New Tavern Sign* (page 50) treats the itinerant artist more kindly this time. He is a handsome young man working in a warm splash of sunlight on a bench outside the tavern. An audience has gathered—the landlord, a serving maid, and a passing gentleman: everybody scrutinizes the painter's work with respectful interest. The reason for the new sign is specified. The discarded version, pocked with holes from musket balls, surmounted by an armorial crown, and bearing a portrait of George III, c. 1774, has been hauled down. The new one, on the artist's improvised easel, depicts George Washington, c. 1776, under the American eagle.

The convention of denoting the passage of time with tavern signs came from William Hogarth or, closer to home, from John Quidor's (1801–1881) American genre paintings, serial works based on Washington Irving's story of Rip Van Winkle's long sleep in the Catskill Mountains. In the mid-thirties, when he looked back into the history of American art for this theme, Rockwell was also doing research on Irving in preparation for a group of portraits— never completed—of much-loved figures in American literature. Two large oil

Yankee Doodle

Mural for the Nassau Inn, 1937. Oil on canvas, 60 x 152" (152.5 x 386 cm). The Nassau Inn, Princeton, New Jersey

The mural was the diagnostic medium of the 1930s. Because murals were permanently affixed to the walls of public buildings, they were the ultimate "art for the people." Government programs for struggling artists in the New Deal era also focused on murals in government buildings because the taxpayer could see what his or her dollars had bought. Rockwell never painted a government mural in the 1930s—his income was too high for that—but he did create this delightful panel for a Colonial-style inn. Applied to restaurants, the Colonial style was a sign of home cooking and hearty hospitality, and Yankee Doodle reinforces a relaxed, festive mood. Although the subject is the Revolutionary War battles fought around Princeton, the Hessians in the picture are simply amused by the sight of the comic Yankee on his nag. For this commission, Rockwell had the military costumes specially made, to ensure authenticity—and because he loved them.

YANKEE DOODLE CAME TO TOWN · RIDING

studies of Ichabod Crane, schoolmaster hero of Irving's "The Legend of Sleepy Hollow," from *The Sketch Book* (1820), date from the same time and show many similarities to *The New Tavern Sign,* especially in the handling of costume and pose. It is apparent that Rockwell identified closely both with the lanky Ichabod and with the colonial artist/craftsmen who cut silhouettes and painted tavern signs.

The notion of an artist working in the public eye, as the sign painter does, was antithetical to the modern image of the creative genius, toiling away in isolation. But the programs for artists begun by the Roosevelt administration in the depths of the Depression to funnel much-needed paychecks to unemployed painters, actors, and musicians operated on the principle that the artist was a functioning member of society; that, for example, plays and symphonies and paintings ought to reflect the common experience and find their audience in the public arena. From 1933 onward, much of the relief funding for visual artists went to muralists who plied their trade in the lobbies of public buildings, with an audience of taxpayers watching every brushstroke. The mural was, by its very nature, a public art form: unlike a portable easel painting, subject to the whims of the owner, the mural remained a permanent part of a building. Although the

PONY · STUCK A FEATHER IN HIS HAT · AND CALLED IT MACARONI

rich and famous Norman Rockwell was not a prime candidate for art relief, the ethos of the federal projects nonetheless finds its way into works that glorify the artist as a common man at work among the people for whom his pictures are intended. The earnest limner of Rockwell's *The New Tavern Sign* is a New Deal painter in fancy dress.

His own mural was painted in 1937 for the Nassau Inn in Princeton, New Jersey. One of the most painterly of Rockwell's works, it is also his only true mural; earlier wall-mounted pictures in the bar of the Society of Illustrators club-house and in the New Rochelle Public Library were cover designs or easel paint-ings adapted to the purpose. But Thomas Stapleton, architect of the neocolonial Princeton restaurant, came to him for a real, thirteen-foot mural after seeing *The New Tavern Sign* in the *Saturday Evening Post.* At first, Stapleton was intrigued by the obvious tavern subject matter. In short order, however, Rockwell talked him into *Yankee Doodle,* from the lyric of the famous song. Princeton, he remem-bered, had been fought over by the Hessians, the British, and the colonials—and the first two groups had splendid uniforms that would be fun to paint. The fop who comes to town with a feather in his cap would make for a nice, light, comi-cal theme, in keeping with a place of enjoyment.

One of the cardinal rules of mural painting was to preserve the flatness of the wall. Insofar as they undermined the apparent structural integrity of a room, plunging views into deep space were discouraged. So Rockwell uses the same flat expanse of facade he had already employed in *The New Tavern Sign*. His figures line themselves up, for the most part, in clearly defined layers, parallel to the picture surface, to reinforce the flatness of the composition. Whereas an experienced muralist might have limited the amount of action packed into a single stretch of wall, however, Rockwell gives every figure a bit of business to do: dogs scamper, small boys dart about, a goose honks, Hessians jeer, and the half-shaved patrons pile out of the barbershop to see the skinny fellow on the horse pass by. The story remains paramount. And the diner's eye moves rapidly across the scene from red coat to red coat, in the direction of Yankee Doodle's progress; Rockwell liked the colorful military costumes so much that he had a set made to order for use in this commission.

For all his seeming candor, *My Adventures as an Illustrator* rarely attempts to explain Rockwell's affinities for certain subjects. The client wanted it! The theme was popular! These are Norman Rockwell's usual ways of accounting for a run of boys with dogs or grumpy couples arguing over political candidates. He was equally reticent about his Revolutionary-era pictures of the twenties and thirties. "At one time I did a great many of these historical illustrations of one kind or another—mostly Colonial," he told Arthur Guptill, his first biographer, at the end of World War II. "They were fun to do for awhile; I liked the elaborate costumes and romantic settings. In recent years, the everyday happenings have been so exciting that I have preferred to interpret them." Yet Rockwell seems to have held that history had crucial lessons to teach—or that his audience understood the past as a repository of hope, belief, and reassurance.

. . . And Daniel Boone Comes to Life on the Underwood Portable (page 46), a 1923 typewriter ad, is the prototype for scores of Rockwells in which old books, memories, bars of half-forgotten music, and famous historical figures make a difference in the lives of the present generation. The Underwood advertisement is Rockwell's version of the "usable past" from which the young writer in the age of typewriters and electric lights conjures up a powerful picture of pioneer heroics. If the sign painter's pictures are reminders of Rockwell's trade and its antecedents, the dream pictures demonstrate the artist's power to bring the past back to life again, in vivid, stirring images. In *The Law Student* (page 58), the 1927 Lincoln's Birthday cover for the *Post*, a young clerk studies his law books on a cracker barrel, with Mathew Brady's photographs of Lincoln to keep him company. Unlike the more remote figures of the colonial past, Lincoln seemed almost contemporary, an ordinary, homely man who read the law in fits and starts because he aimed to get ahead, like his young admirer. The Lincoln Memorial in Washington, D.C., was completed in 1922 because the 1920s recognized a kindred spirit in the Great Emancipator. All of Rockwell's later Lincolns come from the Brady photos filtered through the ennobling artistry of Daniel Chester French, whose seated statue broods in the Memorial. Art

improves upon historical facts; it polishes away the rough edges and makes of the past a place like Norman Rockwell's countryside, where dogs never bite, little boys never grow up, and everything turns out right.

Lincoln and Daniel Boone are specific figures in American history. But the Colonial Revival encouraged a much less rigorous approach to the past. In home decorating, although terms like Tudor and Chippendale were bandied about in the magazines, "antique" was a synonym for anything oldish—or merely old-fashioned. The olden days took in a vast temporal and geographic expanse that ran from one's grandparents' day to 1776, from Plymouth Rock to Merrie Olde England. George Boughton (1833–1905), whose *Priscilla* of 1879 Rockwell's father once copied in pen and ink, ranged in his subject matter from Chaucer and Longfellow through eighteenth-century England, Dutch peasant life, and the New York of Washington Irving: he anticipated the modern revivalist to whom the past was a repository of half-remembered images that soothed, somehow, the shocks of a cruder today. Like his father, Norman Rockwell was drawn to Charles Dickens and the England of Mr. Pickwick and *A Christmas Carol.* There he found a world very different from his own, where time passed slowly, people were memorable characters (who resembled the models he so often talked about), and goodwill almost always prevailed.

Christmas Trio, from the December 8, 1923, issue of the *Post,* is one of eight Dickensian covers Rockwell created between 1921 and 1938. Specific characters and scenes from Dickens are rare: for every Tiny Tim there are a half-dozen jovial coachmen with sprigs of holly tucked in a lapel. But the mood is that of a Victorian Christmas as remembered by subscribers whose parents had read *Dombey and Son* aloud to them when it was serialized in the nineteenth-century *Post.* Internally titled with the words they sing (*"Christmas . . . sing merrilie"*), the *Christmas Trio* is composed of the knobby, craggy faces Dickens and his illustrators loved (Dave Campion, the sock mender, is in the middle) set before a circle that provides a glimpse into their foggy, half-timbered London, long ago. The ghost of Christmas present showed Mr. Scrooge the awful poverty of London; it was against this background of deprivation and hardship that the charity of the season glistened like new-fallen snow in Dickens's wonderful story. Rockwell's music-makers, for all their Christmas spirit, are poor. The boy chorister is bundled up against the cold in a scarf wrapped under a thin jacket with badly frayed elbows. The violinist's tall hat has seen better days. The plump horn player has outgrown his coat. But throughout Rockwell's series, absent relatives head for distant homes, their baskets overflowing with fruit and bottles and fat holiday geese, bringing the gift of unaccustomed abundance for Christmas dinner.

The Dickens covers appeared exclusively during the Christmas season, generally a week or two before Joe Leyendecker's traditional Santa. Even if he sometimes substituted an Americanized Madonna or a red-faced English squire for Mr. Claus, until the early 1930s Leyendecker owned the *Saturday Evening Post* issue closest to Christmas. So Rockwell's Yuletide efforts were printed sometime in the weeks after Thanksgiving. Both the timing and the iconography of Rockwell's early holiday covers may depend, however, on a new, secular definition of

Christmas Trio

1923. Oil on board, 28¼ x 21½" (72 x 54.5 cm). The Norman Rockwell Museum at Stockbridge, Massachusetts. (*Saturday Evening Post* cover, December 8, 1923)

Rockwell's Christmas iconography is that of the secularized and commercialized America of his day. Dickensian subjects that evoked a general, old-fashioned feeling of goodwill toward men (and a fat goose for dinner) were his speciality. The costumes were British versions of the colonial garb worn by his sign painters and tavern keepers. The Post*'s older readers may have remembered that Charles Dickens was once serialized in the pages of the magazine.*

Christmas. His Dickensian motifs, for example, hearken back to the coach rides of little Paul Dombey and David Copperfield, but they also suggest Thomas Nast's (1840–1902) vision of the ideal American Christmas. Nast, a political cartoonist who reinvented the person of Santa Claus for *Harper's Weekly*, made the world of Santa his thirty-year project, beginning in 1866. His was the happy hearth, the fire, the holly, the tree, the sleigh, the stockings, and the presents delivered by a jolly fat man in a bright red suit. Although Santa had once been St. Nicholas and Dickens made reference to Christian charity in *A Christmas Carol*, the common denominator of these observances of the birth of Christ was

Department Store Santa

their nonreligious character. Rockwell, too, avoided any hint of angels and Bible stories. His old-fashioned Christmas covers were as modern as Christmas shopping ads that abjured theology in order to sell the season's crop of electric trains and baby dolls.

In the 1890s, when Norman Rockwell was a little boy, the big department stores began to decorate their windows during the holidays and, in the process, elevated gift-giving from a matter of nuts and oranges to an elaborate ritual exchange, a sort of American potlatch ceremony upon which the health of the economy hinged. In 1941, to the delight of retailers badly hurt by the Depression, Congress and Franklin Roosevelt finally moved Thanksgiving back a week to allow for a longer Christmas shopping season. Throughout the 1920s, pastors of all denominations fulminated against the secular Christmas, symbolized by gala holiday parades organized by retail giants to stimulate sales. Gimbel's (1920) in Philadelphia, Hudson's (1923) in Detroit, and Macy's (1924) in New York City all mounted parades to welcome Santa to town, as if he were some pagan god of shopping. By 1930, Santa impersonators sat in every store, listening to children recite long lists of seasonal toy orders.

Norman Rockwell's Dickensian covers, along with his Santa Clauses, are part of this new nonsectarian, un-Christian celebration of the holiday. As a child, Norman had objected to his parents' strong religious bent—expressed, in the main, by sending their sons to sing in the choir when the boys would rather have been out playing. As an adult, he was simply uninterested in churches. Such religious themes as do appear in his work are Americanized—that is to say, thoroughly secularized. The strangers around the grandmother who prays in the diner in his 1951 *Thanksgiving (Saying Grace)* (page 127) would not think of doing such a thing themselves but, as good Americans, they respect her right to do so. When it is not the subject of mild humor (as in Rockwell's 1954 study of his son, Peter, playing a tardy choirboy), religion is a matter to be documented respectfully, at arm's length. A thoroughly unchurched man, Rockwell always preferred observing people at prayer to creating images that might inspire it.

His children and his associates—the photographers, models, and handymen who worked for him—all have stories to tell about the typical Rockwell Christmas observance. Although he made a determined effort to look pleased and interested while the family gathered around the tree to unwrap presents, by breakfast time father had generally gone to his studio to work, as he did on every other day of the year. And every year he was mildly surprised that no one wanted to come over and take a picture or build a prop with him on Christmas Day. Although Rockwell covers and Christmas cards have made him one of the chief architects of today's version of the holiday, Norman Rockwell did not keep Christmas well, in Dickens's terms.

Some of Rockwell's indifference to Christmas—or perhaps it was just burnout, after all those years of Christmas covers—seeped into his *Department Store Santa* (page 59) of 1940. It was not, in fact, the *Post*'s official Christmas cover: that honor went to Leyendecker's exhausted mailman, soaking his feet after a hard season of delivering cards. But the *Saturday Evening Post* did not want

to ruin Christmas for children by exposing Santa as a fraud before December 25. So Rockwell's cover, like his 1956 holiday effort showing a little boy paralyzed with shock after finding a red suit and whiskers in the bottom drawer of his dad's bureau, was held back until the week after Christmas. *Department Store Santa* shows another wide-eyed boy, his arms full of packages from Drysdale's Department Store, coming upon the Drysdale Santa on the train, on his way home. His cap and whiskers stuffed in his pocket (along with a spicy tabloid), poor old Santa is not the figure of mirth and magic pictured in the poster behind him. He's just a tired old man, alone and a little glum. Behind him on the seat is a discarded sprig of holly, crushed and forgotten.

Hardly the "right jolly old elf" of Clement Moore's *A Visit from St. Nicholas* (1823), the department store Santa Claus pictured by Rockwell in 1940 is a thoroughly commercial figure, a worker who has just completed a hard day on the job. In that respect, he is kin to the Coca-Cola Santas, drawn every year between 1931 and 1964 by Chicago illustrator Haddon Sundblom. Along with Rockwell's, the Coke Santa established the look of the new, revised, twentieth-century model: hugely fat but active, twinkly, dressed in tall boots, a big belt, and the usual red-and-white outfit, he deserves moments of frazzled leisure in living rooms all over America where he discovers bottles of ice-cold Coca-Cola—"The Pause That Refreshes." By emphasizing cycles of work and leisure, the soft-drink manufacturer linked Coke to the rhythm of the industrial order, just as Rockwell did with his off-duty Santa Claus. Being Santa was a job, like being Norman Rockwell at Christmastime.

Rockwell's Santa pictures nonetheless showed an underlying respect for tradition. Although he was a man of his time, more skeptical and less reverent than is sometimes assumed, he understood the language of familiar symbols passed down to his generation from the nineteenth century. He understood the Daniel Boones and the Lincolns, the colonial heirlooms, the stories of Washington Irving and Charles Dickens, the cupids and the Santas to be the cultural currency of his audience, the iconic vocabulary of America. And so he used those symbols even as he adapted them for a nation caught up in dreams of the past because the present seemed to be spinning out of control, a people who needed a magical Santa to survive another Christmas rush.

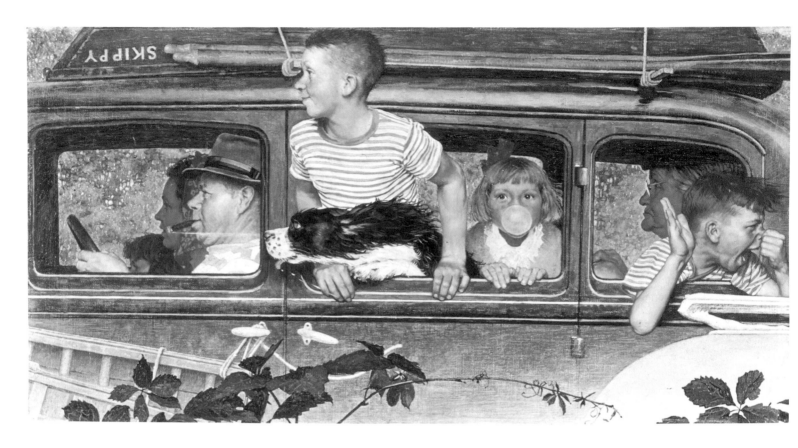

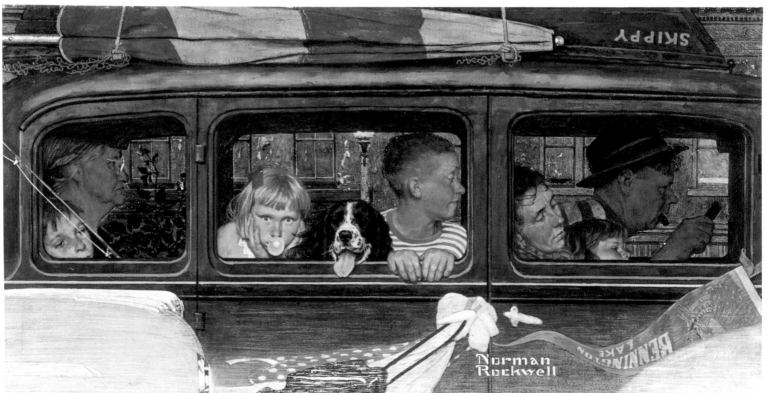

Going and Coming

4. The Saturday Evening Post

In the 1920s and 1930s, Norman Rockwell and the *Saturday Evening Post* went together like apple pie and hot coffee. He had lots of lucrative jobs—ads, story work for other magazines—but the *Post* cover was Rockwell's constant burden, the first thing he thought about in the morning, and the last thing he thought about at night. When *Liberty* was founded in 1924, the editors asked Rockwell to work for them, at twice the price. Troubled as much, it seems, by the prospect of change as by the amount of the offer, the artist went to Philadelphia to ask *Post* editor George Horace Lorimer what he ought to do.

Throughout their unique parent-child relationship, the editor was always "Mr. Lorimer," and the artist was "Norman." Although some of Lorimer's edicts would rankle in retrospect, Rockwell clearly liked having a strong figure at the helm; he worked better without worries and crises. Lorimer's response to the *Liberty* offer was typical. He pressed a thumb down on his desk so hard that it turned white, looked Norman straight in the eye, and asked him what he intended to do. "I'll stay with you, Mr. Lorimer," stammered the dutiful Norman, much impressed by the quiet show of force. And he got a comparable raise. In his autobiography, Norman Rockwell uses the confrontation as a moral fable about loyalty and its rewards. But it was an unequal battle. Despite his fame, Norman Rockwell was still Norman to the boss.

It was Lorimer who, in Norman's telling of the story, saved him from the siren's song of modernism, time and time again. First there was the symbolic cover he did in Montmartre in 1923, full of wild color. Mr. Lorimer turned it down flat with the admonition to do "what you've been doing all along." No crazy color for the *Post*. Then there was the dynamic symmetry affair of 1931 when Norman, still rattled by the aftermath of his divorce, took up a theory promulgated by Jay Hambidge, a Canadian illustrator whose mathematical formulas for composing pictures offered hope of never having to struggle with the problem again. In a tract entitled *Dynamic Symmetry in Composition* (1923), Hambidge also laid out a system of proportion based, he claimed, on the wisdom of the ancients—and a rectangle divisible according to a ratio of .618 to 1.000.

Many respectable artists of the day were interested in Hambidge's ideas; Robert Henri and George Bellows both attended his lectures. Dynamic symmetry was particularly attractive to artists struggling to make the transition from the old art school verities to the anything-goes aesthetic of modernism. "By following his theory," wrote Rockwell with the superior air of a sinner converted, "even a clumsy amateur with hands like ham bones could create a beautiful

Going and Coming

1947. Oil on canvas: each panel, 16 x 31½" (40.5 x 80 cm). The Norman Rockwell Museum at Stockbridge, Massachusetts. (*Saturday Evening Post* cover, August 30, 1947)

Television and the movies suggested new storytelling methods to Rockwell. The old notion of serial covers is updated in a single panel showing two moments in a story, as a scene in a movie might dissolve from morning to afternoon.

63

painting." When his friends took up Hambidge, so did Norman, reasoning that it might ease his perpetual struggle with the next *Post* cover. But the *Saturday Evening Post* was not the right shape to be divided by a magic number and Mr. Lorimer was not inclined to redesign his magazine to suit any wild-eyed theories of Norman's. Dynamic symmetry had to go.

In 1936, Norman was at it again: a modern or quasi-modern cover of which the artist later disavowed all memory. Lorimer stood over the offending object for ten minutes. But instead of rejecting it outright, he wavered for a moment. "I don't know, Norman. I don't know. Some of my editors tell me I should be more modern. . . . Let me think it over." A week later, Lorimer did turn the concept down, but the indecision was troubling. Shortly thereafter, he retired. And everything changed at the *Post*.

Lorimer's *Post* was also Norman Rockwell's *Post*. The magazine ran proprietary stories about the illustrator acknowledging his celebrity status. But, although he was almost as well known as Charles Lindbergh or Mary Pickford, he was the *Post*'s very own star. By the time Lorimer retired, Norman had been working for the magazine for twenty years and had done 161 covers. "Twenty years is a long time," he told the readers, "but all this is not a hail and farewell. I hope and pray that I shall make one hundred and sixty-one more covers, some good, some bad and some indifferent."

In that same twenty-year period, the magazine hit its peak. The 1920s were the heyday of the *Saturday Evening Post*. Its ad revenues and circulation rose like the stock market because the *Post* embodied the giddy effervescence of the decade. F. Scott Fitzgerald published his stories there, alongside Charlie Chan serials. Norman Rockwell and Joe Leyendecker did the covers—the best in the business. Color spread from the cover to the occasional inside feature. The articles, as Jan Cohn observes in her history of the magazine, seemed to take in "all of the prosperous and frivolous American scene, from politics and land booms to antique hunting and sports celebrities. Each big glossy issue presented a portrait of American success, lavish, powerful, abundant."

Although Rockwell is sometimes regarded as a painter of nostalgia, steeped in a half-imaginary past, his *Post* covers under Lorimer were often as topical as the contents of a typical issue. But it is sometimes hard to spot an exciting new fad from a distance of seventy-odd years. Yesterday's follies look quaint and old-fashioned to the grandchildren of mah-jongg fanatics and goldfish swallowers; they seemed pleasantly modern in their own day, however. The 1920s was the golden age of fads. There was a national audience for the first time, linked together by wire service photos and pictures in magazines. Fads spread rapidly through the emerging mass media—and died away almost as fast.

Ouija Board (page 66) of 1920 documents the craze for contacting the spirit world by moving a heart-shaped platform over letters and numbers inscribed on a polished board. The boards gained popularity during the war years, when they were used to predict the fate of soldiers at the front; a million sets were sold in 1918. Afterward, in the face of opposition from clergy who suspected devil worship, the Ouija board became a parlor game, conducive to intimacy, since the

board worked best when perched on the knees of the users, whose fingers invariably touched as they rested lightly on the moving indicator. And Rockwell took full advantage of the romantic implications of the subject by joining his couple at the knees as they ask coy questions about their mutual future. She looks up, avoiding his glance and the embarrassment of acknowledging their close proximity. He uses the occasion to stare openly at her face, as if memorizing every feature. The circle around their upper bodies enhances the closeness of their momentary contact.

This was Rockwell's first use of the circle device, which became a *Post* trademark during the Lorimer regime. In Rockwell's hands, the circle was a supple tool for emphasizing a profile, showing a fragment of a setting, or suggesting a character's innermost thoughts. Coles Phillips is usually credited with inventing the circle to isolate a certain portion of a figure—usually the curvy legs and plump behind of a pretty girl. Vignettes or heavy geometric frames surrounding photographs were frequently used in the rotogravure pages of newspapers to create collages of interesting pictures of the day, without regard to subject matter. But whether Rockwell borrowed his circle from Phillips or from the contemporary *New York Times*, it was as modern as the Ouija board.

Child Psychology (page 67) of 1933 employs both the circle and a topical subject. When Rockwell painted it, his second son had just been born: parental desperation was a topic with which he was becoming intimately acquainted. Here a young mother wavers between taking the hairbrush to Junior or following the advice in a book about child psychology. In 1933, the first edition of Dr. Spock was more than a decade away. Freud had visited America, however, and his teachings had been cited by the defense in the sensational trial of kidnapper/murderers Leopold and Loeb in 1925. Psychology was a kind of a fad in the thirties, a half-serious way of explaining anything, from losing a job to having the blues. A 1939 *Ladies' Home Journal* article on parlor psychiatry laid bare the complexes of Jack Benny and Norman Rockwell in order to show that analysis—like the Ouija board—was a game anybody could play with "a little imagination and a dash of blarney." Based on short answers to silly questions, the author decided that Rockwell was tortured by "emotional frustration, which acts as a constant goad to his already widely recognized talents as an artist. His temperament is emotional, sensitive and withdrawn."

Rockwell would probably have agreed with the diagnosis. In 1933, during his tussle with *Child Psychology*, his work was in real trouble; he never was happy with the finished cover. The idea was sound enough—tradition vs. modern ideas—but the execution is labored. The placement of the circle seems arbitrary and the radical foreshortening of the little miscreant makes him hard to read. The picture has come to pieces, like the clock, the mirror, and the vase reduced to fragments by the boy with the hammer. Rockwell's big slump began in 1930, when his divorce became final. Clyde Forsythe was worried enough about his friend's well-being to insist that Norman come out to California for a change of scenery. It was there, on his second or third night in town, at the Forsythes' house, that he met Mary Barstow, a young teacher. And suddenly, they were

Fire!

1931. Oil on canvas, 41 x 31" (104 x 78.5 cm).
Private collection. Photo courtesy the American
Illustrators Gallery, New York City. (*Saturday
Evening Post* cover, March 23, 1931)

*Despite the old-time theme, this cover is
based on modern theory—the teachings
of Jay Hambidge. Hambidge promised a
perfect composition every time to those
who followed the principles of "Dynamic
Symmetry." Editor George Horace
Lorimer of the* Post *discouraged Rock-
well's excursions into modernism, but the
artist persisted.*

Ouija Board

1920. Oil on canvas, 26 x 22" (66 x 56 cm).
Private collection. Photo courtesy the American
Illustrators Gallery, New York City.
(*Saturday Evening Post* cover, May 1, 1920)

*While it was not a specialty of his, Rock-
well did sometimes highlight modern fads
and follies, like the Ouija board craze.
But he points out that telling the future is
the least of the pleasures afforded by the
parlor game. The circle behind the heads
of the man and woman became an early*
Post *trademark. Rockwell used it for a
variety of purposes: emphasizing a pro-
file, establishing the physical setting of a
scene, or showing what a character was
thinking about.*

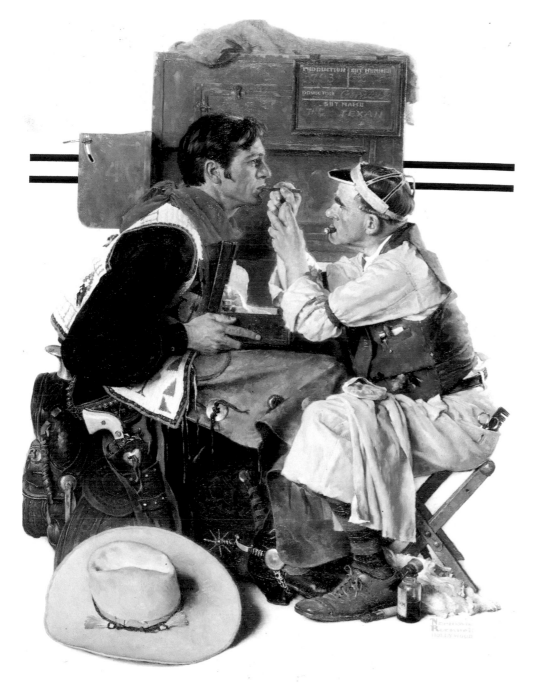

The Texan or Gary Cooper
as "The Texan"

1930. Oil on canvas, 35 x 26" (89 x 66 cm).
Private collection. (*Saturday Evening Post* cover,
May 24, 1930)

In Los Angeles to soothe his frazzled nerves, Norman Rockwell met his second wife, Mary—and movie star Gary Cooper. The positioning of the figures, so that they seem to be sitting a couple of feet away from the artist—like models in a studio—was beginning to look old-fashioned in the 1930s. Younger artists were changing their angle of vision, using photographs as a means of doing so. Rockwell has the makeup man paint Cooper like a pretty picture! Although he was a master of the stereotype himself, in this cover Rockwell challenges the masculine stereotypes purveyed by the Hollywood studios.

engaged. Lorimer sent his right-hand man out to Los Angeles to look the situation over. Apparently, Mary passed muster. The couple was married in April 1930, at her parents' home in Alhambra.

During the middle of this whirlwind courtship, Rockwell went to the Paramount studios to paint Gary Cooper. The idea had already been approved, he later insisted: a cowboy actor in the costume of a tough hombre having lipstick applied by a makeup man. By other accounts, however, *The Texan* was a lucky accident. Rockwell was in town while Cooper was actually filming a horse opera with Fay Wray and the studio agreed to lend him their hottest star for three days, between takes, because of the prestige and publicity attached to a cover appear-

Child Psychology

Saturday Evening Post cover, November 25, 1933

Psychology amounted to a fad when Rockwell turned in this cover. A father himself now, the artist was also suffering through one of his periodic bouts of insecurity, when every cover was a struggle. The problems are apparent in placement of the circle, to no good effect, and the extreme foreshortening of the child's body, which makes the story needlessly difficult to grasp.

ance on the *Saturday Evening Post*. Whatever the facts of the matter, Norman Rockwell liked Cooper. "He was a wonderful model and a very nice, easy guy," Norman said. "He was always playing some cute trick on Clyde and me—exploding matches, ash trays which jumped when you touched them."

The boys back home—Christy and Flagg—wouldn't believe the movie colony, where everybody was a potential starlet or a matinee idol, Norman thought. Why, Cooper was so handsome he made Rockwell wince when he thought of his own scrawny physique. The cover worked because it tweaked Hollywood notions of comeliness, gender, and illusion by showing the striking profile of Cooper—star of *The Virginian* (1929), Western hero extraordinaire—being made up with lipstick, like a beautiful young woman. The figure of the makeup man, stumpy, stout, and rumpled, sets off Cooper's perfection. Instead of the familiar circle behind his head, Rockwell used the back of a set that frames Cooper in a rectangle. The angular shape gives the actor back a touch of his masculinity, as he politely holds the technician's box of supplies and sits perfectly still, as per instructions.

In a way, *The Texan* is a reprise of *Ouija Board*, with the figures seated knee to knee, close to the viewer. Thanks to the dimensions of the *Post*'s cover and his own definition of a pleasing design, much of Rockwell's work of the 1920s and 1930s was similar. A vintage Rockwell cover of the Lorimer era might include a small group of people sitting near the picture surface with their relationship defined by costume or by a few artifacts placed at the bottom of the composition, just above the lines of type announcing the week's features by Edna St. Vincent Millay, Benito Mussolini, and Mary Roberts Rinehart. In the late thirties, after Wesley Stout had taken over from Lorimer, things began to change at the *Post*. The Depression finally hit the magazine hard. Editorial opposition to the Roosevelt administration alienated some subscribers. To attract new readers, Stout tried photographs on the cover, for one thing—photos taken from alarming angles for visual punch. He hired large numbers of new cover artists, too, fifty-two in all during his tenure. The changes made Rockwell nervous. Was he on his way out? He took advice wherever he could get it. A longtime art director told him that all his covers were beginning to look alike. "Norman, it always looks as though the model and you are seated on chairs ten feet apart. . . . Try some new angles, some new poses, positions."

The Depression was barely acknowledged in Rockwell's work. One of the few hints that something might be amiss with the nation came in *Gaiety Dance Team* in 1937. Dolores and Eddie are down and out, stranded on their trunk out there on the vaudeville circuit. His pockets are turned out; her purse is empty. Like the glove in her left hand, the artificial cherries on her hat droop disconsolately. The issue of *Variety* folded up in his pocket offers no prospect of a booking. Pivot the boy and girl around, and they could be the couple from *Ouija Board*. Now, they turn their backs to each other and the circle directs attention to heads that nod in different directions. The trunk, placed parallel to the surface of the page, about ten feet from the artist's chair, tells the story of love gone wrong, the end of vaudeville, and the baleful effects of the big slump. The par-

Gaiety Dance Team

1937. Oil on canvas, 36 x 29" (91.5 x 73.5 cm). Collection *Variety*, Inc. (*Saturday Evening Post* cover, June 12, 1937)

For Rockwell and the Post, *topicality did not mean dwelling on unpleasant current events. The Depression appears in Rockwell's work only indirectly, as in this study of two hoofers out of work and out of luck in the last days of vaudeville. This picture reverses the composition of* The Texan *and* Ouija Board. *By turning the figures back-to-back, Rockwell shows the end of an intimate relationship.*

ticularities of this couple comment on the general case: Dolores and Eddie *are* the Great Depression.

The Depression mattered less to Rockwell than the shake-up at the *Post,* however. In 1937, convinced that he needed to keep up with the opposition, he began to work from photographs on a regular basis. At first, he had justified the occasional picture on the grounds of a difficult pose or an untrained model. Now, the camera was introduced for sheer pictorial effect. After his adviser told Norman to "try some new angles," he constructed a Rube Goldberg-ish platform that allowed him to work dangling in space, peering down on the model. But it was easier, in the end, to let the camera look at things in a fresh way; he saw accidents of highlights and shadow in photographs that he had never noticed sitting ten feet from his model in the even north light of his studio window.

By the time he sat down to record his working methods, in 1946, Norman Rockwell was using a hundred or more photos, sometimes, for a single cover. The ideas were still his. He still found the models and the props. But now he posed them for the camera, worked up his layout drawings from the prints, and projected the finished drawing onto the canvas. Photos and projectors had once been considered dishonest. Not any longer. But some illustrators, he complained, put the photos directly in the projector, without drawing anything for themselves. That was unethical. And the artist who did so was "bound to produce a very inferior machine-made product."

The *Post* was changing. The profession was changing. Norman Rockwell spent the Depression years in a state of indecision and anxiety. In 1938, in the wake of the camera crisis, he went to Europe. He and Mary took the kids—three boys now—and left all the rest behind. The house in New Rochelle. The elegant colonial studio that smacked of contrivance and tradition. The *Post.* He did six covers all that year. Then he came home, pulled up stakes, and moved to rural Vermont. The covers changed right away. In 1936, Norman was doing *Barbershop Quartet* (page 70), full of boys-will-be-boys fellowship from the good old days, when Babbitt and his lodge brothers gathered in the corner barbershop for liberal doses of lilac pomade, the *Police Gazette,* and close harmony. It was stagy, posed, and full of stereotypes. *Decorator* (page 70) of 1940 is fresher and cleaner, the observation sharper. The young wife's sandals and the Art Deco swatches are the last words in modernity. Rockwell's signature is streamlined, too. The scene doesn't seem contrived; there are no irksome circles, for instance, to telegraph a deeper meaning. The artist has resisted the urge to frame the lady nicely with the back of the old overstuffed chair: her hair escapes on one side and her fingers on the other. The viewer looks down at her long legs and up a little at her face, in a subtle but surprising shift of vision that activates the experience. It is a domestic documentary, a slice of life that points toward the masterpieces of the 1950s, in which observation begins to outweigh sentiment and things take on a weight and substance of their own.

The humor in these works is almost incidental: the viewer discovers the joke while perusing the picture. *Double Take* (page 71) of 1941 is a visual pun that plays with the *Post*'s familiar cover format. Rockwell partially conceals the name

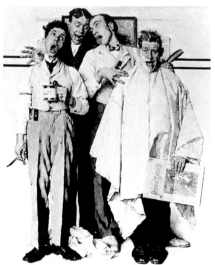

Barbershop Quartet

1936. Oil on canvas, 36 x 27¼" (91.5 x 69 cm).
Private collection. (*Saturday Evening Post* cover,
September 26, 1936)

Here, an old chestnut is refreshed by Norman Rockwell's attention to detail: the straight razor, the watch fob of a fraternal organization, the personalized shaving mug. Editor Lorimer retired in 1936; under his direction, the Post *reassured its readers more often than it challenged them. And covers like this one reassured America that nothing much had changed since the Gay Nineties. In barbershops everywhere, boys would be boys.*

Decorator

1940. Oil on canvas, 36 x 30" (91.5 x 76 cm).
Private collection. Photo courtesy the American
Illustrators Gallery, New York City. (*Saturday
Evening Post* cover, March 30, 1940)

Girls will be girls, too, fussing with a man's favorite chair! But this is a surprisingly fresh piece of design that takes its cue from the new upholstery fabric, and avoids too much clutter. Rockwell has been trying the new angles of vision advocated by his younger colleagues at the Post. *This makes the eye work harder to put the picture together. And he avoids the obvious. Instead of framing the young woman perfectly with the back of the chair, he lets her hair escape on one side and her fingers on the other.*

Double Take

1941. Oil on canvas, 35¼ x 27¼" (89.5 x 69 cm).
Collection Diane Miller, San Francisco. (*Saturday
Evening Post* cover, March 1, 1941)

Walt Disney commissioned Rockwell to do pencil portraits of his daughters to hang in his office at the studio. Sometime afterward, he dropped in on the artist in Vermont. Because Disney came during working hours, the family turned him away. Just as Disney was pulling out of the driveway, an apologetic Rockwell came tearing out the door to greet him. This clever cover design, inscribed to Walt, "one of the really great artists, from an admirer," may commemorate that event. The Post's *cover inspires a* Post *cover!*

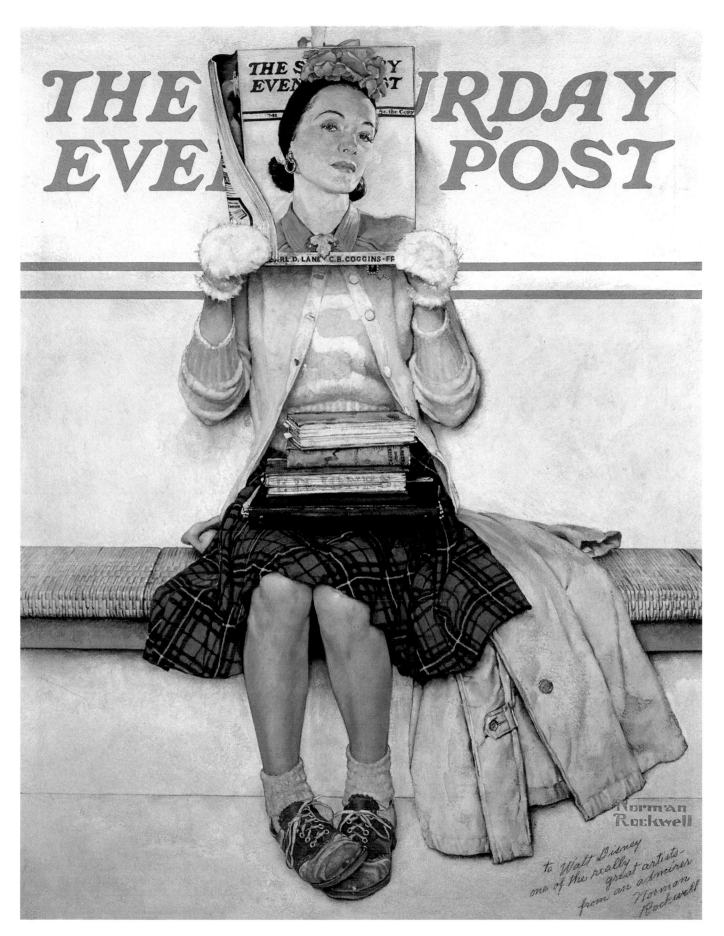

Double Take

of the magazine with the representation of another (fictitious) copy of the *Post*. The effect is to put the glamorous face of a woman who resembles Dorothy Lamour on the body of a bobby-soxer reading the *Post* on a commuter train, on the way home from school. The yellow socks and sweater—with attached fraternity pin—and the plaid skirt pop out of the picture first; the misplaced head is funny because it is the least noticeable feature of the design. In the 1940s, the trajectory of Rockwell's cover work moved toward a closer scrutiny of events and artifacts frozen by the camera's eye and away from the contrived situations and forced comedy of the early years.

In 1942, the *Post* got another new editor: Ben Hibbs. Shortly after he took the helm, Hibbs went up to Arlington to call on Rockwell with a full-blown delegation of subeditors and wives from Philadelphia in tow. Rockwell was in an agony of nerves about the weekend—which dragged on for three more days after the local train derailed, stranding the houseguests in Vermont. Rockwell's strategy with Mr. Lorimer had been to bury the good sketches in a pile of not so good ones and let the editor have the pleasure of putting his OK—two or three pieces at a time—on the designs Rockwell really wanted to do anyway. Hibbs was another kettle of fish. He wanted to be called "Ben." He wore shirtsleeves in the office. He thoroughly flummoxed the artist by accepting nine cover sketches from him during one meeting. And he came calling, hat in hand, to court Mr. Rockwell, the *Post*'s ace artist.

Although Hibbs, like Lorimer, preferred to pick his own covers, in December 1943 he added Ken Stuart to the staff as art editor. An experienced illustrator himself, Stuart had strong likes and dislikes. Among his pet peeves were "run-of-the-mill gag covers, . . . bargain-basement versions of Norman Rockwell." That seemed to take care of most *Post* covers within recent memory. Stuart had a new vision for the *Saturday Evening Post*, heavily influenced by the American Scene painting of the 1930s. He wanted the cover of the *Post* to serve as a living repository of pictorial Americana, Stuart said, "a sort of contemporary Currier and Ives created by such top illustrators as Falter, Dohanos, Atherton and, of course, Rockwell."

John Falter, Stevan Dohanos, and John Atherton were all realists or hyperrealists who worked up complex pictorial essays in Americana by concentrating on things rather than people. Falter specialized in the city seen from odd and revealing points of view. Dohanos did barbershops, hardware and candy stores, a church in the square of a country town; figures inhabit the scenes, but it is the reflections on the penny-candy cases and the faded reds of the barber pole that tell the story. Atherton, who was Rockwell's neighbor in Arlington, painted outright still lifes for the *Post* in which the fisherman was represented by his creel, his hat, and his catch, or studies of industrial scenes that treated the cityscape as a form of large-scale still life.

From the pinnacle of his own success, Rockwell had observed this new trend in illustration with a little skepticism: "young fellows . . . from the Middle West," he called them, whose use of "weird angles" had driven him to make the camera part of his studio equipment. But American Scene painting gave Norman Rock-

well a new lease on life in middle age—a chance to use backgrounds, landscapes, real places farther than ten feet from the end of his nose, the chance to try a whole new range of iconography. Exactly how that subject matter was arrived at is a matter of conjecture. Stuart worked closely with the Middle Westerners, discussing projected cover topics months in advance of deadlines, and offering suggestions for props and locations. Sometimes he brought the idea to the artist. But the process always involved a measure of collaboration. Lorimer was apt to accept or reject an idea. The Hibbs-Stuart *Post* was liable to talk it over.

A rough sketch for *The Expense Account* (pages 74 and 75) of 1957 provides a window on the style of these exchanges. The paper is covered with notes from Norman to Ken, revealing a complex process of negotiation and discussion in progress. Ken doesn't like the Pullman chair in which the salesman worries over his accounts. Norman agrees: he needs to see a seat with his own two eyes (the Santa Fe railroad sent a brand-new one, at the *Post*'s request). Norman was going to put a corner of the expense sheet in the background—almost like an old *Post* circle of thought or memory—to show that the salesman was stuck on specific entertainment items. The briefcase, meanwhile, bulges with theater programs and menus from nightspots like 21 and the Stork Club (changed to the Copa Cabana in the finished version). Ken suggests blowing up the expense sheet instead and floating the figure in front of it. That's what they decide to do. "Any and all suggestions most welcome. Yours. Norman."

In his note to the *Post*, written early in 1944, *Union Station* (page 76) sounds like a classic Norman Rockwell scene. The war was winding down. Joyful reunions were more common. "I would like to show the pathos and humor of the mother meeting the son, the wife meeting the husband, one lover meeting another," he said. But the picture is of a moving crowd in a vast public space throbbing with activity. Rather than extracting a mother and son in order to dwell on the "pathos and humor," Rockwell is the cool documentarian, standing back and letting the color and bustle of the station do their work. *Christmas Homecoming* (page 77), painted for the *Post* four years later, shows Mary Rockwell and her family welcoming son Jerry home for the holidays, with all the emotion her husband had once envisioned for the earlier picture. But somewhere in the discussion stage, that sweet little idea turned into a huge production number.

For one thing, Rockwell wound up in the Midwest, at the Chicago & Northwestern station where the stationmaster was willing to drag his Christmas decorations out of storage—and change them altogether should they fail to meet with Rockwell's approval. The painter mounted the announcer's platform, high above the station floor, and directed a photographer, who took shots of more than a hundred servicemen in transit. Everybody wanted to help. Strangers kissed total strangers; mothers greeted other mothers' sons. The holiday spirit prevailed, even in June. While it is possible to single out any number of interesting figures and anecdotes, the cover is not about the two nuns, the black porter, the redhead kissing the naval officer, the Salvation Army Santa, or the drunk with the wreath and the Christmas tree. It isn't about whether the last train to Milwaukee is running on time. It is a slice of American life in wartime

The Saturday Evening
POST
November 30, 1957 — 15¢

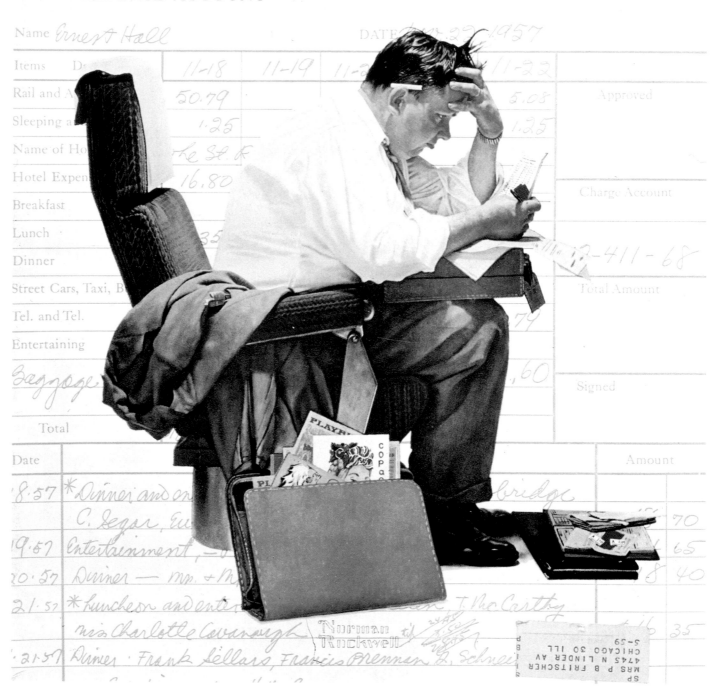

The Expense Account

The Expense Account

1957. Pencil sketch

The notations on the sketch for this humorous view of a new American institution show that Rockwell's covers were created in close consultation with the Post's editors— in this case, art editor Ken Stuart, whose help Rockwell acknowledges.

The Expense Account

Saturday Evening Post cover, November 30, 1957

that also contrives to be a fascinating study of shape and flat areas of color arranged across the surface of a floor tipped up precariously, until it almost mimics the planar surface of the *Saturday Evening Post*.

The early postwar covers—even gag covers, like the husband-and-wife squabble of 1948 called *Election Day* (page 78)—use the crisp definition of detail to comment on the abundance of the changing American Scene. As Truman and Dewey vie for the White House, the voters live in houses stuffed with new electrical appliances, plastic-coated furniture, children, and pets. Rockwell turns his sharp eye on the telling prop and then multiplies the clutter of the domestic scene until the texture of the rug threatens to overwhelm the old joke. Brushwork is apparent not simply in those areas of local color that seem to demand it—the marbleized plastic edge of the table, for example—but everywhere: the stove, the walls, the curtains, and the floor all contain areas of vigorous, tactile crosshatching, angular stabs of the brush that argue the case for a Rockwell being a painting, a material object as shocking in its existential presence as the front of the new kitchen range.

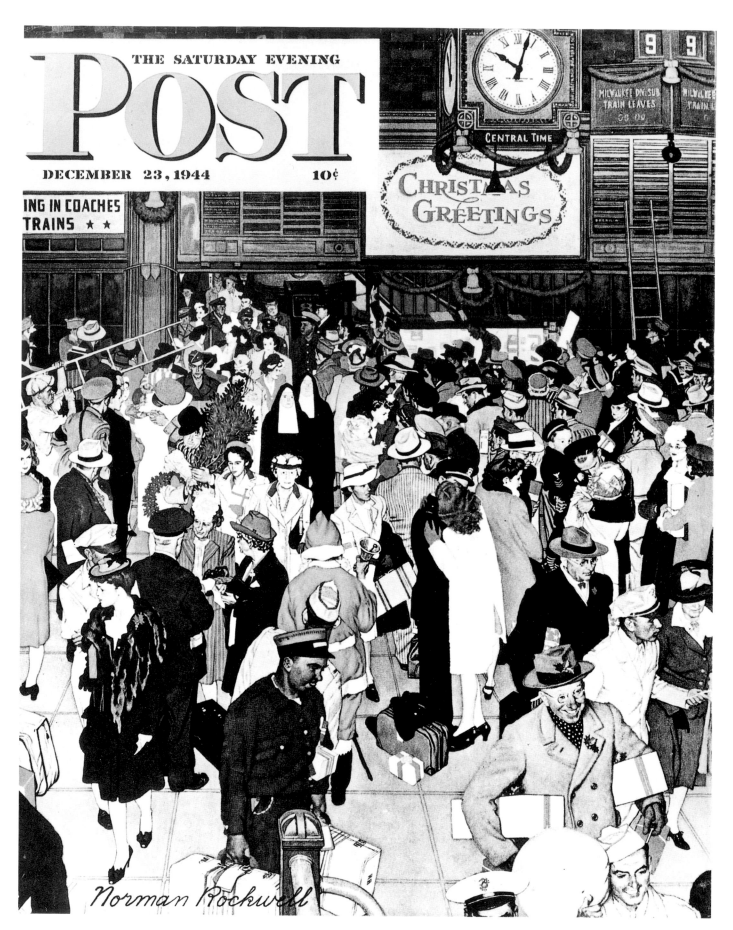

Union Station

Christmas Homecoming

1948. Oil on canvas, 35½ x 33½" (90 x 85 cm).
The Norman Rockwell Museum at Stockbridge,
Massachusetts. (*Saturday Evening Post* cover,
December 25, 1948)

*Using a different approach to the docu-
mentary, Rockwell here assembles a large
group of portraits, each one painted as
though it were the singular subject of the
cover. The old lady at the left is Rock-
well's New England neighbor, Grandma
Moses, a folk artist almost as popular as
Norman Rockwell. Like the covers of the
Saturday Evening Post, her work docu-
mented America—but the nation of her
girlhood, which existed only in her
mind's eye.*

Who-Dun-It?

Unused cover idea, *Saturday Evening Post*, c. 1960.
Charcoal and pencil on paper mounted on compo-
sition board, 44 x 41" (112 x 104 cm). Private col-
lection

*Begun on a stay in Hollywood in the
1940s, with 20th Century-Fox stars cast
in a murder mystery the Post's readers
were going to be invited to solve, this pic-
ture was finally abandoned, unfinished,
years later. Norman never could get the
mystery to work. But the real problem
may have been that the portraits were all
of faces the public knew, including
Ethel Barrymore, Linda Darnell, and
Richard Widmark. They competed for
attention and, in the absence of a strong
story, pulled the picture apart.*

Union Station

1944. Oil on canvas, 32 x 25" (81 x 63.5 cm).
Private collection. (*Saturday Evening Post* cover,
December 23, 1944)

*Ken Stuart took it as his mission to make
the Post covers into a repository of living
Americana. The artists he favored were
realists whose pictures were more intense
versions of the American Scene style of the
1930s. In keeping with this documentary
approach, Rockwell looked beyond his
usual one- or two-figure compositions to
sweeping panoramas like this one. More
than a hundred photographs of travelers
went into this single view of a Chicago
station at Christmastime. The photos
were taken from above, and the angle of
vision helps to flatten the image pieced
together from these many visual sources.*

Election Day

1948. Oil on canvas, 35 x 34" (88.9 x 86.4 cm). Harry S. Truman Presidential Library and Museum, Independence, Missouri. (*Saturday Evening Post* cover, October 30, 1948)

There were enough postwar fads to keep an army of artists busy at the Post *in the 1940s and fifties. Although the subject of this cover is the Truman-Dewey election, Rockwell scrutinizes the new American family in its new tract house, full of appliances, pets, and children.*

Commuters

1946. Oil on canvas on board, 22 x 20½" (56 x 52cm). Private collection. Photo courtesy the American Illustrators Gallery, New York City. (*Saturday Evening Post* cover, November 16, 1946)

Here Rockwell examines the treeless subdivision from the outside. Newly liberated from the armed forces, the ex-GI now joins the army of the employed, rushing to get to work in the city. The landscape and patterned layout look as though Grandma Moses had suddenly decided to paint cars and newspapers instead of horses and sleighs.

Commuters (1946) is a Stuart-style cover, a panoramic view of an American landscape without any obvious gags except, perhaps, for the newsboy standing straight and tall in the foreground while ranks of commuters sweep past him, all bent forward at identical angles as they scurry toward their train. The landscape is the story, an almost treeless subdivision of pseudo-Tudor cottages built for the returning GI and his new family: nature thoroughly domesticated. The picture takes its character from the dead autumn grass in the field behind the station: everything is painted just as the field is, in tiny, textured stitches of color. *Commuters* seems to be a sampler, a textile covered with repetitious rows of houses and cars and figures—the very fabric of American life made whole again in the aftermath of World War II.

Television was the most revolutionary component of the postwar life the *Post* had set out to chronicle. TV was the illustrator's new competition: soon, Rockwell's cleverest gags would pale before domestic comedies like *I Love Lucy*, in which his-and-her tiffs at breakfast time were weekly happenings, presented with a fresh new twist every time. Eventually, TV would run the picture magazines out of business. *Life* and *Look* hung on for the time being by taking strong editorial

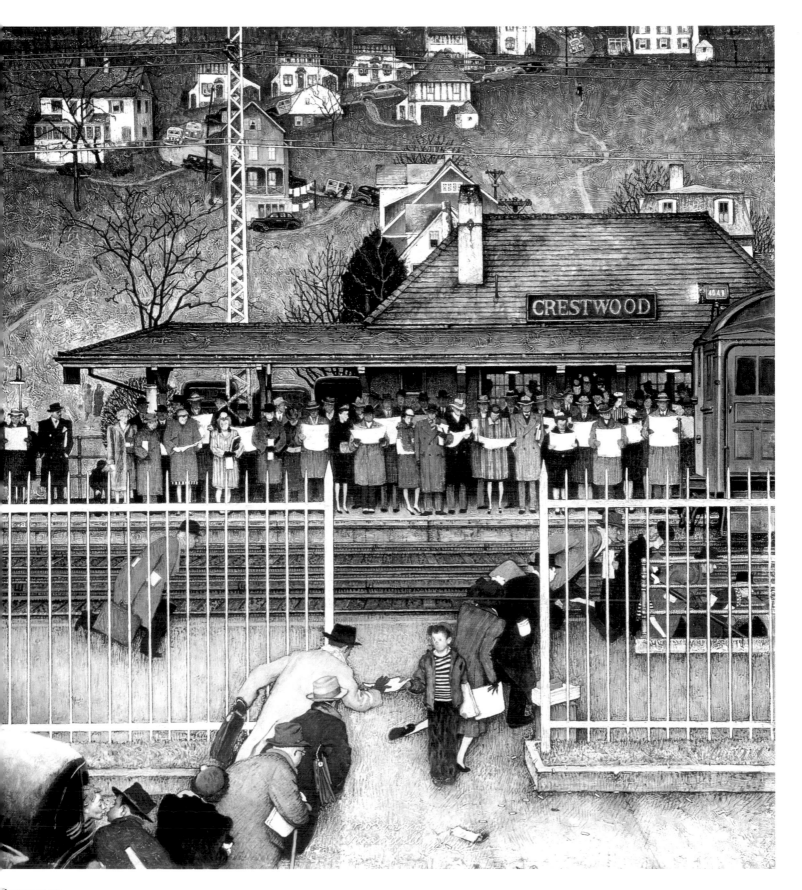

Commuters

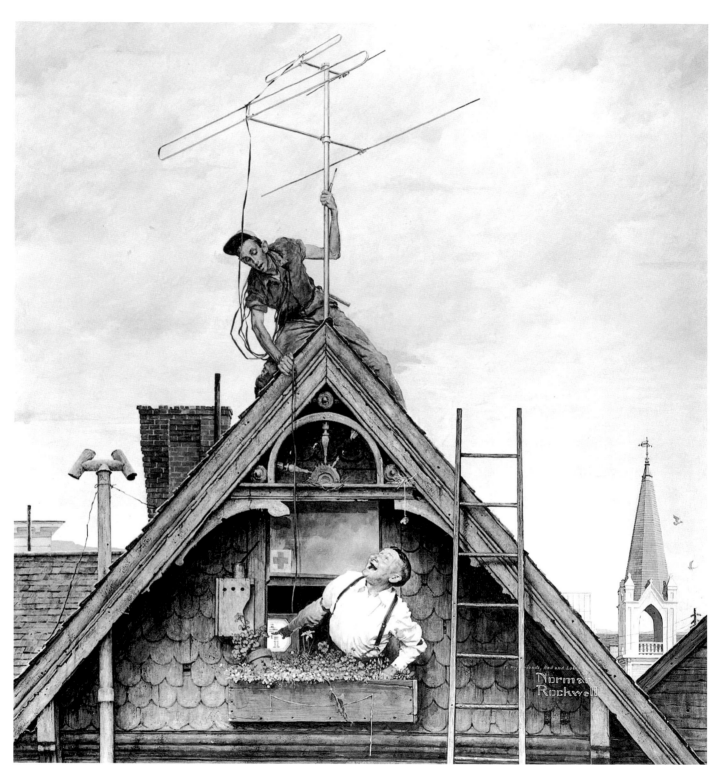

The New TV Set

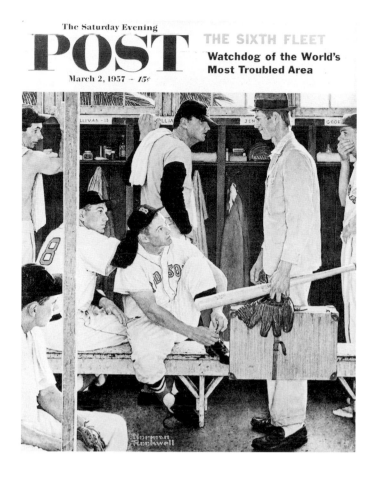

THE SIXTH FLEET

Watchdog of the World's
Most Troubled Area

The Saturday Evening

POST

March 2, 1957 – 15¢

The Rookie

Saturday Evening Post cover, March 2, 1957

The story of a kid arriving for spring training at the Boston Red Sox camp in Florida might once have been an excuse for endless gags. Here, what captures the eye are the lockers behind the players and the windows above them, engaged in a subtle push-pull movement into shallow space. The picture is almost flat—as flat as the baseball card from which Rockwell drew his portrait of the great Ted Williams, positioned on the central axis of the composition. The team sent the rest of the players up to Massachusetts to pose. Their faces and attitudes are real. But they hardly register in this cool assemblage of verticals and horizontals.

positions and showing pictures the networks did not. In 1951, the *Post* went into a revenue slump from which it never recovered. But throughout its long twilight years, the magazine continued to celebrate America's newfound prosperity. And, ironically, the television antenna was one of its most visible symbols.

The New TV Set was painted in the peak year of the television bonanza—in 1949, when 100,000 sets were sold in a single hectic week. The picture is background as subject: the architecture tells the story. A workman installs an antenna on the roof of an old Victorian house. It has seen better days. The millwork in the peak of the gable is broken, the chimney is shy a few bricks, and the scalloped siding needs repairs. But inside, the modern world has arrived in the Adams Street neighborhood of Los Angeles. A shadowy figure has appeared on the little black-and-white screen. Although the owner's delight is evident, neither he nor the workman on the roof really registers in the scene, against the strong, dark triangle of the gable. That shape appears again, elongated, in the empty church steeple at the right. The modern American worships at a new church now.

The viewer observes the living room in *Easter Morning* (1959; page 83) from the vantage point of a 21-inch, console-model TV, peering across an expanse of wall-to-wall carpet at the picture window of a perfect tract house. The omniscient eye sees the perfect family, too: father, mother, and three exemplary children—a boy and a pair of identical twin girls. But all is not well on the American Scene.

The New TV Set

1949. Oil on canvas, 46½ x 43" (118 x 109 cm). Los Angeles County Museum of Art. (*Saturday Evening Post* cover, November 5, 1949)

TV was another infallible mark of post-war prosperity. In Rockwell's early covers, the background was virtually absent. In this cover, the architectural setting is the whole story.

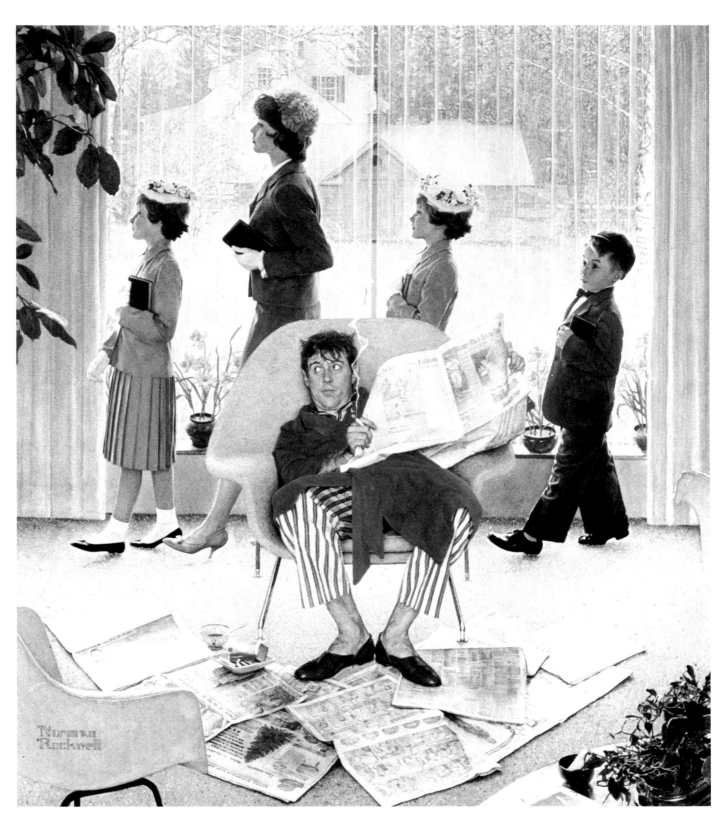

Easter Morning

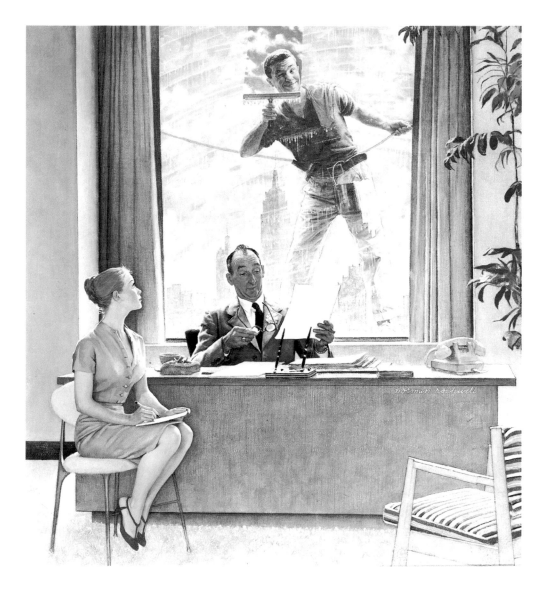

Window Washer

1960. Oil on canvas, 45 x 42" (114.5 x 106.5 cm).
Private collection. Photo courtesy the American
Illustrators Gallery, New York City. (*Saturday
Evening Post* cover, September 17, 1960)

Window Washer

1960. Charcoal on paper, 48 x 40" (122 x 101.5
cm). Collection Olive Kempton

*Again, Rockwell experiments with the
relationship between the cover's propor-
tions and those of the objects pictured.
The view of the city out the soapy window
becomes a framed picture, and the cover,
a complex puzzle: is the interior, with its
desk and perky secretary, more or less real
than the window washer and the sky-
scrapers veiled in suds?*

Easter Morning

1959. Oil on canvas, 53 x 49" (134.6 x 124.5 cm).
Private collection. Photo courtesy the American
Illustrators Gallery, New York City. (*Saturday
Evening Post* cover, May 16, 1959)

*Father's refusal to go to church would not
have been tolerated during the Lorimer
regime. But the most interesting part of
the picture is not the cowering sinner but
the setting: the sleek modern furniture,
the muted colors, and the picture window
that Rockwell treats like a highly textured
painting within a painting.*

The man of the house, wearing his pajamas and slippers, slumps in an Eero
Saarinen womb chair in the middle of the room, hiding from his brood. Only a
wisp of smoke rising from his cigarette gives his position away. They parade past
on the way to church, studiously ignoring him anyway, except for the little boy
at the end of the line of march, who looks at his father with awe and envy.

The father who refuses to go to church is a character who seems to have
strayed from a comic cover of a few decades earlier—except, of course, that no
family magazine would have dared to sanction such behavior in the twenties or
thirties. And when the reader got the joke in those more innocent times, all that
remained was to remark on how the objects discarded at the father's feet rein-
forced the gag. In this case, however, by documenting the gray and beige aus-
terity of the new, modernistic decor, all angular shapes and skinny metal legs on
the furniture, Rockwell manages to make the father into a kind of hero by for-
mal means alone. He is the rebel who brightens the living room with his red
bathrobe, the liberator who fills up spaces of a calculated emptiness with dis-

carded sections of the Easter Sunday paper, cigarette butts, and a coffee cup with a spoon left dangling dangerously over the lip. He is a bull in a china shop decorated by George Nelson and Charles Eames.

Unlike the work of the prewar period, this cover no longer has a single center of interest. Neither the husband, just below midpoint, nor his departing family, just above, can compete with a sort of picture within a picture: the framed view (of Rockwell's Massachusetts house, as seen from his studio) out the picture window. The colors of the spring foliage and the grass outside are muffled by sheer curtains drawn across the panorama. The curtains are not quite closed. An inch of so of real green grass and sharp-angled architecture is visible, before the rest of the scene is muffled in fabric and subdued. Paradoxically, this graying of the colors makes the view seem more like a part of the room, like an enormous painting, chosen to match the tones of the furniture. An abstract rendering, perhaps, of the hard-edged things with which Rockwell builds his composite portrait of the American Scene, coffee cup by coffee cup.

The visual richness and complexity of the covers Rockwell did for the *Post* shortly before his final break with the magazine in 1963 are not best appreciated by seeing them in reproduction. Even pictures with embedded chuckles acquired a pictorial authority, a presence, that went far beyond the requirements of journalistic ephemera. There is in *Easter Morning* and other covers of the period—*Window Washer* (1960; page 83) is based on the same ideas: modern furniture and gray carpet seen in conjunction with a window that could be a painting—a strong textural interest in the picture surface. If these modern interiors are sparsely furnished, the effect is to give every object a new emphasis, as though the office chair and the white phone were being seen for the first time. There is a delight in the newness of things, a delight expressed in the haptic invitation to touch their nubby, overwrought surfaces.

This is a consumer's sensibility, sharpened by advertising, the home magazines, and the interiors shown on TV; Donna Reed could have decorated any one of Rockwell's living rooms and Rob Petrie (Dick Van Dyke) could have worked in his offices. But it is also a painter's sensibility that compares one rectangle to another—desk to window—and toys with the notion that if the picture plane is a glass curtain separating the viewer from the fictive space within the office, then a picture window inside that space can turn a view of the Manhattan skyline into a painting. It is clear, too, that modern means "modern art" to Rockwell—that he had looked at gestural abstraction before he undertook these cover assignments for the *Saturday Evening Post*. The real joke is not that the pretty secretary is distracted by the cheeky window washer but that Norman Rockwell was painting parodies of Abstract Expressionist masterpieces in the guise of picture windows.

Rockwell never let "modern art" obscure his self-appointed task, however. His aim was to tell stories. "My creed," he told an interviewer in 1945, "is that painting pictures of any kind is a definite form of expression and that illustration is the principal pictorial form of conveying ideas and telling funny stories." But the one-frame gags of earlier years failed to measure up to the narrative

sophistication of a culture immersed in moving images. The movies and TV changed the way Rockwell told a story as his association with the *Post* played itself out in the postwar period. In *Going and Coming* (page 62) of 1947, he went back to a strategy that had served him well during his *Country Gentleman* days: a before and after sequence. Now the sequence was compressed into one frame, one cover consisting of two separate paintings. In the top picture, it is morning and the family is bound for a day's outing in an old, prewar car. In the bottom panel, night has fallen, and the same family limps home from Lake Bennington. The only element in the two scenes that has not changed in some subtle way is Grandma, stoic and upright in the back seat (and she has acquired a lapful of foliage along the way). Rockwell relies on the viewer to compare one picture to the other, line by line, in order to flesh out the story with a wealth of incident. Day vs. night. Country vs. city. Anticipation vs. exhaustion. Even the rope holding the boat to the roof of the car is worth examining: in the "Going" picture, it is tied off smartly, while in the "Coming" panel, it is as frayed as the parents' nerves.

Based on a nasty story circulated about Rockwell among his Vermont neighbors, *Gossips* (1948; page 87) breaks the narrative down into fifteen units, each one showing the tidbit passing from teller to listener. The vignettes are arranged in rows that read from left to right, from top to bottom, like the words of a story. But they more closely resemble frames of film, moving past the eye in a series of rapid dissolves. In a story, the characters could be fictional—made up. These men and women are as real as the personalities in any newsreel. By applying his American Scene technique to faces instead of settings, Rockwell succeeds in making a kind of documentary film on the baleful effects of gossip in the life of a small town. The same technique could also spotlight the discontinuous narratives characteristic of the electronic media. In a sketch for an unexecuted cover, first submitted around 1955 (page 88), Rockwell lines up three rows of three TV screens each, showing a then-popular "adult Western" interrupted incessantly by ads for toothpaste.

In 1961, editor Ben Hibbs, Norman's friend, was replaced and then replaced again. *Post* employees were laid off. Issues appeared erratically—and finally, not at all. The *Saturday Evening Post* folded in 1969. Rockwell's cover for September 16, 1961 (page 89), shows graphic designer Herb Lubalin seated at his drafting board in a pose Rockwell had made his own, redesigning the *Post* in a last-ditch effort to keep the magazine afloat by retooling the cover typography. Norman Rockwell seized on the occasion to make a point about what the *Post* used to be. He assembled issues of the journal going back to 1728 (when Ben Franklin called it the *Pennsylvania Gazette)* and grouped them around young Lubalin's head like one of his old circles of inspiration, guiding a boy to future greatness with heroic stories of Daniel Boone and pioneer times.

The magazines run in chronological order from right to left, and three of the modern, color covers can be identified. One, by Constantin Alajalov, from a recent issue for June 3, 1961, is a Rockwell-style gag cover with a bride and groom, in the midst of the marriage ceremony, imagining their future life

The Marriage License

1955. Oil on canvas, 45½ x 42½" (115.5 x 108 cm).
The Norman Rockwell Museum at Stockbridge,
Massachusetts. (*Saturday Evening Post* cover,
June 11, 1955)

Often, the intensity of Rockwell's gaze renders the ostensible subject of a picture invisible. The textures and surfaces of the desk, the spines of the books, the brick wall framed in the window, the wall-paper, and the floorboards amount to a still life so intense as to muffle the story line about the clerk who wore rubbers to work in the morning but will walk home in warm June sunshine.

Gossips

1948. Oil on canvas, 33 x 31" (84 x 79 cm). Private collection. (*Saturday Evening Post* cover, March 6, 1948)

The complexity increases when Rockwell shows the same event repeating itself fifteen times in a narrative sequence that moves across the page from left to right, and top to bottom, like a story in the Post, *or a reel of movie film. His wife, Mary, is the second gossip in the third row. The story was about poor Norman, who hears it in anger and disbelief in the lower right-hand corner.*

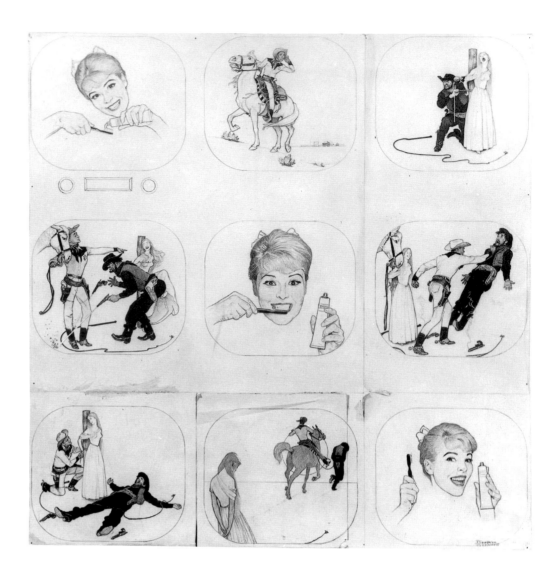

together in two thought circles that float above their heads. He imagines her bringing him breakfast in bed. And she sees a future in which he performs the same service for her. Another, by Joe Leyendecker, shows the beloved New Year's baby as a Depression-era working man, forging the final "1" for the year 1931. The last cover is a Rockwell, one of the famous Willie Gillis covers from World War II. The background is entirely black—a fade-away cover. In a few bright areas of color, the head of the young soldier appears alongside the face of a pretty girl. They are reading a GI-issue pamphlet: "What To Do In A Blackout."

In that group of covers, with a gracious nod to the Young Turks who had all but replaced the Leyendeckers and the Rockwells, Norman Rockwell pays tribute to the illustrators who made the *Saturday Evening Post* a national institution. But he sees the darkness gathering around the old *Post*. He sees the colors, the gags, and the stories disappear, like Willie Gillis and his girl, into the encroaching night.

Lubalin Redesigning the Post

Willie Gillis: Hometown News

5. Willie Gillis Goes to War

In 1941, Norman Rockwell and his family had lived in rural Vermont for almost three years. His flirtation with modern art—"my James Joyce-Gertrude Stein phase"—was behind him. His closest friends now were the other illustrators who lived near Arlington. He was settled, comfortable. The boys were in school. The local doctor, the owner of the garage, the teachers, the editor, and the pharmacist welcomed Mary and Norman to the weekly square dances at the West Arlington Grange Hall. Rockwell swept up afterward.

His career was going smoothly. If there were rumors of another shake-up at the *Post,* they hadn't reached Vermont. Norman went to the White House in 1940 with his son Jerry to present a poster in aid of a children's reading campaign: the Rockwells met Franklin Roosevelt and posed for pictures with him in the Oval Office. At the beginning of 1941, his first one-man show opened in New York, at the Ferargil Galleries. Crowds blocked the sidewalk to catch a glimpse of the pictures in the window. The gawkers, said *Art Digest,* "are a symbol of the millions of fans that this illustrator's pictures in the nation's magazines have created." The exhibition of thirty-odd cover paintings and book illustrations went on to the Milwaukee Art Institute in May.

But the country had a bad case of war jitters. A military draft had been put in place in 1940. On January 6, 1941, President Roosevelt delivered his "Four Freedoms" speech to Congress, calling for aid to the beleaguered British and outlining his hopes for a better world to come—a world without hunger, fear, religious intolerance, or the brutal suppression of unpopular ideas. In May, defense bonds went on sale. In August, meeting with Winston Churchill on a ship off the coast of Newfoundland, Roosevelt persuaded the prime minister to sign an Atlantic Charter of common principles, including his Four Freedoms.

Long before the Japanese attack on Pearl Harbor brought the United States into World War II on the British side, Norman Rockwell had been thinking about the effect of global conflict on towns like Arlington—and on the kids who lived in small-town Vermont. He found himself "pondering the plight of an inoffensive, ordinary little guy thrown into the chaos of war," Rockwell wrote. One Friday night, at the Grange Hall, he saw that sweet-faced, plucky innocent in the person of Robert Otis Buck from West Rupert (population: 400). Bob Buck, age sixteen, was going to be Rockwell's everyman—everybody's son, kid brother, boyfriend, ex-paperboy. He was going to be the *Saturday Evening Post's* Willie Gillis, Jr.

Buck agreed to pose; he had never done such a thing before, but the fee was tempting. In *Willie Gillis: Package from Home* (page 93), the *Post* cover for Octo-

Willie Gillis: Hometown News

1942. Oil on canvas, 38 x 30" (96.5 x 76 cm). Private collection. (*Saturday Evening Post* cover, April 11, 1942)

Willie Gillis, Rockwell's everyman, stays in touch by a variety of means: letters, packages, and newspapers from home, and the pictures he sends to the girls he left behind. In Rockwell's hands, even starlets seem like wholesome, hometown girls, as unlike naughty World War II pinups as could be imagined. The previous cover in the series pictured Willie at the Hollywood USO, feted by a New York model and a young woman from Los Angeles (under contract to Warner Brothers) just named "the most beautiful girl in Hollywood" by the Navy. In other Willie covers, executed after model Bob Buck had enlisted, Willie is evoked by a photograph that becomes a bone of contention between two girls modeled by Mead Schaeffer's teenage daughters.

Hero's Welcome

Saturday Evening Post cover, February 22, 1919

Although couched in the boys-and-dog language of Rockwell's early covers, this study of a doughboy's return explores the distance between boyhood and manhood. To the boys, war is an adventure. To the young man in the well-worn uniform, it was serious business.

ber 4, 1941, Bob played a raw recruit returning from mail call at Fort Dix with a package of homemade goodies and an escort of new buddies, all big and hungry-looking. Already thinking of using Bob as a recurring character for the *Post*, Rockwell had gone to Fort Dix, New Jersey, to do research and had come home with a full set of uniforms, from "boudoir blues to the ballroom browns." In *Package from Home*, Buck wears Army-issue dungarees rolled up at the cuffs to emphasize his small size. As the series wore on, and Bob became a sort of GI mascot for the home front, readers wondered why he was still in Vermont, posing for Norman Rockwell, and not in the service. Was he too short for the Army?

Bob Buck's slight stature and boyish looks were just what Rockwell needed to arouse the protective instincts of his audience. Mary Rockwell, who had been reading the adventures of "Wee Willie Winkie" to her own boys, called him Willie after the character in the book. The antithesis of the warrior-hero, little Willie Gillis expressed Rockwell's own deep ambivalence about war. During World War I, Rockwell had done his share of doughboys. *Hero's Welcome*, a 1919 *Post* cover, juxtaposes Rockwell's standard cast of kid actors—the fat one, the boy in the straw hat, each one captivated by the glory of a military parade—with their grown-up counterpart, a young soldier with a chestful of decorations. Unlike the perfect Arrow collar–man soldier, however, this one is undaunted but a little rumpled, his uniform unpressed and his hat badly dented. His human qualities remind the viewer that he was once one of those boys: war is no abstrac-

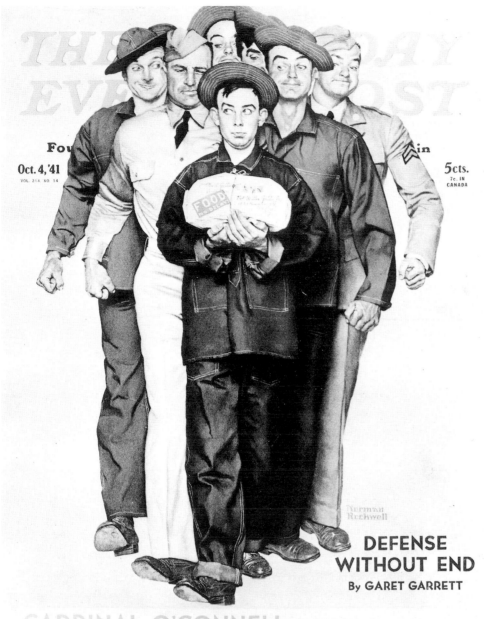

Willie Gillis: Package From Home

Saturday Evening Post cover, October 4, 1941

The decision to revert to the serial covers of his first years as an illustrator was Rockwell's solution to the restrictions created by the cover format. Until now, he had not been able to develop or sustain an idea over time: every cover was its own gag. Throughout World War II, however, Rockwell's constant theme was home— and the ties between men in battle and the loved ones who awaited their return. The Willie Gillis covers spoke repeatedly to that bond of affection.

The Saturday-matinee movie serials always left the hero in peril. Rockwell's serial works of the 1940s—the Willie Gillis covers, the Four Freedoms, the reportorial picture essays—aimed instead to covey a comforting sense of continuity. Rockwell (or his editor) was reluctant to drop the perennial hero after World War II. A mild-mannered, middle-aged Iowa voter named Junius P. Wimple was briefly considered as Willie's successor.

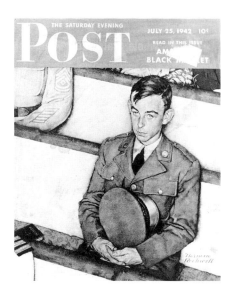

Willie Gillis in Church

Saturday Evening Post cover, July 25, 1942

Rockwell was working on this uncharacteristically solemn Willie cover when the idea came to him to do the Four Freedoms series. With the addition of more subsidiary characters, the striking composition of this cover served as the basis for the first version of Freedom of Speech.

The sixth in the series, Willie Gillis in Church *came a month after his only "fade-away" cover, the fifth Willie picture, showing the hero and a pretty girl caught in a blackout. That very modern approach to incorporating the logo into the design of the cover marked Ben Hibbs's assumption of power at the* Post. *Clearly, Hibbs approved of and supported the Willie series, which kept readers coming back for another glimpse of his doings.*

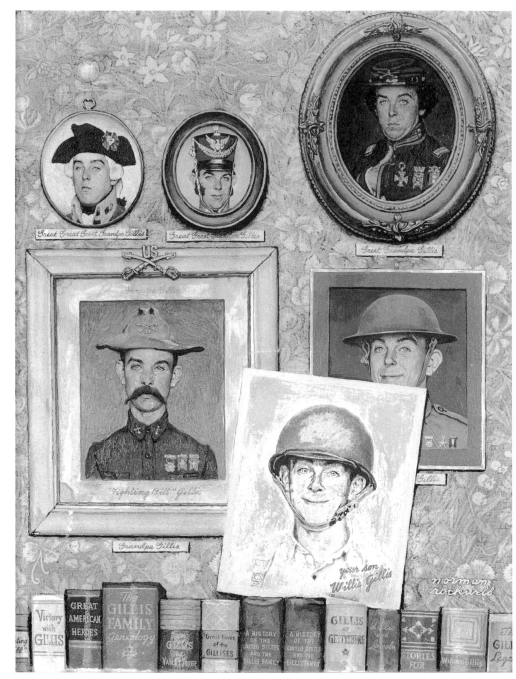

The Gillis Heritage

1944. Oil on board, 13¼ x 10¼" (34 x 26 cm). Private collection. (*Saturday Evening Post* cover, September 16, 1944)

This was a clever way to handle his model's absence and, at the same time, to emphasize the importance of continuity and family which underlie the series. The work of art within the work of art would become a recurring Rockwell theme in later years.

tion, but a monster that snatches little boys off quiet streets and sends them home battered and old beyond their years.

The Willie Gillis covers—eleven in all—turned the *Post* into a bully pulpit, reminding readers that behind the battle maps and the grainy wire-service photographs of military objectives in flames were all those nice kids from home. *Willie Gillis: Hometown News* (1942; page 90) looks in on him on KP duty, a cog in the great military machine, but still in touch with Arlington via a package of newspapers, carefully annotated in his mother's handwriting. *Willie Gillis in Church* (1942) finds him in the post chapel, serious now, a little scared, thinking about what it all means. To the *Post*'s readers, Bob Buck had become an adopted

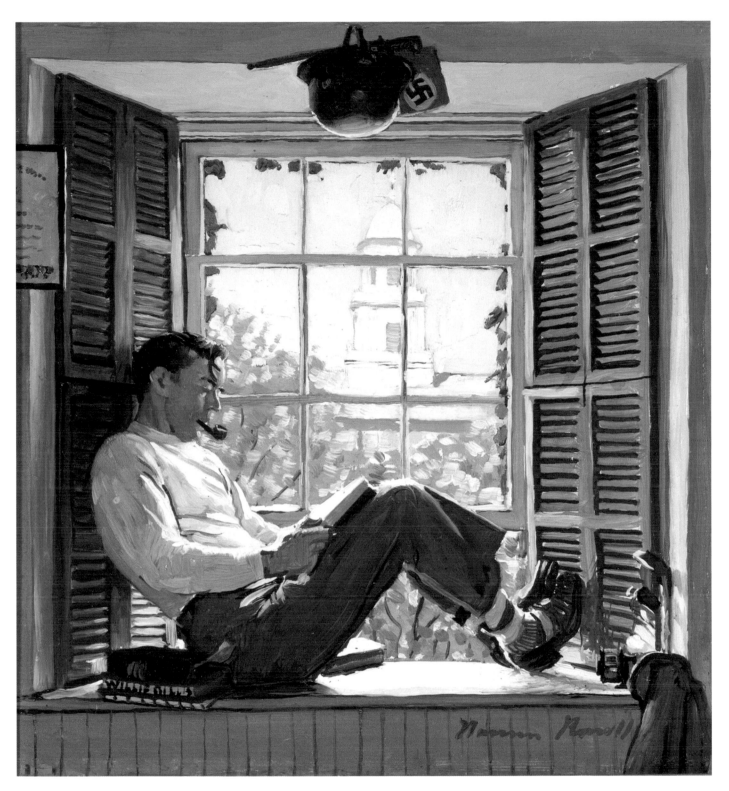

Willie Gillis at College

Study for *Saturday Evening Post* cover, October 5, 1946. Oil on canvas, 36 x 35" (91.5 x 90 cm). Private collection. Photo courtesy the American Illustrators Gallery, New York City

The last of the eleven Willie Gillis covers brings him home. A little older, a little bigger, and a little wiser, he is going to college on the GI Bill, along with vast numbers of his fellow veterans.

son, one of the family. The first two Willie covers went on display at the Fort Dix Service Club almost as soon as they were finished but the rest got far wider distribution as USO posters in railroad stations and bus depots. Willie became a salesman for savings bonds, so popular and familiar a figure that he survived the purge in progress at the *Post* when the fifth episode of his story hit the newsstands.

But young Bob had recovered now from the stomach surgery that kept him out of uniform, and he joined the Navy in the fall of 1942. "While Bob Buck was becoming one of the better-known Army figures because of Rockwell's pictures," a *Post* article revealed, "Buck was riding Navy planes based in Los Alamitos, California, as an Aviation Ordnanceman, third-class." So, around episode seven, Willie began to appear occasionally as a photograph argued over by female penpals or looking down from the bedroom wall on his girl, fast asleep at midnight on New Year's Eve. When Buck shipped out for the Pacific, he became a set of historical portraits showing *The Gillis Heritage* (1944; page 94), six generations going back to the Revolution, every man among them a military hero.

People wrote to the *Post* wondering where they could buy the books about the Willis clan standing on the shelf under the portraits. Rockwell had made up the titles, of course—*Gillis at Gettysburg, Victory with Gillis, Great Loves of the Gillises*. By then, however, Willie was real to the readers who had followed his adventures for the duration. So Norman Rockwell brought him back, one last time, in 1946—and sent the veteran off to college on the GI Bill. *Willie Gillis at College* (page 95), the final cover in the series, brings him home again, to a peaceful world of golf clubs, old sweaters, and textbooks. His discharge papers decorate the wall of his dorm room, along with a German helmet and his sergeant's stripes. But the war is over, and Willie is a civilian in droopy socks, lazing away a peaceful autumn afternoon with a pipe and a book.

Although he elected not to dwell on weaponry and battle, Rockwell could do a conventional war poster if circumstances demanded one (page 98). Shortly after Pearl Harbor, like many other illustrators, he volunteered for defense work with the Artists Guild, which was acting as a liaison with agencies in need of design services. Through the Guild, Rockwell was assigned to the Army's "Keep 'Em Shooting" campaign. After his preliminary sketch was approved, however, came the logistical problem of how to get Rockwell together with a real soldier and actual equipment. As the issue was being discussed with the brass, a retired officer who lived in Arlington, Colonel Fairfax Ayers, made arrangements to have a machine gun and crew driven 140 miles to Vermont so that Rockwell could get the details straight. This was to be an action picture—guns blazing— and, at first, Rockwell thought the Army must have made a mistake: the gun looked entirely too clean to be believed. But the gunners were more willing to have their uniforms torn and soiled by the artist in the name of combat art than to see a smudge defile a piece of Army ordnance. The gun, Rockwell learned, was always clean. In his original sketch, the gunner had been smiling out of the picture, encouraging the folks back home to keep the ammo coming. Faced with a real machine-gun crew, Rockwell decided his idea "was a little silly" and posed his gunner instead intent upon the task of wiping out the enemy. There were lots

of empty cartridges on the ground near his feet and heaps of cartridge tape to show that his ammunition was almost gone.

The poster was a success. Rockwell's role in creating it was the subject of a feature in the *New York Times,* the sort of story routinely planted by service publicists during World War II to tie the distant front to familiar figures back home and to bolster civilian morale. But it was to be Rockwell's only conventional war poster, with visible signs of a raging battle. "I don't like to do posters," he said in 1961. "They're all propaganda. . . . I don't like to do pictures which glorify killing even in a good cause."

The role of the illustrator in public affairs was changing, too. During World War II, combat photography preempted the reportorial and inspirational duties illustration had assumed in World War I: convinced that the grim realities of the trenches had been masked by dapper Arrow shirt men in uniform (and beautiful Christy girls wrapped in the flag), the public now demanded hard photographic evidence from the field of battle. And between 1917 and 1942, the photo had become the medium through which facts customarily reached the man and the woman in the street. Sports, current events, and Hollywood trivia were everyday rotogravure subjects printed in the hometown newspapers that Willie Gillis read at Fort Dix. Thus illustrators took a back seat to photographers among those charged with wartime public relations. The most popular poster of World War II, for the 7th War Bond Loan Drive in 1945, was a color version of Joe Rosenthal's Pulitzer Prize–winning photo of the Marines raising the flag on Iwo Jima. To make the poster more appealing, the government had the photo copied in color by illustrator C. C. Beall, who moved in closer on the figures of the Marines, eliminating distracting detail at the edges of the image. But the artist, in the process, had become little more than a retouch man, the servant of the camera.

Later in 1942, Norman Rockwell learned at first hand about the low esteem in which illustrators were held by Washington bureaucrats. He sat up in bed, he remembered, at 3 A.M. on the morning of July 16, ready to paint the Four Freedoms. He had heard the president's speech, and read the lofty, abstract language of the Atlantic Charter. But he had also just finished painting Willie Gillis sitting in church, listening to a sermon. He had just attended an Arlington town meeting at which a neighbor, Jim Edgerton, got up and spoke about whether the township ought to build a new high school. Nobody agreed with Jim, but Edgerton had his say: everybody listened. Freedom of Speech, Norman thought; Jim and the town meeting could show what that phrase really meant. It was something like Freedom of Religion—like Willie sitting solemn and sober in his pew. Something about that arrangement of seats, that view down from above on the single figure, made Norman Rockwell's hair stand on end. It was Freedom of Speech.

For three days, Rockwell fussed and drew and consulted with his neighbor Mead Schaeffer, the *Post*'s current cover specialist in American servicemen. The project was an enormous step for Norman Rockwell: no client, no skull sessions with an editor. These were just paintings—paintings on a peaceful theme Rockwell had chosen for himself. They were illustrations of a theme devised by

*The closest thing in Rockwell's repertory
to a conventional battle painting, this
poster was one of the few he actually
designed during World War II (although
he permitted other works to be used as
posters). Rockwell had no interest in
works that glorified bloodshed and select-
ed subjects that extolled instead the bene-
fits of peace. This attitude explains why
Franklin Roosevelt's formulation of the
Four Freedoms for which the Allies were
fighting registered so powerfully in his
mind.*

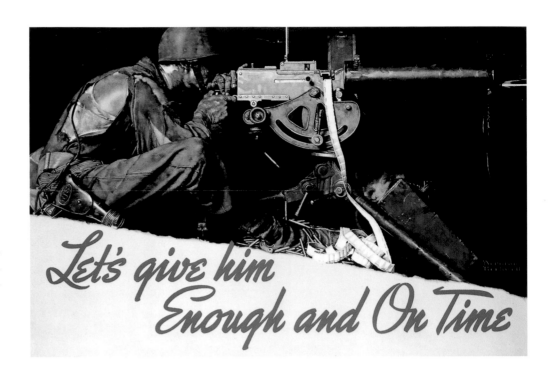

Franklin D. Roosevelt, but you might as well say that the paintings on Michelan-
gelo's Sistine Chapel ceiling were just Bible illustrations. The Four Freedoms
were paintings, all right, important paintings, *big* paintings on the most crucial
subjects of his time.

The issue of whether Rockwell was an artist—somebody fit to paint impor-
tant pictures—or a mere illustrator had begun to be raised more and more fre-
quently in recent years. He didn't want to be called a commercial artist: that
implied a person who worked only for the money. He wasn't an illustrator,
either; most of his pictures told stories he made up himself. "I suppose I could
just call myself an artist, but that doesn't—well, it doesn't feel right," he admit-
ted. "I can't say why. Maybe I want to have my humble pie and eat it too." But he
rolled up four huge sketches and set out for Washington with Schaeffer, con-
vinced that it didn't matter. He was the best-loved picture-maker in America and
he wanted to give these paintings—pictures—to Uncle Sam.

Norman and Schaef trudged from office to office, unrolling the sketches
like a pair of carpet merchants. Sorry. No thanks. Can't use 'em. Don't need any
more posters. The war was going badly, the two friends reasoned. The under sec-
retaries were busy and distracted. Finally, at the end of a long day, they found
themselves in the Office of War Information, the nerve center of the American
propaganda machine. The man in charge didn't even want to look at the stud-
ies. "The last war you illustrators did the posters," he said. "This war we're going
to use fine arts men, real artists." Maybe Rockwell would like to do some garden-
variety illustrations for a Marine training manual on calisthenics.

The Washington savant was wrong about Rockwell and the Four Freedoms.
On their way back to Vermont, Rockwell and Schaeffer stopped off in Philadel-
phia and showed the drawings to Ben Hibbs. He told Norman to go ahead. The

Post would print the pictures. Beginning on February 20, 1943, with *Freedom of Speech,* they appeared in successive issues, in color, inside the magazine. Each painting was accompanied by a facing-page essay or "parable" by a leading writer of the day. Novelist Booth Tarkington, a Pulitzer Prize–winner, wrote the first piece. *Freedom to Worship* came next, with an essay on German repression of Christian belief by Will Durant, the best-selling historian of philosophy. *Freedom from Want,* on March 6, was paired with a meditation on freedom and plenty by a young Filipino poet, a recent immigrant to the United States who made his living as an itinerant worker. *Freedom from Fear* featured commentary by poet Stephen Vincent Benét, who died on March 13, the day the *Post* ran the last in its Rockwell series "depicting the four freedoms for which we fight."

After the *Saturday Evening Post* published the paintings, to wild acclaim, the government prudently decided to give Rockwell another chance. The Four Freedoms pictures became the official posters for the 2nd War Bond Loan Drive. Four million sets of posters were eventually distributed by the Treasury Department. Rockwell went on tour with his originals to sell bonds in person. For the newsreel cameras, he reassembled his models and pretended to be painting the finished canvases. NBC radio, in the fall of 1943, carried the premiere of a new symphony, written in honor of Rockwell's imagery. The artist—or illustrator— was feted at a gala Washington banquet (where he was mistaken, of course, for Rockwell Kent).

Despite Hibbs's promise to print the series, the Four Freedoms were still strictly Norman's. The pressure of painting independent, large-scale oils was enormous. For a man wrestling with questions of self-worth and professional identity, the pictures were killers. In all, the work took seven months, more than two months on *Freedom to Worship* alone. "The job was too big for me," he said later. "It should have been tackled by Michelangelo." He began with *Freedom of Speech* (page 102), and it gave him the worst headaches. Everything had seemed so clear at 3 A.M.: Jim Edgerton, Willie in church, that arrangement of chairs. In practice, nothing worked. The first version had too many people, the wrong point of view. "It was too diverse," he wrote, "it went every which way and didn't settle anywhere or say anything." The second version looks up at the speaker from below, making it plain that he is the center of attention. His mouth is open. His eyes are fixed on the person in the front of the room to whom he is responding. Most of the faces in the audience are shown as fragments, including Rockwell's. Norman's single eye is visible at the left margin of the painting, as if to take one last look—to make sure the picture is really OK.

Freedom to Worship (page 104) was another nightmare. Norman had already used his church composition on the first canvas in the series. But there was a larger problem: how do you paint religion in a pluralistic society without offending someone? How do you paint freedom to believe? Again, the first version had to be discarded after anxious weeks of work. Rockwell had conjured up a small-town barbershop with a Jewish man in the chair, being shaved by a New England Protestant, and two other customers waiting for service: an old black man and a chubby Catholic priest. And it was all wrong. The figures were crude racial

stereotypes and the situation in which they found themselves had nothing to do with religion. Neighbors who saw the work in progress weren't impressed. "Priests don't look like that," said the Catholics. "And the Jews didn't like my portrayal of the Jew," Rockwell said.

There were four versions of *Freedom to Worship* in all. "I got a bad case of stage fright," Norman remembered. The definitive canvas was suggested by a phrase that seemed to come to Rockwell out of nowhere: "Each according to the dictates of his own conscience." While Mary Rockwell tried to find the source (possibly the writings of Mormon leader Joseph Smith), Norman gathered eight Vermont neighbors in prayer. Unlike the other pictures in the series, this tableau vivant would be seen in reverent close-up. Mrs. Harrington, her braids pinned up on the top of her head, was the mother figure in the foreground; along with the other models, she too joined in the effort to find the elusive quotation that Rockwell intended to inscribe above the faces in order to make the message clear. The lady just to her left with the rosary beads, Rose Hoyt, wasn't a Catholic. Norman wanted to make sure she didn't mind being one for art's sake.

After Rockwell's struggles with the first two pictures, the rest were almost too easy. For *Freedom from Want* (page 103), he took an ordinary American Thanksgiving dinner as his theme. And on Thanksgiving Day in Arlington, he photographed the Rockwells' cook, Mrs. Wheaton, bringing the turkey to the table. Then the family—including Norman's mother, the white-haired woman at the right—sat down to eat; this was the first time the artist could recall devouring one of his models. Just as unpretentious and anecdotal, *Freedom from Fear* (page 105) showed a mother and father looking down on their sleeping children. These images failed to satisfy Rockwell, however. "I never liked *Freedom from Fear* or, for that matter, *Freedom from Want*," he wrote. *Freedom from Want* was justly resented overseas because what it really showed, he thought in retrospect, was overabundance, too much food. *Freedom from Fear* was smug. "Painted during the bombing of London, it was supposed to say, 'Thank God we can put our children to bed with a feeling of security, knowing they will not be killed in the night.'" In both cases, he had missed the universality of Roosevelt's message.

The Four Freedoms were a great wartime success, despite Rockwell's personal reservations, probably because they affirmed the continuities of American life in the midst of a frightening and disruptive conflict. But the artist was not without his critics. In a story written shortly after the paintings appeared in poster form, *Time* magazine took issue with Norman Rockwell's view of the world. "Rockwell would probably be incapable of portraying a really evil human being or even a really complex one—perhaps even a really real one," *Time* argued. "Though he paints and composes exceedingly well, it is questionable whether any of his work could be seriously described as art. Even the Four Freedoms posters fall short of artistic maturity through their very virtue as posters: they hit hardest at first sight. But, as a loving image of what a great people likes to imagine itself to be, Rockwell's work has dignity, warmth, value."

Great art—real art—was much on Rockwell's mind as he wrestled with his first series of independent paintings in 1943. Those ideas took seriocomic form

in *Rosie the Riveter* (page 106), a *Post* cover for May of that year. In some ways, the sociological importance of Rosie has obscured the significance of the manner in which Rockwell elected to depict her. With her rivet gun and overalls, Rosie does represent the unprecedented numbers of women who went to work in war industries when their husbands and brothers enlisted. In airplane factories alone— and his protagonist seems to work in a California aviation plant—the percentage of female employees jumped from 1 percent in 1941 to 65 percent two years later. *Rosie the Riveter* is a patriot-warrior, too, posed before her nation's flag, one foot resting in triumph on a copy of Hitler's *Mein Kampf,* her work clothes bedecked with buttons from the Red Cross and other voluntary organizations. But, as a sharp-eyed reader from Lawrence, Kansas, informed the *Kansas City Star* on June 6, her posture, her bearing, and her physique were copied from the prophet Isaiah as Michelangelo had depicted him on the Sistine ceiling in 1509. Isaiah didn't have a sandwich and a lunch bucket: otherwise, he and Rosie could have been twins.

Rosie the Riveter was meant to be humorous. After the solemnity of the Four Freedoms, a return to the gag cover tradition of the *Post* must have been a relief. And the joke is on Rosie, or rather, on the female stereotypes represented on magazine covers. She is independent, self-sufficient, and strong. Unlike the pretty housewives, mothers, and single girls who cavorted across Rockwell's own covers over the years, Rosie is muscular, untidy, and disinterested in appearances. Yet just as Michelangelo used the twisted pose of the prophet to reveal the force of his message, so Rockwell adopts the same torque to hint at both power and tension. The power is Rosie's. The tension is all Norman's, as he tries to make great art in the tradition of Michelangelo.

Conversely, of course, *Rosie the Riveter* can be seen as more of Rockwell's characteristic "aw, shucks-ism," a wry admission that he wasn't any great shakes as an artist compared to that Michelangelo fella. And since it was just a magazine cover, after all, Rockwell and the *Post* donated the original painting to the 5th War Bond Loan Drive. Won in a contest for bond buyers by a Mrs. P. R. Eichenberg of Mt. Lebanon, Pennsylvania, it was acquired almost immediately by the Chicago company that made the pneumatic tool Rosie carried. In April of 1945, the picture wound up in the window of their New York office, on East 44th Street, surrounded by rivet guns identical to the one Rockwell depicted on Rosie's ample lap.

Props like Rosie's rivet gun had always been crucial to Rockwell's success. His collection of costumes, artifacts, and reference books was renowned in illustrators' circles. So the fire that destroyed his Vermont studio in May of 1943, at the height of public interest in the Four Freedoms, was a major calamity. The fire was big news and Rockwell eventually reported it as such for the *Post* a couple of months later, when he had had a chance to regroup. Accompanied by a full-page drawing showing episodes in the destruction of a large portion of his life's work, "My Studio Burns Down" signaled a turning point in Rockwell's art.

The loss of his collection meant no more historical work: from now on, Norman Rockwell would keep his attention focused on the present. The article became the linchpin in a new series of pictorial reports to the *Post:* a night on a

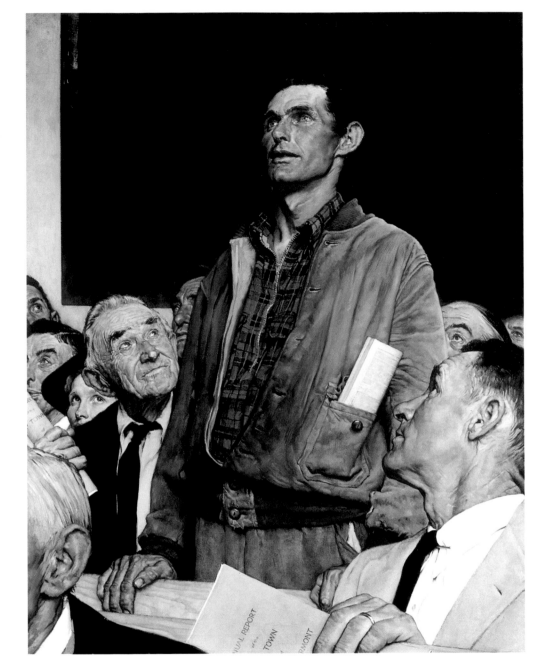

Freedom of Speech

Unused design for the first in a series of four paintings, 1943. Oil on composition board, 21 x 17" (53.5 x 43 cm). The Metropolitan Museum of Art, New York. George B. Hearn Fund, 1952

Based on Willie Gillis in Church, *this design seemed too cluttered for Rockwell's taste. What was the central figure doing? His actions do not convey the meaning of the picture.*

Freedom of Speech

1943. Oil on canvas, 45¾ x 35½" (116 x 90 cm). The Norman Rockwell Museum at Stockbridge, Massachusetts

Here, the central figure is seen from below, standing out from the crowd. The angle of vision helps to clarify the story. Rockwell, the single eye at the far left, looks on anxiously, as if to gauge the viewer's response to his picture.

Freedom from Want

1943. Oil on canvas, 45¾ x 35½" (116 x 90 cm). The Norman Rockwell Museum at Stockbridge, Massachusetts

Rockwell liked Freedom of Speech *and* Freedom to Worship. *The other two had come more easily and he thought they lacked "wallop." Criticized at the time, especially in Europe, for showing American overindulgence in scarce foodstuffs, this Thanksgiving picture is now the most popular in the series.*

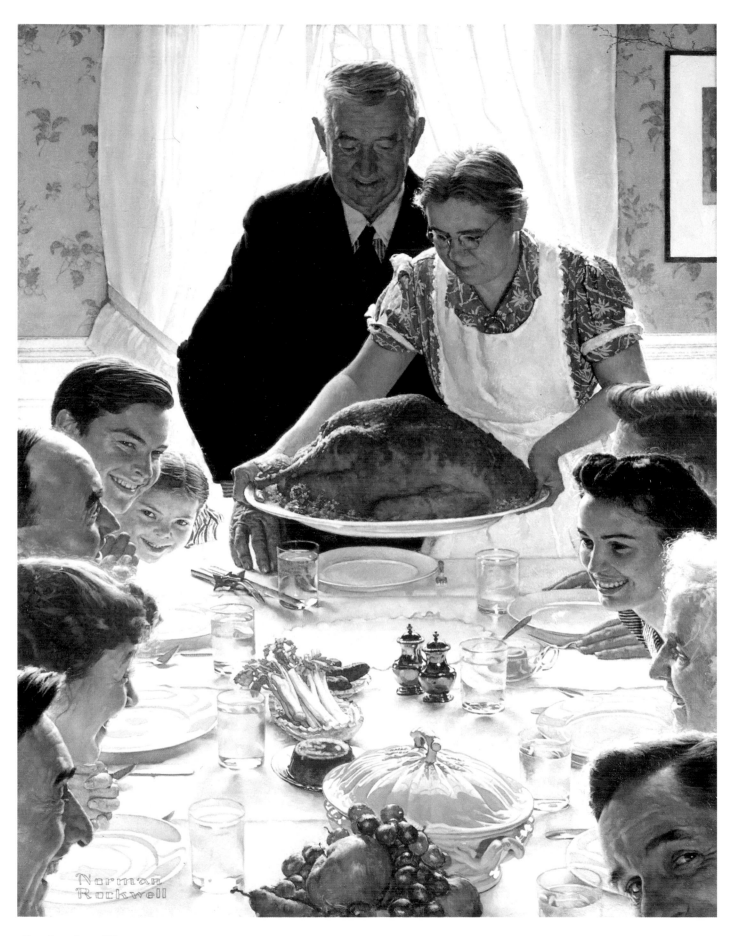

Freedom from Want

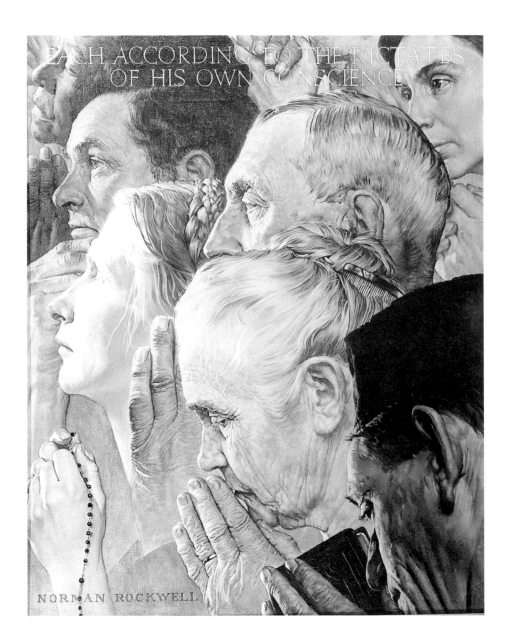

Freedom to Worship

1943. Oil on canvas, 46 x 35½" (117 x 90 cm). The Norman Rockwell Museum at Stockbridge, Massachusetts

This work went through several versions before Rockwell hit on the quotation and the point of veiw. But there is something forced and empty about the golden inscription and the assortment of ethnically distinct faces pressed too close to the picture plane. Rhetoric replaces the narative of the other panels as Rockwell strains after a "big idea." Seen alongside the other three images in the series, Freedom to Worship *is especially jarring because of the extreme close-ups; the rest of the pictures are set in clearly defined spaces within which half- or full-length characters move freely in depth.*

Freedom from Fear

1943. Oil on canvas, 45¾ x 35½" (116 x 90 cm). The Norman Rockwell Museum at Stockbridge, Massachusetts

The newspaper headline refers to the bombing of London by the Germans. Rockwell thought himself too smug in retrospect for showing an American couple putting their children to bed without worrying that they would be killed as they slept. A narrative based on historical events, it is harder than the others to read today without some knowledge of the facts of World War II.

troop train, a visit to F.D.R.'s office, a meeting of the ration board, classes in a country school, the work of the county agent, the small-town newspaper, the family doctor. Until the late 1940s, Rockwell immersed himself in the transient facts of the present. Like James Agee and Walker Evans, whose *Let Us Now Praise Famous Men*, published in 1941, explored Depression-era poverty in the rural South by examining the material possessions of several families in minute detail, Rockwell would turn the microscope of art on the humble and the mighty in his reportorial pieces. But his paintings changed, too. Or rather, toward the end of World War II, the readers of the *Saturday Evening Post* began to get paintings instead of cover art from Norman Rockwell. And those paintings scrutinized the physical properties of person and place with an intensity that amounted almost to prayer.

The end of the conflict and the prospect of homecoming seem to have stirred Rockwell's deepest emotional response to World War II. He anticipated

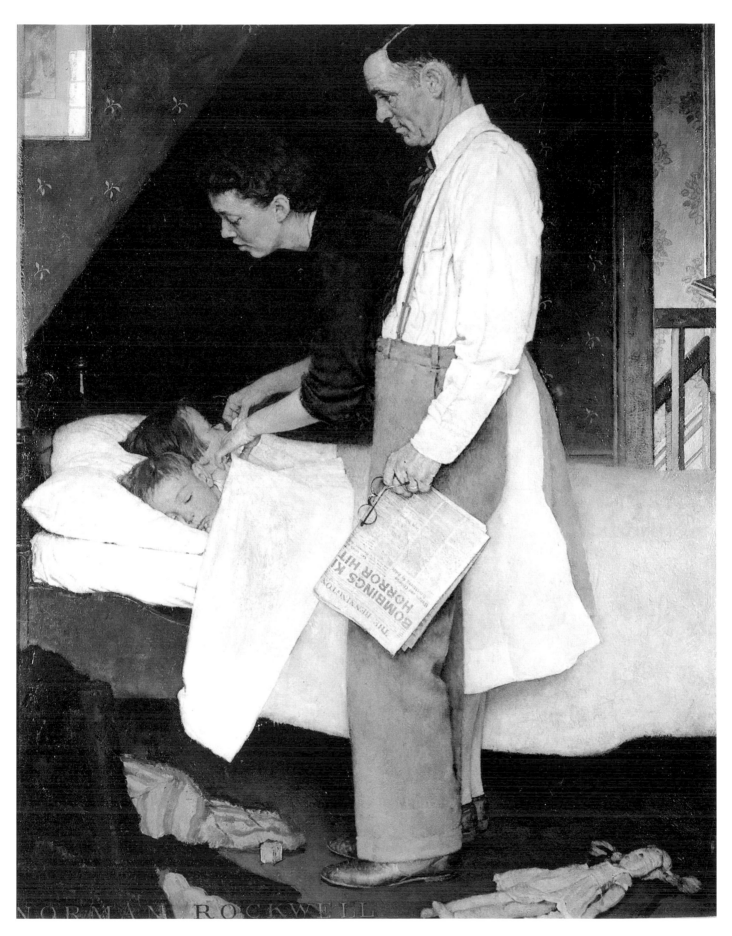

Freedom from Fear

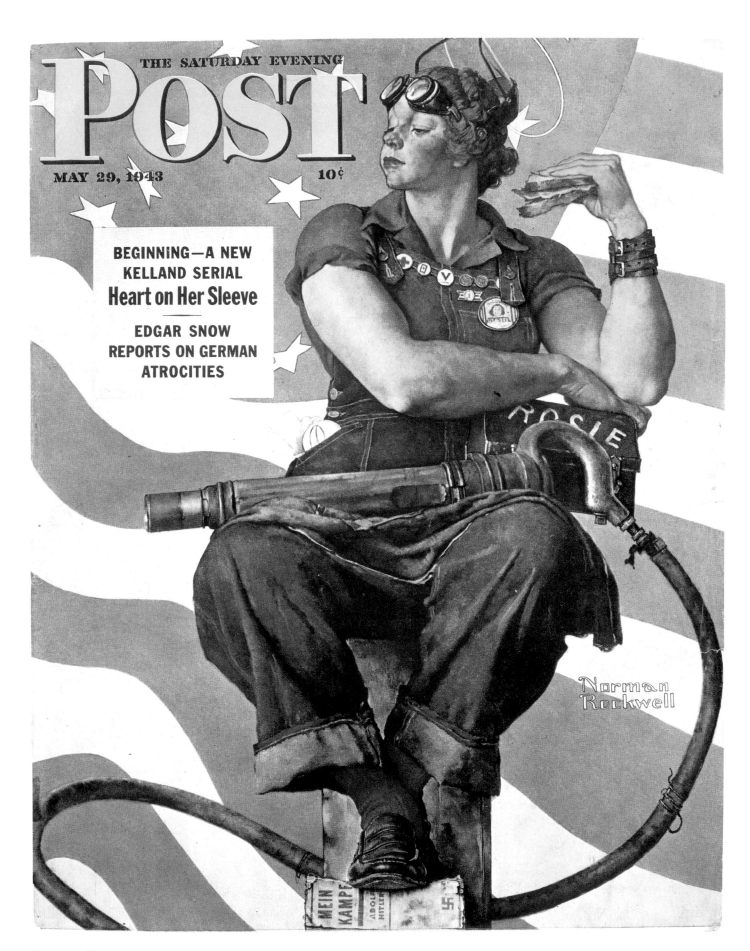

Rosie the Riveter

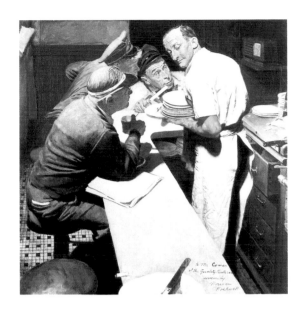

War News

Unused cover for *Saturday Evening Post*, 1944. Oil on canvas, 41½ x 40½" (105 x 103 cm). The Norman Rockwell Museum at Stockbridge, Massachusetts

Rockwell substituted another rendition of the same theme—listening for news of D-Day on the radio—because this picture did not make it clear what the men were hearing. The tension of the composition itself is palpable, however: Rockwell had arrived at a watershed where paintings and covers diverged for the first time.

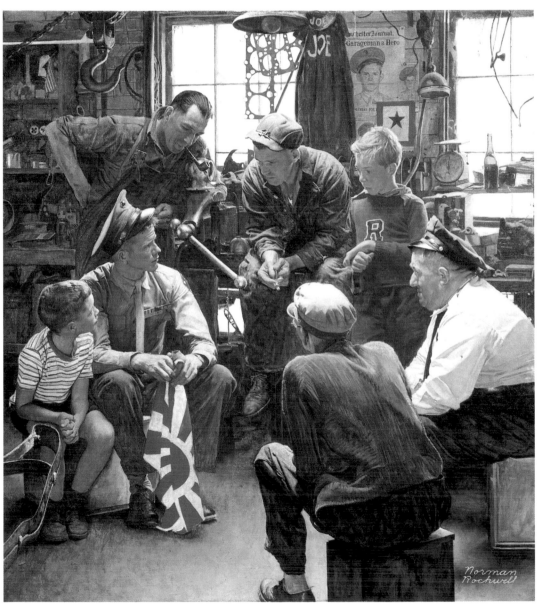

Homecoming Marine (The War Hero)

1945. Oil on canvas, 46 x 42" (117 x 106.5 cm). Private collection. Photo courtesy the American Illustrators Gallery, New York City. (*Saturday Evening Post* cover, October 13, 1945)

The greatest of Rockwell's wartime works, this cover makes the garage in which the veteran tells his story into a shrine, and each object is solemnized by the artist's meticulous attention to it. This is home—at last. Young Joe's war story is no boast or brag. It is quiet as a prayer. The gravity of the occasion is mirrored in the still, sorrowful faces of his listeners.

Rosie the Riveter

Saturday Evening Post cover, May 29, 1943

Thanks to the women's movement, this has become one of Rockwell's most famous images. So it is pertinent to ask why he bases his aircraft worker on one of Michelangelo's male prophets. Is it just a joke on the Rosies of the world, who are (literally) filling a man's shoes for the duration? Or does the tension of the pose mirror Rockwell's own anxiety about his first independent oil paintings—the Four Freedoms series—and about being a great artist, like Michelangelo? When asked about the Four Freedoms, after seven months of intense labor, he said that "the job was too big for me. It should have been tackled by Michelangelo."

*Thanksgiving: Mother and
Son Peeling Potatoes*

Sketch for Thanksgiving cover,
Saturday Evening Post, August 1945

the defeat of the Axis for the *Post,* served as eyewitness when the boys came home, and celebrated with their families as they slipped back into the rhythm of American life. *War News* (page 107), a cover idea Rockwell abandoned in 1944, shows four men at a lunch counter, listening for news of the D-Day invasion. Although there are figures present, the work has the motionless solemnity of an old master still life: the men are frozen in place by the voice on the radio, pinned to the canvas by the gridwork of tiles on the floor and the pattern of wrinkles on their foreheads. A wide white swath of countertop cuts through the stillness like a scream, the visual counterpart to the invisible sound. Although the work is a subtle and memorable painting, Rockwell had doubts about its storytelling qualities. Would people understand that the men were listening for news that the invasion of Europe had begun? The substitute cover, with a man tuning the radio surrounded by maps of the theaters of war, pictures of Eisenhower and MacArthur, and photos of his three sons in the service, clarifies the story at the expense of the emotional resonance of the first version. The one is reportorial prose. The other, pure poetry.

In *Homecoming Marine (The War Hero)* (1945; page 107), the story of the landing on Iwo Jima comes straight from the mouth of a young man who has been there. Joe's home! Tacked to the back wall of the garage where he worked before going off to war, between the windows, is the clipping from the *Manchester Journal* that names him a hero of the battle. It hangs there, along with his coverall and a star that stands for a boy in the armed forces, awaiting his return. But he's back, safe and sound! Here he is, a Japanese flag dangling absently between his fingers, reflecting on a bad time. There is no cheap heroism in Rockwell's picture. The boy's weariness and distress register on the faces of his listeners, from the slender blond child to the stocky old man. The infinite tenderness of their response is conveyed less by facial expressions than by the pains Rockwell takes to delineate every bottle and scale, every light bulb and cable and vise. Every item gets its due, in a gesture of respect that makes the garage into a sacred space—Socrates' Academy, or the temple where young Jesus discoursed with the elders.

Homecoming Marine was one of no fewer than five homecoming covers that Rockwell would paint in 1945, but the Thanksgiving issue was special—the ultimate thanksgiving for any anxious parent with a child still overseas. Rockwell's war years had been anxious ones, too, and he needed a change of scenery. He had in mind a cover that would show a mother reunited with her son in the kitchen, the heart of the home, as the feast was being prepared, and he persuaded himself that the right kitchen would surely be found in Maine. So, with biographer Arthur Guptill trailing along, he headed north in August. En route, they heard the announcement of the Japanese surrender. Gas rationing ended. They stopped in Prout's Neck, to visit Winslow Homer's studio. Then Rockwell got down to business. He hired a photographer and took lots of pictures for the Thanksgiving cover: interiors, props. He worked up a full-scale sketch in which the mother bends over an old coal range, while her son peels potatoes, like Willie Gillis, in the foreground. And then he gave it up.

WILLIE GILLIS GOES TO WAR

Thanksgiving: Mother and Son Peeling Potatoes

1945. Oil on canvas, 35 x 33½" (89 x 85 cm).
Private collection. (*Saturday Evening Post* cover,
November 24, 1945)

*Rockwell was on his way to Maine when
the Japanese surrender was announced
(August 14, 1945). The troops would be
coming home at last! Rockwell commem-
orated the final Thanksgiving of the war
with this moving scene, set in the kitchen,
the heart of the home. Dinner has been all
but forgotten as the mother looks at her
son with the eyes of love. The quiet emo-
tion stands in marked contrast to the hol-
iday bustle of* Freedom from Want.

The boy model from Maine was too young. The story was right, but the
mood wasn't. "I lost all interest in it," Rockwell said, "just couldn't go on. I
couldn't seem to loosen up—to get away from my photographic references." In
the end, he started over, with an Arlington kitchen and local models—a young
man who had flown sixty-five combat missions over Germany as a bombardier
and his real-life mom. Nothing in the room matches: diamonds on the wallpa-
per, checks on the tablecloth, dots on her dress, the woven patterns of twill in his
uniform, the tracks of a comb in his hair. The authenticity of the scene is a func-
tion of its own disinclination to form a conventionally pleasing composition.
The floorboards spill the figures and the room halfway into the viewer's space,
making an intimate connection between the onlooker and a scene of great,
affecting quiet. The only sound is breath and the tiny, creaking noise the
knifeblade makes on the potato. The mother looks at her son with sweet satis-
faction and he smiles in the warmth of her happiness. "Thanksgiving," it says in
script across the bottom, as if anyone could miss the point. Reality, in Norman
Rockwell's best work, can speak eloquently on its own behalf.

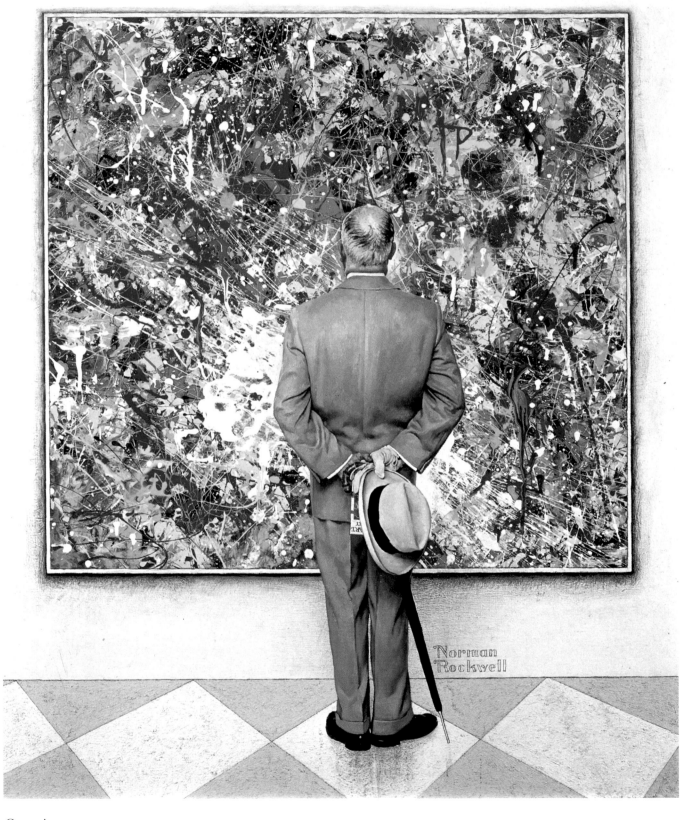

Connoisseur

6. Norman Rockwell—Painter

For most of his life, Norman Rockwell called himself an illustrator. His autobiography, serialized by the *Saturday Evening Post* in 1960, was entitled *My Adventures as an Illustrator*. But in an interview arranged to coincide with the publication of the book, he seemed not quite sure. "How would you define . . . illustration?" asked the interrogator. "Making pictures from somebody's writing," Rockwell replied. "I'm not an illustrator any more. I do genre. That's spelled g-e-n-r-e." Ben Hibbs, in a preface to the memoir, put things more baldly: "It is no exaggeration to say that Norman Rockwell is the most popular, the most beloved of contemporary artists." In the opinion of his boss, Norman was an artist.

From the beginning of his career, Rockwell had recognized the growing rift between illustration and the fine arts and had made sporadic efforts to keep a foot in each camp. As early as 1912, he interrupted his practical training to spend a summer in the Provincetown art colony, working under the direction of Charles W. Hawthorne (1872–1930). One of the last credible genre painters, Hawthorne—with his pictures of the vanishing fishing industry of Cape Cod— stood at the end of a long line of American chroniclers of everyday life that reached back to William Sidney Mount (1807–1868), George Caleb Bingham (1811–1879), and Winslow Homer (1836–1910).

But Rockwell looked forward, too. In the 1920s and 1930s, he took long trips to Europe to see famous masterpieces, to expose himself to the modern art of Paris, and, to the dismay of the *Post*, to paint his own "very lousy Matisses." In 1958, Rockwell announced that he would take a sabbatical the following year. At the age of sixty-five, he said he wanted to "buckle down to real painting . . . real art." He wanted to see "if there's anything else in me" besides covers and calendars. The possibility that there was not scared him badly. What, exactly, did Rockwell want to try on this leave of his? the reporters asked. What kinds of stuff would he paint? Whose work did he like best? "Picasso," said Rockwell, "he's the greatest."

But Rockwell had done a host of things almost guaranteed to demonstrate that he was not a serious artist. First, in 1948, he designed a line of Christmas cards for Hallmark. Then, that same year, he joined the faculty of the Famous Artists School of Westport, Connecticut, which promised to make amateurs into working professionals through a correspondence course. Just fill out the coupon and wait for the money to roll in! Ads for the school promised that anybody could become an artist: it was a rags-to-riches American success story. Author of an exclusive method of explaining "characterization and the secrets

Connoisseur

1962. Oil on canvas mounted on board, 37¾ x 31½" (96 x 80 cm). Private collection. (*Saturday Evening Post* cover, January 13, 1962)

For this, the ultimate "what-is-art?" picture, Rockwell made the fake Jackson Pollock himself, with the help of a house painter who dropped a bucket of white paint on the canvas as a finishing touch. The man looking at the painting is less colorful and interesting than it is and seems to be in imminent danger of being swallowed up by the dynamic, surging forms of art.

Sketchbook page, showing carved sign over mustard shop, France

1932. Pencil on paper, 15 x 11" (38 x 28 cm). The Norman Rockwell Museum at Stockbridge, Massachusetts

Like his art-school friends, Rockwell aspired to go to Europe—and did so often in the 1920s and 1930s, when he was formulating his own understanding of art. Although his sketchbooks display a taste for visual gags, like this scatological sign, Rockwell also paid much closer attention to modern art than he was later willing to admit. He did belatedly confess admiration for Picasso. Henri Matisse's views from windows may have had a more lasting influence.

My Studio Burns

1943. Charcoal on paper, 21½ x 17" (54.5 x 43 cm). Private collection. (*Saturday Evening Post* story illustration, July 17, 1943)

The loss of his props and notes in 1943 was a turning point for Rockwell. It shook him out of established patterns of thought and led him to look more carefully at the world around him, including the contemporary art scene from which his own success as an illustrator had isolated him.

of color" to Famous Artists School pupils, Norman Rockwell was held up as the prime example of a man who had quit regular school at fifteen himself but was now rich and famous.

Did Jackson Pollock or Pablo Picasso hang around Hollywood? Norman Rockwell did. A Rockwell portrait of Jennifer Jones playing the lead in the 20th Century-Fox production of *The Song of Bernadette* was once reproduced at so large a scale as to cover the wall of an eight-story building. Rockwell himself appeared in ads for oil paints throughout the 1950s, offering tips for making backgrounds dry faster and for improving the realism of flesh tones with the addition of a certain shade of yellow from the manufacturer's catalog. In 1954, he unveiled a portrait of comedian Bob Hope on a live TV hookup seen from coast to coast. Election years did not seem quite official without Rockwell's quadrennial portraits of the candidates, looking so affable and pleasant (and so much alike) that it was hard to believe they said those awful things about one another in the course of the campaign.

Perhaps it was the company he kept. Rockwell's work was never seen in places where artists extolled by the powerful critics Clement Greenberg and

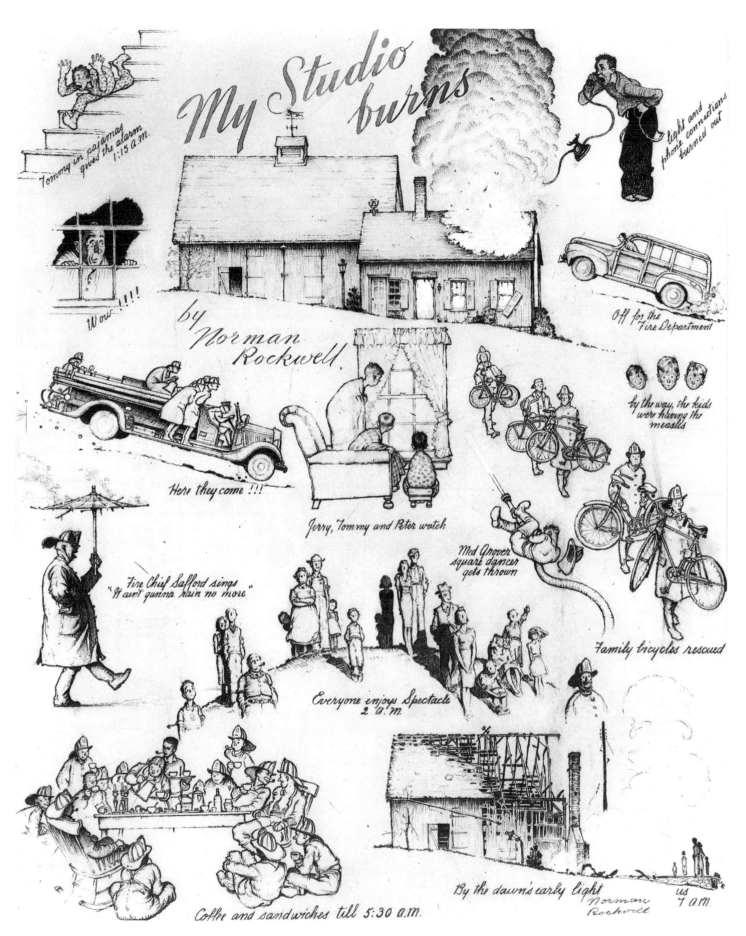

My Studio Burns

Harold Rosenberg showed their wares. His exhibition record was spotty and a
major 1955 show at the Corcoran Museum in Washington, D.C., was made up of
covers from the *Saturday Evening Post*. Magazine covers in an art museum! In the
1950s, the assumption was that to be art, the object must be free of the encum-
brances of commerce and editors, subject matter and popular approval. Yet dur-
ing his one-man show in Washington, the *Post* had mounted a splashy
nationwide contest, a poll to choose the Rockwell Americans liked best. The
votes poured in by the hundreds of thousands. Thirty-two percent picked
Thanksgiving (Saying Grace), which showed an old lady and her grandson saying
grace in a sleazy lunchroom. The runner-up, at 27 percent, was the picture of
the rancher's son, going off to college.

But more important than the totals were the testimonials. "I had not been
to church for years. Something in *Thanksgiving* so stirred me that I started
going," wrote one anonymous entrant. "I have found serenity and a steady new
courage. I am happy." Insofar as Rockwell's images attached themselves to the
lives and emotions of his viewers in unaesthetic ways, they were not art, by the
operative definitions of the day. The discourse that currently validated "art"
seemed irrelevant to whatever Norman Rockwell was doing. Did the Museum of
Modern Art pass out ballots to determine its most popular Pollock? Did impor-
tant critics attest that the sight of a Picasso had made them holier—or happier?

There had been a moment, in the 1940s and early 1950s, when the peren-
nial conflict between art and commerce seemed to have ended. Thomas Hart
Benton maintained that working for the corporation was a logical extension of
working for the government during the Depression: based on paintings done in
his usual style, Benton's ads for Lucky Strike cigarettes—some of them appeared

April Fool: Checkers

Voyeur

The intensity with which Rockwell attacks certain parts of the picture—human hair, for example—is disturbing. Pushed this far, realism becomes Surrealism.

on the back covers of magazines for which Rockwell designed the fronts—reached a far wider audience than any New Deal mural. While the Regionalists and realists were particularly active in the art-in-advertising movement, Georgia O'Keeffe, Isamu Noguchi, and other modernists were also commissioned. Spanish Surrealist Salvador Dalí was as well known in the United States, perhaps, for his provocative ads, his Hollywood set designs, his Manhattan display windows, and his naughty pavilion at the New York World's Fair of 1939 as he was for his painting. Pepsi-Cola and Hallmark both held national art competitions, with the work of the winners widely disseminated in the form of calendars and other retail products. Discriminating shoppers could also buy yard goods based on paintings by Grant Wood and Grandma Moses.

There was, in other words, a legitimate place in the art hierarchy for the anti-avant-garde, or art that catered to the tastes of an increasingly affluent middle-class audience that read popular magazines and drank Pepsi. But critical support for this kind of art, never strong, evaporated in the 1950s with the rise of Abstract Expressionism and what one scholar called "the triumph of American painting" on the global stage. Interest in the American avant-garde abroad validated the style at home for intellectuals who had never believed that art, like Pepsi-Cola, was for everybody. Beginning to stake his claim as a fine artist in this changing climate of opinion, Norman Rockwell was also its first victim. He was a commodity, fit for consumption, perhaps, but not an artist liable to hold his own among the Picassos and the Pollocks in international exhibitions. They were truth-seekers. He worked for the *Saturday Evening Post*. They were bold experimenters. He was an old-fashioned realist, a genre painter by his own admission, although genre had been a dead issue among the cognoscenti since before he was born.

Class snobbery, a programmatic preference for experimental art, a fervent belief in the modernist aesthetic: whatever the reasons for the rejection of Rockwell by those who explicated, exhibited, and sold the work of abstract painters in the 1950s and 1960s, he was rejected. The reasons must have been just as puzzling to Rockwell himself since, when the pendulum of style swung back toward figurative painting in the 1960s, he was still anathema, although his realism no longer seemed to be at issue. Publisher Harry N. Abrams told the story of going to see a Rockwell show at New York's Danenberg Galleries in 1968 and passing the Whitney Museum of American Art along the way. The lines at the Whitney stretched around the block: there was an Andrew Wyeth exhibit inside. At the Danenberg, there was nobody—just Rockwell. In 1971, Abrams told the story to Richard Reeves, who was preparing an article on Norman Rockwell for the Sunday edition of the *New York Times*. The incident, Abrams said, led him to offer to issue the lavish book of Rockwell reproductions that appeared in 1970. Tom Rockwell, Norman's son, still wonders aloud if this was the whole story. But it sounds right. Wyeth—old N. C. Wyeth's son, a painter of grassy fields and run-down barns—in the Whitney. Rockwell down the street, in a small, commercial gallery.

Despite the suspicion and outright hostility with which the art world often viewed Norman Rockwell the illustrator, he was fascinated by the nature of painting. Beginning in 1942, with his work on the Four Freedoms canvases, Rockwell began to confront the difference between painting to order for a magazine—with all the support and constraints of the craft—and creating an independent composition. Although *Freedom from Want* and the others were used as posters and illustrations, they were not first conceived as assignments for either venue. The infinite trouble the four pictures caused Rockwell is proof enough that he was treading on unfamiliar terrain. And try as he might, the pictures never meshed to form the coherent whole he once envisioned: his actors appeared in close-up, extreme close-up, in middle-distance shots, and in profile; they avoided the viewer's eyes, or, like the family with the turkey, appeared ready

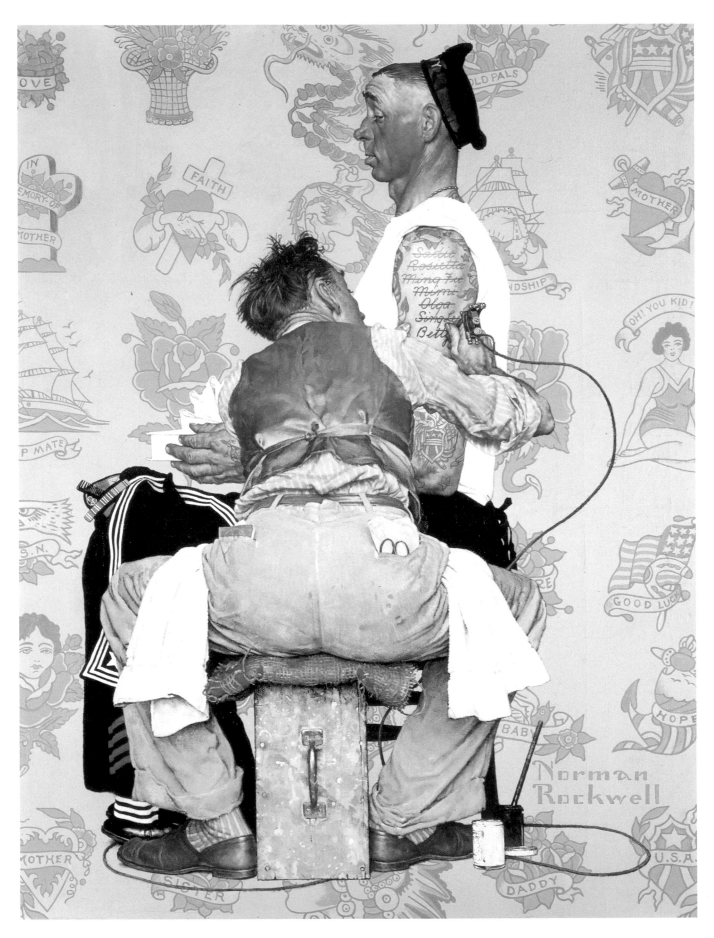

Tattoo Artist

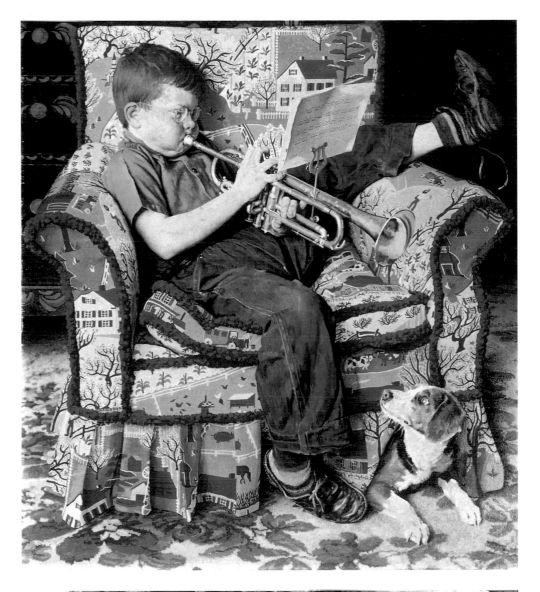

Practice

1950. Oil on canvas, 34 x 31" (86.4 x 78.7 cm). Private collection. Photo courtesy the American Illustrators Gallery, New York City. (*Saturday Evening Post* cover, November 18, 1950)

Art is the background or setting for this otherwise ho-hum look at a boy's tussle with music lessons. The slipcover material, which Rockwell made up for this picture, is based on a painting by his friend and neighbor Grandma Moses. Thanks to her immense popularity, however, Grandma Moses upholstery fabric really was sold in the 1950s. If tattooists and untaught amateurs were artists, perhaps the honorific was elastic enough to include Norman Rockwell!

Norman Rockwell Painting "The Soda Jerk"

1953. Oil on board, 4½ x 6¼" (11.4 x 15.9 cm). Private collection

This tiny canvas is noteworthy for the use of thick, distinctive brushwork on the portions of the scene depicting a work of art. The cover he is seen working on here was published on August 22, 1953. Unlike Rockwell's copy, the illustration is smooth and even in tone. But brushwork identifies the hand of the artist. In 1953, signature brushwork was the hallmark of Abstract Expressionism.

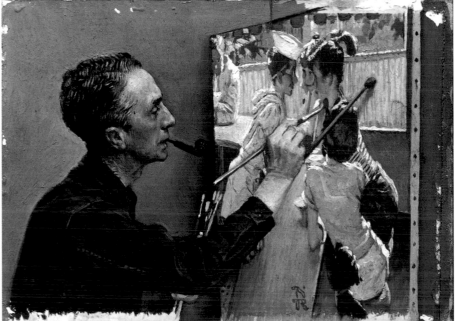

Tattoo Artist

1944. Oil on canvas, 43 x 33" (109 x 84 cm). The Brooklyn Museum. (*Saturday Evening Post* cover, March 4, 1944)

Rockwell knew about contemporary art; he was also sensitive to the nature of the artist's calling, although he often expressed his feelings in comic form. Like his many studies of colonial sign painters, this cover probes the distance between art and craft, or wonders if there is much of a difference between one kind of artist and another. The figures hover before a flat backdrop made up of sample tattoos; Rockwell handles space here with the aplomb of a card-carrying modernist.

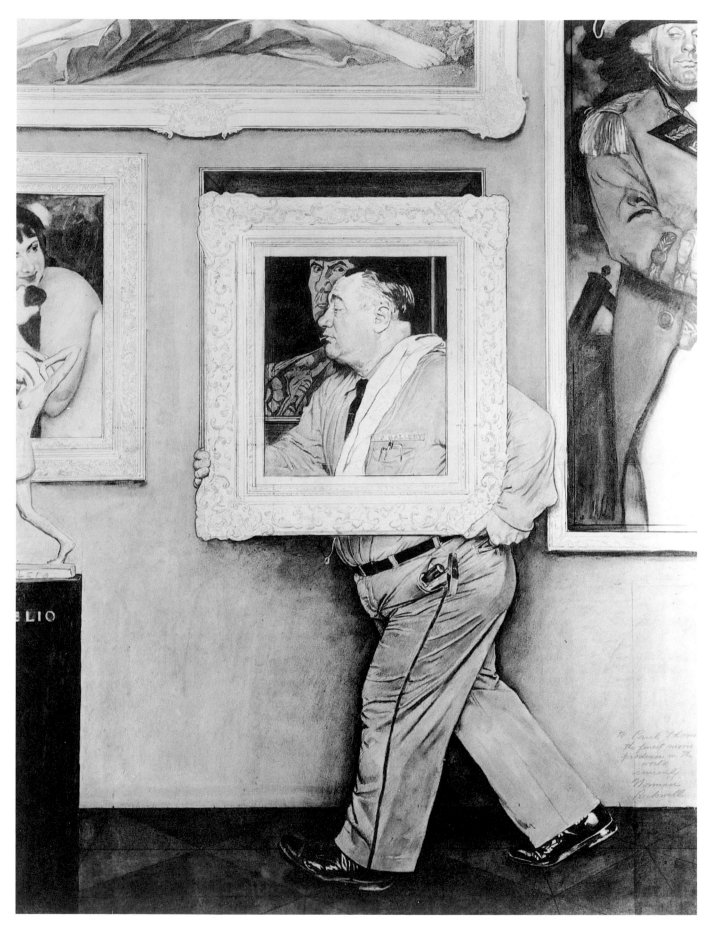

Framed

Art Critic

Sketch for *Saturday Evening Post* cover, April 16, 1955. Pencil on paper, 4¾ x 4¼" (12 x 10.8 cm). The Norman Rockwell Museum at Stockbridge, Massachusetts

In the preliminary sketch submitted to the Post, *this picture was centered on the personality of the beatnik in the museum.*

Framed

Saturday Evening Post cover, March 2, 1946

Rockwell was deeply interested in the persona of the artist. He was also fascinated by the museum and the institutional framework in which "legitimate" works of art were seen and used. In his hands, the topic became a series of jabs at the notion that art and daily life have little in common. As Rockwell sees it, art and life are much the same—or ought to be. The pictures on the wall peer down on the hapless handyman centered in the frame as if to ask what's happening to the neighborhood. Him? Art?

to slide out of the fictive space behind the picture plane, bringing their cranberry sauce with them. The public adored the Four Freedoms, however. Walt Disney wired his congratulations. Rockwell was wined and dined in the highest circles. Yet he knew that he had lost his fight with paint, canvas, and his own first idea for the series. "My worst enemy," he wrote, "is the earth-shaking idea. I just can't handle it."

Throughout the later forties, Rockwell worked on the problem of how to make a painting and what a painting is, using the *Post* as his laboratory. The April Fool's Day covers (there were three in all: 1943, 1945, and 1948) seem, at first glance, to be the least artistic of all his work, bad jokes in paint. But they can also be understood as exercises in the limits of realism. The first in the trio, *April Fool: Checkers* (page 115), was Rockwell's response to the kind of criticism his fans directed at any given sample of his work. Unlike a painter whose composition or color or relationship with the work of others might be fair subjects for remark by a professional critic, the illustrator heard about how the fisherman's boots were laced up wrong if he actually was right-handed (and he was holding the rod in his right hand!). "I have never done a cover yet," Rockwell complained, "but that some one has found things wrong with it." So he built forty-five errors into

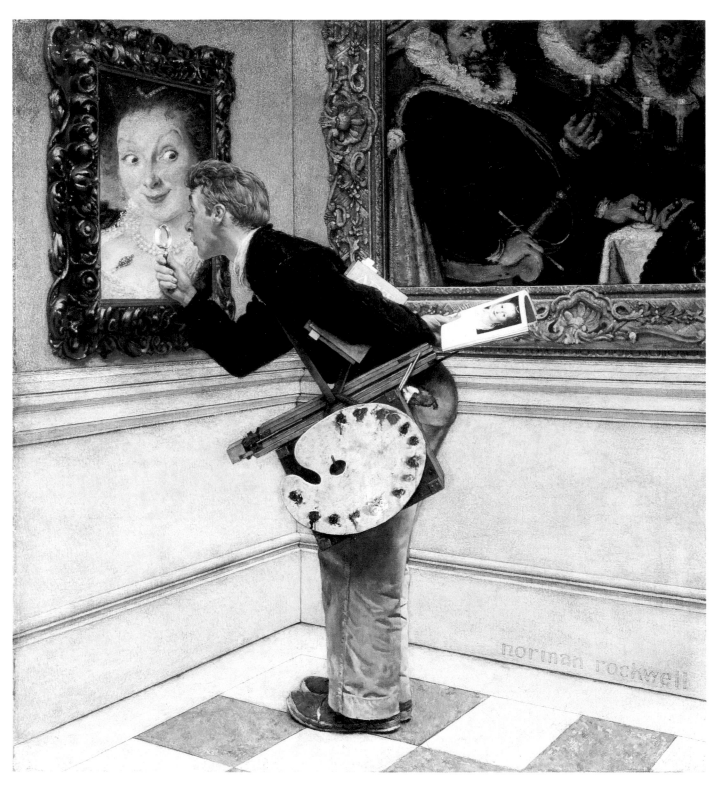

Art Critic

Boy in a Dining Car

Study for *Saturday Evening Post* cover, December 7,
1946. Oil on paper, 11¼ x 10¼" (28.5 x 26 cm).
Collection Richard Rockwell

*The third category of self-conscious "art"
pictures that Rockwell produced in the
postwar period dealt with squares within
squares, or the relationships between the
support and the image. Although this
picture of his son Peter figuring out the
proper tip to leave a waiter in the dining
car of the New York Central's Lake Shore
Limited is a nice genre painting on its
own terms, Rockwell may have seen it dif-
ferently. He rejected the first railroad car
he was offered because it failed to match
the composition in his mind's eye.
Increasingly, that composition hinged on
rectangles, or real-life paintings. The
viewer looks through or past one scene
into another dimension. Sometimes,
because of a combination of light and
flatness, the distant view pops back into
the foreground, diminishing the impor-
tance of the apparent subject.*

the picture, signed his name backward, and waited for the fun to start. The *Post*
got 140,000 letters complaining that the artist's list of mistakes wasn't nearly
inclusive enough: a Latin American reader, for instance, identified 184 separate
blunders.

But the picture, which pushed realism in the direction of nonsense or utter
chaos, also contained Rockwell's most fully developed background to date.
Packed with wallpaper patterns that change from one side of the wall to the
other, portrait subjects who refuse to stay in their gilded frames, and visual puns,
like the automobile tire that substitutes for the fireplace grate just because it has
the same shape, the busy background flattens the picture, too, creating a nice
sense of ambiguity in the conflict between the two-dimensional cover and the
scores of apparently "real" objects that contrive to occupy this peculiar room.
The hyperintensity of detail aligns Rockwell's work with the Social Surrealists of
the 1930s and 1940s, American artists whose response to economic collapse,
labor unrest, and war was an intensified realism, often applied to subjects that
did not exist in such form in the realm of ordinary reality. American artists who

Art Critic

1955. Oil on canvas, 39½ x 36¼" (100.5 x 92 cm).
Private collection. (*Saturday Evening Post* cover,
April 16, 1955)

*In the finished version, the subject is the
ongoing dialogue between art and life, as
the Dutch paintings, with amusement
and a little alarm, examine the young
man who has come to study them. The
palette at the center of the picture func-
tions as a trademark or logo: this picture
is about art! Rockwell's name appears on
the baseboard like a sample of very neat
graffiti: Picasso dared to write across the
canvas, asserting its flatness, and so
does Norman Rockwell. In Cubist art, a
word can take the place of a picture. Per-
haps* Art Critic *is a self-portrait in which
Rockwell's name—and convictions—
appear in lieu of his likeness.*

Norman Rockwell making his own
versions of Jackson Pollock
"drips," c. 1962

Photo by Louis Lamone, Lenox, Massachusetts

were not otherwise associated with orthodox Surrealism exhibited surreal tendencies. Benton did landscapes and still-life fragments of larger canvases in which the vegetation, studied tendril by leaf by flower, writhes under the pressure of the scrutiny directed at it. Rockwell's April Fool covers pushed realism to the point of lunacy. Unlike the charming covers or the cute covers, they exuded a perfumed scent of calculated madness whiffed by the 140,000 readers who rushed to their mailboxes to write to the *Post*. They didn't call it Surrealism but they knew that something very strange was happening right under their noses.

The cover for August 12, 1944, sometimes called *Voyeur* (page 116), carries this tendency to an extreme. The subject is a soldier on leave, spooning with his girl in a Pullman car on a crowded train. The couple has commandeered two facing seats and turned them into a love nest: the shade is lowered and his coat blocks the rest of the window. But their intimate moment is disturbed by two outside forces. The conductor, a slice of whose hand appears at the right edge of the picture, has stopped to punch their tickets. And a little girl—the voyeur—stares fixedly at the lovers over the top of the seat in front of them.

The situation has the potential for good humor, but the child's scrutiny of the man and woman becomes disturbing, largely because of Rockwell's treatment of the forms that make up the storytelling components of the composition. Each strand of hair, for instance, is painted separately and every hair wiggles and twists like a snake in the coiffure of the Medusa. Likewise, the headgear atop the hair possesses a kind of neurotic energy of its own; the mother of the staring child wears a chapeau outlined in fitful contours that double back upon themselves at strange angles in a disquieting way. All the subsidiary characters are represented by hair or hands or hats. Only the voyeur has eyes to watch the lovers—except for a single eye, attached to no one in particular, that stares at the viewer out of the upper right-hand corner. Beginning with *Spellbound* in 1945, the Hollywood films of Alfred Hitchcock popularized the staring-eye motif invented by Salvador Dalí. Rockwell anticipates Hitchcock here, however. And if popular Surrealism appears in its purest form in the postwar horror movie, then Norman Rockwell's creepy little *Voyeur* is surely the prototype for Patty McCormack's macabre demon-child in *The Bad Seed* (1956).

Although he claimed that Lorimer had cured him of the habit, during the 1940s and 1950s Norman Rockwell continued to experiment with stylistic devices in vogue in the fine arts. But the most significant works executed in the years before Rockwell quit the *Post* were original, idiosyncratic canvases that dealt with three nettlesome issues: being an artist, the world of art, and the relationship between image and support. He had always been interested in the first of these themes, to the point of self-consciousness: the many studies of colonial sign painters and silhouette cutters have obvious autobiographical implications. In addition, these pictures of the 1920s and 1930s seemed to assert that being a craftsman (that is, an illustrator) was just fine with Norman Rockwell.

Set against the historical background of World War II, *Tattoo Artist* (1944; page 118) is another entry in the series. Illustrator Mead Schaeffer, Rockwell's companion on the unsuccessful Washington trip of 1942, posed as the "artist"

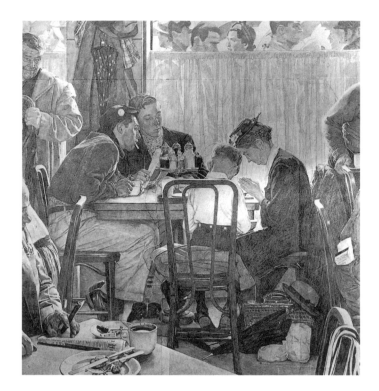

Thanksgiving (Saying Grace)

Study for *Saturday Evening Post* cover, November 24, 1951. Charcoal and pencil, 42 x 41" (106.5 x 104 cm). Curtis Publishing Company, Philadelphia, Pennsylvania

Rockwell tried a number of possible scenes outside the window before he hit on the railroad yard. In part, the decision was made on iconographic grounds. But Rockwell liked the effect of a horizontal scene framed in a horizontal window opening.

Thanksgiving (Saying Grace)

1951. Oil on canvas, 42 x 40" (106.5 x 104 cm). Collection Mr. and Mrs. Kenneth Stuart. (*Saturday Evening Post* cover, November 24, 1951)

In a poll taken by the Post, *this was his best-loved painting. Although the details of the foreground and the still life of hanging coats and hats on the wall of the restaurant are endlessly engaging, this is another instance in which Rockwell distracts attention from his own sermon in paint to concentrate on the foggy day outside the window. The curious push-pull of the background view makes it the active element in the picture. The figures around the table are static and inert by contrast. Rockwell needed bright red seats on the chairs to draw the eye back to the place where the story was being told.*

working intently on the arm of a sailor with a girl in every port. The names of Mimi and Olga and Ming Fu have been crossed out; Schaef is writing "Betty" in the last few inches of biceps that remain. The anecdotes attached to this *Post* offering would fill a small book. Rockwell did his research in New York City, in the Bowery, at the kind of shady, shave-and-tattoo parlor that Reginald Marsh liked to paint in the 1930s; his own desire for a tattoo quickly evaporated when he got a good look at the operator's unsanitary instruments. Schaef, it is said, kept up a running protest against the exaggerated size of his backside in the picture. But the stories cannot obscure the fundamental oddity of what seems, at first glance, to be a straightforward, anecdotal picture. There is no background, for one thing, or rather, no real space. The figures simply hover in front of the tattooist's sample sheet—the heart inscribed "Mother," the frigate under full sail, and the artist's signature: "Norman Rockwell," maker of icons just like these. The flat designs iron out the pictorial space (and widen the model's backside). The scene is an illusion, a construct, as much a work of art as the inscription being written on the sailor's arm. Each one of the sample designs has its own appended text: "Faith"; "Old Pals"; "Oh, you kid!" Art is a process of writing such messages on any available surface, be it an arm or a magazine cover.

Norman Rockwell Painting "The Soda Jerk" (page 119) of 1953 is a painting within a painting. On the easel is a version of the picture that, in fact, appeared on the front of the *Post* on August 22, 1953, casting one of the artist's sons as a gawky boy suddenly fascinating to a bevy of teenage girls because he is in charge of making ice-cream sodas. The finished cover is noteworthy for the photographic cropping of the image on both sides, mimicking a fleeting glance from

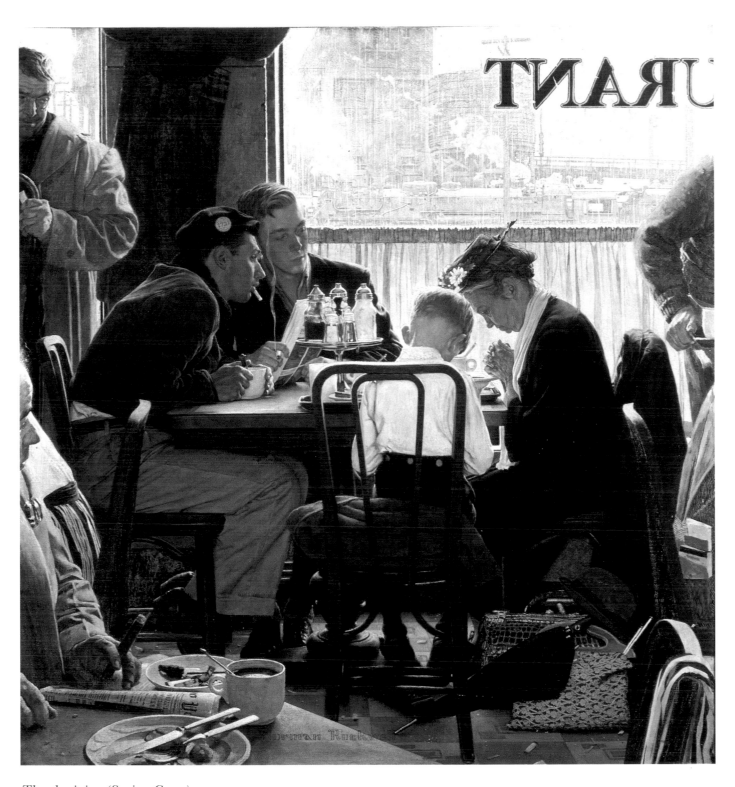

Thanksgiving (Saying Grace)

an observer unnoticed by the actors. Rockwell seems to be hovering above a countertop that swoops through the picture almost straight up and down, compressing the depth of the shop to a matter of an inch or two. But in the version on the easel, cropping and space are less important than texture. The artist's brush makes highly visible strokes and splotches of unmodulated color. The picture, indeed, is less a picture than it is a painted surface—or a painting.

Rockwell renders himself in much smoother strokes, except for the hand reaching across the canvas. He illustrates himself, in other words, but paints his picture, separating one activity from the other; the hand that holds the paintbrush belongs to the domain of art. Although the style of *The Soda Jerk* incorporated into the self-portrait has much in common with the colorful, pretty strain of French Impressionism popular in the United States in the 1950s, *Norman Rockwell Painting "The Soda Jerk"* is a gestural painting, too. In figural guise, it explores the signature brushwork associated with Adolph Gottlieb, Franz Klein, Robert Motherwell, and the contemporary American avant-garde. The lone hand painted in the style of the canvas alludes to the primacy of the Abstract Expressionist brushstroke later parodied by Pop artist Roy Lichtenstein.

The Rockwell-on-Rockwell series reached its climax with *Triple Self-Portrait* (frontispiece) of 1960. Printed as a vignette in the corner of the *Post* cover announcing the first episode of his autobiography, the painting is almost too full of iconographic symbolism for the small size of the reproduction. Rockwell, seen from behind straddling a stool, adopts the pose of *Tattoo Artist*. It is an artless pose, deliberate in its denial of grace and decorum. Rockwell had painted himself this way before; an October 1938 *Post* cover entitled *Deadline* is a cartoonish interpretation of the same posture, with giant, two-toned saddle shoes planted in the foreground, and Rockwell's skinny arms and legs pinwheeled about his torso for the sake of a laugh. In the earlier picture, he perches on his chair like a praying mantis trying to create a *Post* cover with time running out. "This is not a caricature of myself," he wrote of *Deadline* in 1961. "I really look like that." He may have thought so, but it's not the way he portrayed himself a year earlier. The Rockwell of the 1960 self-portrait is thicker through the trunk. He sits heavily on his stool, subject to the laws of gravity. His feet are positioned so that their length is no longer apparent. He is a man of years and dignity. This is a serious reinterpretation of the self-deprecating artists of *Deadline* and *Tattoo Artist*.

Triple Self-Portrait plays with the distance between illusion and reality—the gap between art and life that Pop artist Robert Rauschenberg staked out for his own in 1959. There are seven separate Rockwells here (eight if the artist who painted the others is counted, too): Number One on the stool, looking at Number Two reflected in a mirror propped up on a colonial chair (borrowed from the first *Post* color cover of February 6, 1926, with James Van Brunt as a Revolutionary-era sign painter), while painting Number Three on the easel, with reference studies of Numbers Four, Five, Six, and Seven pinned to one corner of the canvas. Because Rockwell has his back to the viewer, it is impossible to judge the honesty of any of the likenesses; the standards of good illustration do not apply.

No longer compelled to be the funny, skinny kid with the pipe, Rockwell can be anybody he wishes to be. The possibilities are represented by three self-portraits by great artists attached to the opposite corner of the canvas on the easel: Albrecht Dürer, Rembrandt van Rijn, Vincent van Gogh. And there is a fourth, apparently, a Cubist man by Picasso with eyes in unorthodox parts of his face. Except that it is a Picasso woman, c. 1929, all but concealing the artist's lumpish gray self-portrait. Norman Rockwell either mistakes the colorful face in the foreground for Picasso, or doesn't care. The issue is no longer likeness. Rockwell on Picasso. Rockwell as Picasso, adjusting reality according to the imperatives of art.

In the mirror, Rockwell wears glasses, the lenses opaque with fog and reflected light. This was to show, he said, "that I couldn't actually see what I looked like—a homely, lanky fellow—and therefore, I could stretch the truth just a bit and paint myself looking more suave and debonair than I actually am." The Rockwell on the canvas is much younger than the man in the mirror. And he doesn't wear glasses. One man peers into the looking glass. Another is reflected in it. And someone else altogether appears in the work of art. Rockwell paints himself in the center of this visual conundrum, in the existential gap between one illusion and another.

The self-portraits are about art-making. A second series of works, running parallel in time with the first, deals with the work of art in a museum setting. Museums are environments in which Rockwell's characters always find themselves right at home in *Post* covers of the 1940s, fifties, and sixties. The pudgy handyman in *Framed* (1946; page 120), for instance, strolls through the galleries holding an ornate picture frame that just happens to frame his far-from-handsome visage. Museums are good settings for classic Rockwell gags based on the possibility that art and life are almost the same. Thus, on the wall behind the handyman, three paintings—an Impressionist nude, a Flemish burgher, and a three-quarter-length British general—all swivel their painted glances around to look down upon the newest work of art in their midst with expressions of mild curiosity, indignation, and disdain. The "modern art" sculpture that seems to lead the procession of objets d'art of which the workman is a member walks the same way he does—except that the statue is very thin and he is very fat.

Unlike the other paintings in this museum, the workman is larger than his frame; his legs and torso dangle below it and his arms protrude from either side. He literally pops out of the confines of art into the life of a good joke and into the space of the museum where, despite his corpulence, Rockwell allows him to occupy the width of a single checkerboard square on the patterned floor. All of Rockwell's museums have this same floor; the grid of squares repeats the shape of the framed rectangles on the wall. But while the design seems to measure volumetric space, its real function is to make the floor identical with the vertical wall. The design flattens space and renders a fat man no bulkier than a general painted on a two-dimensional surface.

The general's canvas is not painted in the smooth, invisible technique used in most eighteenth-century portraits. The paint application is deliberately

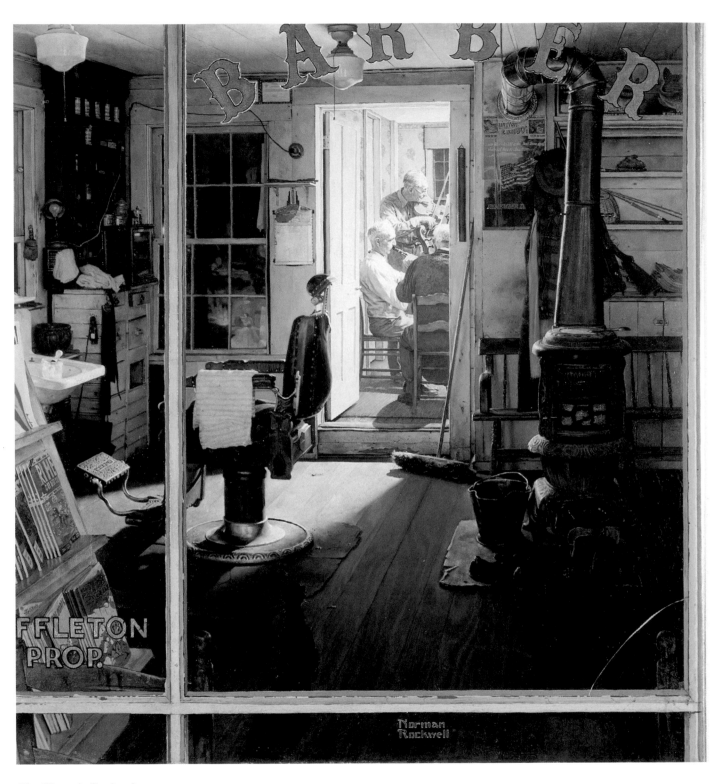

Shuffleton's Barbershop

rough, as if the artist had scrubbed at the surface with a brick (which Rockwell indeed did on occasion). The surface texture is easiest to see on the general's trousers, but the blank white wall, the pale gray handyman's uniform, and the dark gray floor tiles are all treated in a comparable manner. Within the confines of the museum, everything is art. Rockwell signs his name in flowing script atop the baseboard to claim it all for his own: contradictory space, eerie paintings, and nonchalant Norman Rockwell handyman.

Art Critic (1955; page 122) revisits the joke in a corner of the gallery where the Dutch masters of the seventeenth century are on exhibit. In the rough sketch for the cover approved by the *Post*, Jerry Rockwell was a beatnik in sandals looking at blank squares on the wall where Norman planned to add paintings; the scruffy figure of the museum-goer was the focus of the picture. Over the course of working the idea up into a finished cover, however, the paintings took on a life of their own. Rockwell couldn't seem to finish them as pastiches of existing masterpieces and, when he decided to make them into live actors in the scene instead, he spent months on the facial expressions of the framed paintings. The amused Rubensian lady whose locket and bosom are being examined by the art lover and the syndics who watch in disbelief are the new subjects of the picture.

They are positioned above the dado, at the top of the visual field. Below, at the heart of the composition, Rockwell arranges a sort of still life made up of the impedimenta of the aspiring artist: his folding stool, his paint box, a well-thumbed history of art, the museum's catalog, and a palette stained with colors. That palette—art—lies at the center of the picture, like an emblem or a coat of arms. In black and white, the catalog illustrates the Rubens portrait as most art lovers would know it, indifferent to the stares of passersby. But the art in books and the art that comes to life in the emotions of the observer or the painter are two different things. And so the lady lives.

In 1955, *Art Critic* was a charming anachronism. Art students seldom painted copies of old masters: they were more likely to be found gaping at big-name artists in New York's West End Bar or in the Hamptons than subjecting themselves to the scrutiny of Dutch portraits at the Metropolitan Museum. Paintings hardly ever contained lively ladies these days. The average museum-goer—Rockwell's *Connoisseur* (1962; page 110)—had to contend with the drips and splashes of contemporary art instead; indeed, the dapper gentleman in the gray suit is almost swallowed up in the swirl of the pseudo-Pollock he is examining. Unlike most Rockwells, in which the human actor is the focus of the picture and the source of its meaning, the work of art on the wall dominates *Connoisseur*. Created by Norman Rockwell himself with the help of a man who was painting the window frames in his studio as the elderly artist capered around a canvas laid flat on the floor, *Connoisseur* reflects his lively interest in Abstract Expressionism. "If I were a young man, I might paint that way myself," he said. "Recently, I attended some classes in modern art technique and I loved it. . . . I wish I'd had those lessons before I did this cover."

Clearly, the *Connoisseur* has not come to scoff at this newfangled style of painting; he stands close to it, alert in posture, bent backward a little at the waist,

Shuffleton's Barbershop

1950. Oil on canvas, 46½ x 43" (117.5 x 109 cm). The Berkshire Museum, Pittsfield, Massachusetts. (*Saturday Evening Post* cover, April 29, 1950)

Rockwell's masterpiece, Shuffleton's Barbershop, *is also an exercise in making ordinary things profoundly mysterious through the manipulation of light and space. Another view through a room into a different place, this picture is complicated by spaces that seem easy to read but defy all logic. What is going on in the window next to the doorway where the old men are playing their music? What is being reflected in the glass and what is on the other side of it? That door next to the violinist: where does it go? Into the void behind the window?*

Rockwell once told an interviewer that he was a genre painter. Nineteenth-century genre painters like William Sidney Mount painted music-makers in lighted rooms at the back of darkened barns. But the goal was always to create fictive spaces as rational as blueprints. Using the same theme, Rockwell lets space move as it will, often in irrational dimensions that suggest the unknowable nature of nighttime and music and human work.

as if by the force of an invisible gale emanating from the canvas. The spot he conceals from the viewer of the cover seems to be the area where Norman Rockwell's collaborator dumped a whole can of white sash paint at the artist's request: the effect is to create a halo around the figure, a change in the force field of pictorial energy in the spot closest to the man in the bland gray suit. The living man is colorless and still. The picture pulsates with vibrant color. In the unequal contest between art and life, art seems poised to win again.

Connoisseur is something of an anachronism, too, of course. If Rockwell had been intent on keeping up with the avant-garde, he was, in fact, sadly behind the times. Jackson Pollock died in 1956; there were newer stars in Madison Avenue's firmament. But Norman Rockwell was interested in some of the same artistic problems Pollock faced, including the relationship of the image to the canvas on which it rests. Since the Renaissance, the illusion of space in art has occurred behind the picture surface; in Abstract Expressionism, forms seem to escape the picture and sizzle into the air in front of the frame. In *Connoisseur,* this has the paradoxical effect of rendering the human being flat and lifeless while the flat painting on the wall takes on fresh resonance and depth. As the reader of the *Post* watches, the painting enfolds and gradually absorbs the onlooker who serves as the viewer's surrogate in the scene.

In his acknowledged masterpieces of the early 1950s, Rockwell incorporates the spatial complexities of modern art into his own brand of apparently artless realism. In a Pollock drip picture, the painting is the canvas. Many Rockwell compositions of the 1950s and 1960s seem to have been suggested as much by the presence of a rectangle or rectangles within a given scene as by any story line. In other words, Rockwell found a special energy in compositions made up of shapes—often those shapes were paintings or views out windows—that mirrored his working surface in proportion and intention. He painted pictures full of flat pictures (or windows, which amounted to much the same thing). And these views-within-a-view were generally the contested areas of any given canvas.

In the case of the sentimental *Thanksgiving (Saying Grace)* (1951; page 127), the most popular Rockwell of his time, he changed the scene framed by the window of the lunch counter repeatedly. First, it was a flower garden; next, a phalanx of hurrying pedestrians; and finally, a railroad yard, cold and sullen in the rain. The changes affected the meaning of the old lady and the little boy praying in the restaurant. When Edward Hopper painted studies of private emotions on display in public places, he stripped interiors bare of complexity to reveal the inner dilemma of the sitter: his windows looked out upon obdurate sheets of color. Rockwell, on the other hand, used windows to locate his scenes in the geography of a story. The windows identify happy places, sad places, home. But he was constantly bedeviled by the spatial paradox presented by such views. Instead of plunging the eye into deep space, the framed view often has the opposite effect. Full of light and air, it struggles back toward the surface and the viewer, overpowering and diminishing the pious scene to which it was intended as a mere grace note.

In *Shuffleton's Barbershop* (1950; page 130), Rockwell looks through a window into a darkened interior, and beyond that, into a luminous back room, where the old musicians play in the after-hours quiet. This is the sort of convoluted conceit that was a specialty of the American genre painter William Sidney Mount in the nineteenth century: a subject that must contrive to evoke what the ear hears through what the eye sees; the focus—the spiritual "here"— over there, far away, in deep space. But it is also a spatial puzzle made up entirely of tall rectangles, just like Rockwell's canvas. Some are transparent, like the picture plane itself, coextensive with Shuffleton's front window, bearing his name and Rockwell's, or the second darkened window in the middle distance, which reflects back phantom objects, nowhere seen inside the shop. Some rectangles are placed at an oblique angle to the plate glass, like the comic books, and the footrest of the barber chair. Some are voids, openings: the door into the back room and a second door, inside, into another lighted chamber.

Suddenly, everything has its double, its doppelgänger. Two open doors. The back window of the shop. The back window of the back room. What is there is really here, and vice versa. Reality slips sideways a notch, disclosing art. Trompe l'oeil: the eye is truly fooled. The act of seeing creates a secret space, unknowable for all its banality, neither here nor there.

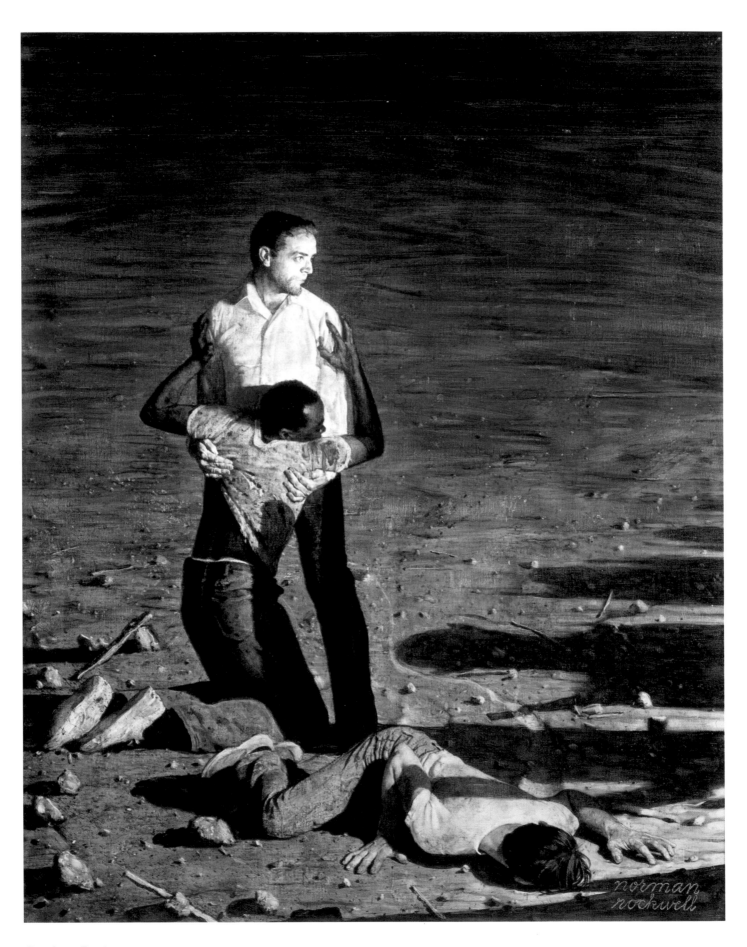

Southern Justice

7. The "New" Norman Rockwell

T here were two Norman Rockwells, according to a 1970 review of his work in the Christmas issue of *Good Housekeeping*. The old Rockwell gave the world Santas and kids and the sad-funny problems of daily life. The old Rockwell painted grandmothers saying grace in railroad restaurants, vintage 1951. And he painted them for the *Saturday Evening Post*. The *Post* was his employer, his cheerleader, and custodian of a growing body of Rockwell mythology. The picture with the praying grandmother, said art editor Ken Stuart, came from an incident he had witnessed with his children at the Juniper Street Automat in Philadelphia after a matinee concert: there, in the midst of the bustle, they had seen an Amish family, heads bowed in grace. He planned to tell Rockwell but Norman, in the meantime, had worked up a sketch based on the same incident at the suggestion of a reader from West Philadelphia who had been there, too. Coincidence? Serendipity? Maybe. But the stories seemed to suggest that Norman Rockwell and the *Post* were connected on some deeper, mystical level.

The new Norman Rockwell worked for *Look*. He wasn't a cover artist anymore, selling magazines with pleasantries and quips. He was an inside-the-book man now, concerned with social problems and politics and the space program. He painted "big" pictures, like the Four Freedoms series from World War II— works that tackled important themes with passion and urgency. Instead of grandmothers at prayer, his subject was the civil rights movement. *The Problem We All Live With* (page 142), a special foldout that appeared in *Look* on January 14, 1964, commemorated the tenth anniversary of the Supreme Court's *Brown v. Board of Education of Topeka* decision on school desegregation. Ten years after the fact, integration was still being opposed in the South. According to the therapist who worked with the child, Rockwell's picture showed Ruby Bridges, a first-grader at the William Frantz Primary School in New Orleans, being escorted past a jeering mob by federal marshals in 1960. Behind her, on the splattered wall, a racial epithet bleeds through the whitewash. Beneath her white sneakers, Rockwell's name runs across the sidewalk in tidy script. The "n" in Norman is a positive version of the "n" in "Nigger" still visible on the wall. Ruby Bridges was the little heroine of *Children of Crisis*, a new book by child psychiatrist Robert Coles, published in 1964. And psychiatry gave a name to the identity crisis that turned the old Norman Rockwell into a new Rockwell, beginning in 1953.

In the fall of 1953, Norman and Mary Rockwell suddenly moved from Arlington to Stockbridge, Massachusetts. The shift has always been something of a mystery. The artist had been a mainstay of the Vermont community for fourteen years, his three sons had been raised there, and he had an intimate circle

Southern Justice

Unpublished version of *Look* illustration, June 29, 1965. Oil on canvas, 53 x 42" (134.5 x 106.5 cm). The Norman Rockwell Museum at Stockbridge, Massachusetts

Although Look *printed the sketch, with its indistinct faces and slashing brushwork, the version Rockwell preferred is more chilling because James Chaney, Michael Schwerner, and Andrew Goodman, who had been murdered in the summer of 1964 for their activism on behalf of civil rights in Mississippi, are real people. The landscape is as surreal as the face of the moon, however. When Rockwell came to paint the lunar surface several years later, he used the same long inky shadows and odd bits of rubble studied so closely—too closely—as to burn the scene into consciousness.*

Portrait of Erik Erikson

1962. Charcoal on paper, 17 x 14" (43 x 35.5 cm).
Private collection

Similar in style to Erikson's own pencil portraits, this drawing depicts Rockwell's analyst and friend, who became a major influence on his choice of subject matter during the 1950s and 1960s. The "identity crisis," which Erikson studied, is directly reflected in Rockwell's many pictures of artists. Erikson was also a student of racial prejudice and its effects on the personality. This would be the subject of Rockwell's "big" civil rights pictures of the period.

of friends and fellow artists in the vicinity. Yet he packed up and moved without, it seemed, a backward glance. Their son Tom, in a recent foreword to a new edition of his father's autobiography, addresses some of the personal matters omitted from that book, including Mary Rockwell's ongoing "struggles with alcohol and other problems." Her anxieties led to a course of treatment at the Austen Riggs Center in Stockbridge and a hard, hundred-mile commute on narrow New England back roads. With snow season fast approaching, the Rockwells thought it best to spend the winter of 1953–54 in a clinic-owned inn nearby. Come spring, they decided to stay.

Founded in 1919 by Dr. Austen Fox Riggs as the Stockbridge Institute for the Study and Treatment of Psychoneuroses, the center was a private clinic offering a highly personalized regimen that worked best when the patient elected to live in town. Because the emphasis was on neurotic illnesses rather than full-blown psychoses, those who came to the clinic were treated as guests in a social setting that encouraged informal exchanges between therapists, patients, and families, between outpatients and the Stockbridge community. Therapy leaned heavily on the arts, including painting in oils and watercolor.

When the Rockwells came to Stockbridge, Mary's husband was also in the throes of what was probably a bout of recurring depression. Rockwell describes several such episodes in his working life, each one characterized by restlessness, a loss of confidence, and a firm conviction that he would never work again. Throughout 1953, he confessed, "I sank deeper into the muck. I was dissatisfied, doubted my ability; decisions made in the morning evaporated by three o'clock. . . . Among those I listened to were several psychiatrists from the Austen Riggs Center. . . . And that, finally, was how I recovered from the crisis." Rockwell's emotional problems would properly be nobody's business but his own were it not for the influence of psychiatry and the Austen Riggs Center on his changing perceptions of art and American society. Norman Rockwell credited his ability to work through the 1953 crisis—and his aversion to reaching into a tired bag of tricks one more time for long-term clients like the *Post*—to Erik H. Erikson, a psychoanalyst and senior staff member at the center. "I wasn't mentally ill or anything like that," Rockwell was quick to point out. "But you don't have to be desperately sick . . . before you call a doctor. I sure owe a lot to Erik Erikson." Erikson became his doctor, his mentor, and his lifelong friend.

A German-born amateur artist who came to Stockbridge in 1950, Erikson had worked with Anna Freud in Vienna in the 1920s. With the rise of Hitler, he emigrated to Boston and became that city's first child analyst. *Childhood and Society* (1950) asserted that black children in white America had lost their sense of identity. Convinced of their own inferiority by a racist culture, wrote Erikson, they had come to hate themselves. His work during the 1950s, and that of his colleagues and students at the Riggs Center, was dominated by three themes: creativity in middle life; psychohistory, aimed at learning how an identity crisis can lead to self-discovery; and the civil rights movement. In other words, just as Norman Rockwell was undergoing his crisis, Erickson was wrestling with the problem of how Martin Luther had used a similar life episode to free himself from

the authority of a rigid medieval church. In Rockwell's case, the omniscient church was the *Saturday Evening Post*. Lorimer had once instructed Rockwell not to put "colored people" on his covers unless they were performing menial tasks. Another imperious editor, in 1949, had a key detail painted out of one of his cover pictures without telling the artist about it.

Rockwell's crises of confidence in the 1950s coincided with more troubles at the *Post* and in June 1963 it was with the backing of the center's staff that he made a final break with the magazine. "I write this letter only after a lot of thought and consultation with my doctor, Frank Paddock, and my friend, Dr. Howard, who is a psychiatrist on the senior staff of the Riggs Foundation," Rockwell told the *Post*. Dr. Paddock, who wrote an article on Rockwell's "hidden side" for the revived *Post* in 1988, spoke guardedly about his patient's depression. But Paddock did use his civil rights paintings to illustrate Norman Rockwell's sensitivity and occasional moments of despair over the imperfect America that rarely marred the pages of the *Saturday Evening Post*. In notes for the 1963 speech in which Rockwell announced his turn to activism, the artist also made an implicit connection between his new iconography, Erik Erikson, and the Austen Riggs Center. "There was change in the thought climate in America brought on by scientific advance, the atom bomb, two world wars, and Mr. Freud and psychology," Rockwell concluded. "Now I am wildly excited about painting contemporary subjects . . . pictures about civil rights, astronauts, . . . poverty programs. It is wonderful."

The Problem We All Live With was a radical departure for an artist who had painted African Americans infrequently before World War II, and then only when the text demanded it. In the 1930s, for example, the Mark Twain illustrations called for a black Jim; as shown by Rockwell in extreme foreshortening, he was a grotesque figure of minstrel-show origin. More interesting was a two-page color spread in *American Magazine* (page 139) in 1936, accompanying a Kenneth Perkins short story entitled "Love Ouanga." A dialogue piece set in New Orleans, "Love Ouanga" deals with Spice Mackson, a pretty quadroon and mother of an illegitimate child, who is about to be run out of town by her lover's father, a prominent ghetto politician. The Boss wants more for his son than Spice. And she, in desperation, seeks refuge in a church where the presence of a fancy woman attracts much notice among the pious. "Spice slumped on a bench," Perkins writes. "The Blood of the Lamb Congregation gaped and wondered. A city gal sho' nuff—what did she want with them?"

The story and the appended illustration do not stand up to close scrutiny, constructed as they are out of a grab bag of racial stereotypes, condescension, and the operative American belief that the sorts of people who neither wrote for the big magazines nor read them were liable to be picturesque. In the 1920s and 1930s, in the eyes of white observers, black culture represented a kind of homegrown exoticism anyway. *Porgy and Bess*, Marc Connelly's *The Green Pastures*, and the *Amos 'n' Andy* show on the radio all presented Spice Mackson—or somebody just like her—as profoundly alien in speech and mores, in appearance and attitude. Rockwell distinguished himself from his contemporaries in this instance

Analyst with Patient

After 1953. Pencil on paper, 3¾ x 4½" (9.5 x 11.5 cm). The Norman Rockwell Museum at Stockbridge, Massachusetts

In November of 1953, Norman and Mary Rockwell moved to Stockbridge, where Mary underwent a course of treatment at the Austen Riggs Center. Suffering from the depression that surfaced periodically throughout his life, Norman Rockwell also sought treatment at the center.

Roadblock

1949. Oil on canvas, 30 x 23" (76 x 58.5 cm). Collection Philip M. Grace. (*Saturday Evening Post* cover, July 9, 1949)

The restlessness associated with Rockwell's depression drove him to the West Coast often during the 1940s. A Freudian could find ample food for thought in the image of the alley (near Seventh Street and Rampart Boulevard in Los Angeles) blocked by the moving van. Rockwell's consuming interest in the persona of the artist is also shown at the left, as the painter and his model lean out the window to offer advice; sketches hang from a line affixed to the studio casement.

by painting one of his only truly beautiful women for the story of the New Orleans quadroon in *American Magazine*.

After World War II, the few African Americans who appeared on Rockwell's covers were Pullman porters and waiters. During the war, however, when Rockwell attempted self-defined compositions dealing with the great public issues of the day, his independent vision was more inclusive. The black woman at prayer in the corner of *Freedom to Worship* moved the head of the Bronx Inter-Racial Conference to ask Rockwell for a companion series on the subject of race relations in America. He should paint a group of works like the Four Freedoms but showing the contributions of blacks to the common good, wrote Roderick Stephens; it would be "a contribution of unmeasurable significance to the nation of today and the world of tomorrow." Recent race riots in Detroit, Houston, and Los Angeles had exposed a lack of tolerance for difference. Rockwell's *Freedom to Worship* was still a dream unfulfilled. Much of black America, Stephens concluded, still lived in want and fear.

Rockwell corresponded with Stephens but the project melted away in peacetime. As the soldiers who fought for the Four Freedoms came home, settled down in the suburbs, and went back to their civilian jobs, Rockwell went with them. He painted some of his most memorable covers in the years after World War II,

works that openly explore texture, light, and the new points of view made possible by the camera. But Rockwell seemed constantly to be rethinking the distance between great art and his own weekly ephemera: he returned time and again to the theme of the painting within a painting, in which he asserted his kinship with the Dutch masters, with Vincent van Gogh, and finally, with Jackson Pollock. Ironically, it seems to have been this long retreat into the world of art that triggered a renewed interest in society, in social problems, the social responsibilities of the artist—and civil rights. Important painters, after all, tackled important subjects. What he called "the big picture . . . tremendously conceived and tremendously executed," still appealed to Rockwell's self-confessed "hankering after immortality."

The big-picture bug bit Rockwell again in 1953. The result was *The Golden Rule,* a 1961 *Post* cover begun as a tribute to the United Nations, with his long-suffering Vermont neighbors as models. The original project had foundered on the shoals of postwar tensions; the various U.N. delegates once pictured along the bottom edge of the composition, with the peoples of the world symbolically massed behind them, came and went with each new diplomatic crisis and, after five months of work, an exasperated Rockwell gave up on the picture. In 1961, now living in Stockbridge, he resurrected the preparatory sketches and photographs, squared up the composition, got rid of the U.N., and put his wife Mary, who had died suddenly in 1959, in the top right-hand corner. And, in golden letters reminiscent of the text in *Freedom to Worship,* Rockwell inscribed the canvas with a paraphrase from the biblical story of the Good Samaritan, urging universal tolerance. As if to prove his point, he added, in the corner diagonally opposite his late wife, a little black girl clutching her schoolbooks.

Love Ouanga

1936. Oil on canvas, 30 x 62" (76 x 157.5 cm). Private collection. Photo courtesy the American Illustrators Gallery, New York City. (*American Magazine* illustration, June 1936)

Before 1953, Rockwell had used black subject matter sparingly. One exception was this illustration for a short story by Kenneth Perkins. The story is full of minstrel-show accents and picturesque atmosphere. The picture is saved from the same fate by Rockwell's attentiveness to the lovely heroine in the red dress, one of his only truly beautiful women.

Another version of *Freedom to Worship, The Golden Rule* errs on the side of bombast. Dressed in colorful costumes and blessed with faces of an impeccable beauty, Rockwell's multiracial, central-casting characters do their best to look godly and meaningful as they confront the viewer and the hovering motto. If they fail to convince, it is the fault of the artist's overblown solemnity and earnestness. Nonetheless, *The Golden Rule* was treated as a big picture in some quarters. Rockwell won an award for it from the National Council of Christians and Jews. The State Department made a movie about the painting to show how diverse and harmonious America really was, despite the awful wire service photos of white parents shrieking obscenities at black children trying to go to integrated schools.

The Problem We All Live With faces that reality directly. As such, it is the first painting by the new Rockwell and the big picture of his dreams. It is also a confession of his own sins. "I was born a white Protestant with some prejudices which I am continuously trying to eradicate," he admitted to *Esquire* in 1962. "I am angry at unjust prejudices, in other people or myself." A depiction of an African-American child being walked to school by four burly escorts, with the prejudice of others spelled out on the wall behind her, *The Problem We All Live With* did not illustrate the words of a *Look* story in January of 1964. The picture was part of an issue devoted to the question of "How We Live." Most of the articles dealt with middle-class affluence, the housing boom, and the ongoing battle between traditional and modern design. Suburban schools, ghettoization, token integration, and white flight were also discussed, albeit in less detail. There was a paragraph on redlining, or the practice of denying equal opportunity in housing to members of minority groups. "What the Negro wants, " said *Look*, "is the right to take his chances like the rest of us in this democracy, and move wherever his ability can take him." Tom Rockwell insists that his apolitical father was deeply committed to only two causes in his lifetime: the Nuclear Test Ban Treaty and civil rights for black Americans.

Norman Rockwell used the opportunity afforded by *Look* to commemorate the fight for school integration because he knew about it at first hand, from his association with the Erikson circle in Stockbridge. Much of the evidence presented to the Supreme Court in 1953 in the *Brown* case, for instance, came from a body of data to which Erikson and his colleagues had made important contributions. In that landmark case, the NAACP argued that the psychological and intellectual damage inflicted by segregation precluded equality. Black psychologist Kenneth Clark was asked to conduct a doll experiment in the segregated schools of Clarendon County, South Carolina. In the study, Clark showed black and white dolls to sixteen African-American students. Confirming the conclusions of Erikson's *Childhood and Society,* most of the black students described the black doll as "bad" and were deeply disturbed when asked to identify with the toy that matched their own skin color. When, on the basis of such tests, the court ruled in favor of the Kansas minister whose child had been barred from a white school near her home, psychology became the nation's conscience.

And conscience became politics and activism. Robert Coles, in the introduction to a recent collection of his writings, describes his own conversion from

theory to participation under the influence of Erik Erikson and the latter's field studies of young children caught up in real-life situations. In 1960, doing a residency in the South, Coles saw, admired, and finally worked with Ruby Bridges, a six-year-old who integrated the New Orleans school system in the first important test of the federal government's will to enforce *Brown*.

It all began in the fall of 1960, when New Orleans grudgingly implemented an integration plan at two elementary schools. Many black applicants were rejected or scared off. Finally, only four little girls and their families remained as the targets of explosive white rage. Three of the girls went to McDonogh School No. 19. One, Ruby Bridges, went to the Frantz School—all alone. And to enter the building with her cadre of guards each morning, she had to pass a mob of screaming mothers, teenagers, and hangers-on, shouting obscenities and death threats. In *Children of Crisis,* Robert Coles describes how he played with Ruby after school, learning how the ordeal was affecting the child through analysis of her drawings. When she rendered white children, they were large and lifelike; her self-portraits were small, often missing limbs and fingers.

The notion that art—child art, in this case—can be revelatory and therapeutic echoed the philosophy of the Riggs Center. But Coles was less interested in the obvious conclusion (that her art showed the damage segregation could do to a child) than in Ruby Bridges's moral courage in facing the mob. This was his special contribution to the story of the civil rights movement—and the subject of Rockwell's picture. Rockwell knew Coles. One of the few books he illustrated, taking his cue from somebody else's words, was *Dead End School,* a 1968 children's story by Coles, a work of fiction describing the successful drive for the integration of a neighborhood school. In 1963, Coles had written a much-discussed preliminary report on his work in New Orleans. *The Desegregation of Southern Schools: A Psychiatric Study* contained the conclusions from his work with Ruby Bridges and some details of her story, without names or anecdotes. It is not a text for *The Problem We All Live With* in the classic sense. But Coles's work was the spiritual force behind Rockwell's big picture.

The model was Lynda Gunn. In almost-white Stockbridge, Lynda was the natural choice: she was the only black student at the local elementary school. Her grandfather, David Gunn, had already posed for Rockwell. The first black man to serve as athletic director of a white private school in New England—the Lenox School—Gunn was a Stockbridge native and a great-grandson of Agrippa Hull, who had served in the Revolutionary War as General Kosciusko's valet. He was proud of his granddaughter's role in Rockwell's great work. But for Lynda, it was nothing special. The nine-year-old walked to Mr. Rockwell's house after school every afternoon for a week and posed all by herself; the marshals were added later. "He used two pieces of wood to position my feet," she recalled, "and showed me how to stand. It was hard for me to be still, but he worked around that." She liked the picture afterward, except for the pigtail: "I didn't wear my hair that way. He got that hairstyle himself—I don't know from where." The pigtail may have been Rockwell's device for showing the hair ribbon mentioned in all the newspaper accounts of Ruby's first day at the Frantz School. Or, by giv-

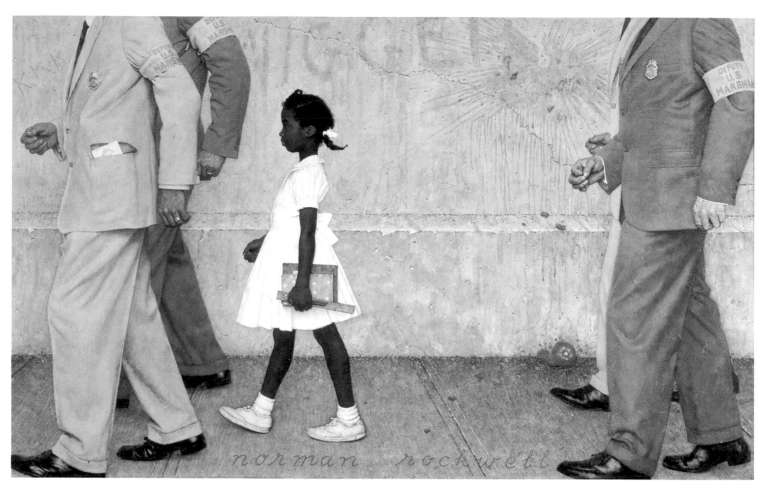

The Problem We All Live With

1964. Oil on canvas, 36 x 58" (91.5 x 147.5 cm).
The Norman Rockwell Museum at Stockbridge,
Massachusetts. (*Look* illustration,
January 14, 1964)

*The little girl is Ruby Bridges, who sin-
gle-handedly integrated an elementary
school in New Orleans in 1960 in the
face of death threats and cruel taunts.
Based on child psychiatrist Robert Coles's
study of Ruby's drawings and a descrip-
tion of the episode in John Steinbeck's*
Travels with Charlie, *this painting is the
"new," activist Rockwell at his best. The
details—the books, the ruler, the two
sharpened pencils, the paper in the mar-
shal's pocket marked with an official
seal, the badges—are almost clear
enough for the viewer to read the words
and numbers. That's the old Rockwell,
involving the viewer in the story through
details plucked from our common life
experience.*

The Problem We All Live With

Study for *Look* illustration, January 14, 1964. Oil on
board, 13 x 20½" (33 x 52.5 cm). The Norman
Rockwell Museum at Stockbridge, Massachusetts

*In the color study for the painting, the
white hair bow is shown on the top of
Ruby's head, as it was in the wire service
photos of the first day of school in New
Orleans in 1960. Rockwell had done his
homework.*

Like the Post *during World War II,*
Look *took advantage of Rockwell's con-
siderable skills as a documentarist. But
Rockwell never took reality as it was
given. The difference between the study
and the painting shows him rearranging
forms for effect. The child's fear is harder
to bear when she moves closer to the lead
guards for protection.*

THE "NEW" NORMAN ROCKWELL

New Kids in the Neighborhood

1967. Oil on canvas, 36½ x 57½" (91.5 x 146 cm). The Norman Rockwell Museum at Stockbridge, Massachusetts. (*Look* illustration, May 16, 1967)

Norman Rockwell integrates the America he has always painted by the simple expedient of being color-blind. It's moving day but kids are kids and pets are pets: wary and a little frightened. The sneakers and the ball gloves are the common denominator of an American childhood. The new Rockwell persists in being old-fashioned about his favorite topic.

Blood Brothers

Study for painting once in the collection of the Congress of Racial Equality, c. 1965–68. Oil on canvas

In the light of the Vietnam War—which Rockwell opposed—this study of two young men of different races united in death takes on a deeper meaning.

ing Lynda Gunn a brave and jaunty pigtail, perhaps Rockwell was saying something about Ruby's courage, as she marched along in step with four huge men.

The incident is best described in John Steinbeck's *Travels with Charlie,* published in 1962, and already in its fourth printing by Christmas. Steinbeck's book was Rockwell's kind of book, a series of stories—parables, really—drawn from a cross-country trip: the writer, his truck, and his dog, Charlie. In New Orleans, he went to see the "Cheerleaders," the semi-permanent mob encamped around

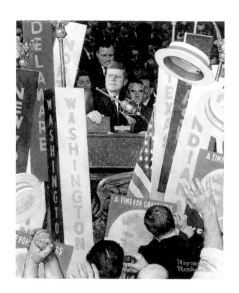

A Time for Greatness

1964. Oil on canvas, 41 x 33" (104 x 84 cm). Private collection. (*Look* cover, July 14, 1964)

Rockwell was a great admirer of the young John F. Kennedy, whom he painted for Look *as a presidential candidate in 1960. In this convention scene, painted long after the election—and Kennedy's assassination—Rockwell aimed to recapture the idealism and hope that had begun to wane toward the middle of the decade. As he had done in his own self-portrait of 1960, Rockwell compares the image of Kennedy on the campaign posters with the real person, an older version of Kennedy, in fact, at the podium.*

The podium is covered with swirls of brushwork. Working from photographs made it especially crucial to find and maintain the contour. Often, an assistant completed the mechanical transfer of the image to the canvas, using a Balopticon or projector. When Rockwell began to paint, he was careful to avoid brushing away the charcoal outlines so his brushwork often puddled up in complex patterns within outlined areas.

the Frantz School, much as a tourist would visit Antoine's or the French Quarter. And he saw a terrible piece of street theater. "The show opened on time," Steinbeck wrote. "The crowd seemed to hold its breath. Four big marshals got out of each car and from somewhere in the automobiles they extracted the littlest Negro girl you ever saw, dressed in shining starchy white, with new white shoes on feet so little they were almost round. . . . The little girl did not look at the howling crowd but from the side the whites of her eyes showed like those of a frightened fawn. The men turned her around like a doll, and then the strange procession moved up the broad walk toward the school, and the child was even more a mite because the men were so big."

That's Rockwell's *The Problem We All Live With*. The white starched dress. The new white sneakers. The spots of white in her eyes. The broad sidewalk: all Steinbeck's. In the color study for the picture, Ruby Bridges is even smaller and frailer, but in both cases Rockwell uses the bulk and stature of the marshals to emphasize her tiny size. By decapitating her guardians at the top of the canvas, the artist also hints at the violence and danger of the scene, otherwise muted in the whitewashed racial slur on the wall behind her and the faint tracings of the letters "K. K. K." The tomato is the only real touch of color—bloodred against the wall, with a trail of pulp following Ruby along the pavement.

Rockwell never said much about the painting, except to observe that in Russia, which he visited several times, "they thought she was being taken *out* of school." But the anecdote led him to meditate on the changes that had overtaken Norman Rockwell's America. Were the old days of the *Post* covers really that much better? "Yes," he said, speaking like a true follower of Erik Erikson. "But only because we pushed our problems and prejudices under the rug. Now they're out in the open. That's probably better because now we can try to solve them." And for the rest of the 1960s, he continued to drag the horror of prejudice into the light of day in the pages of *Look*. *New Kids in the Neighborhood* (1967), created to accompany an investigative article on black settlement in the suburbs, is the old Rockwell looking at a new problem; the topic of cute kids and their pets admits of no meaningful distinctions between black (the dog) and white (the cat). *Southern Justice* (1965) protested the murder of three Freedom Riders outside Philadelphia, Mississippi, in the summer of 1964 in an image so powerful that *Look* chose to print the sketch—raw with blood and anguish—instead of the quieter finished version. *Blood Brothers* (page 143), from the same series, shows two young men lying dead, side by side, one black, the other white, as if to suggest that death alone erases prejudice.

In a retrospective interview for the *New York Times Magazine* in 1971, Richard Reeves asked Rockwell about the civil rights pictures. He was shocked that the old man had done them in the first place; Rockwell, he thought, was more like a cobbler than an artist, eager to please, most at home with other people's ideas—"his great and sad flaw." His "short black period" in the 1960s, Reeves sneered, happened only when race "was finally fashionable." And Rockwell, polite as always and a little dispirited by the drift of the conversation, seemed ready to agree with his relentless questioner. "I was doing the racial thing for a

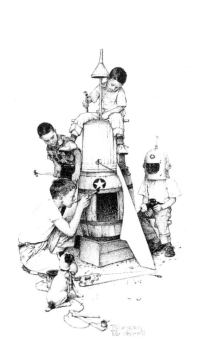

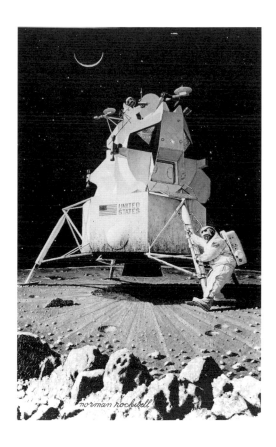

Spaceship

c. 1959–60. Pencil on paper, 21 x 13" (53 x 33 cm). Connecticut Valley Historical Museum, gift of Massachusetts Mutual Life Insurance Company. (Ad for Massachusetts Mutual Life Insurance Company)

Rockwell's new interests—in this case, the space program, and its inspiring effect on children—spilled out of his Look *paintings into his strictly commercial work. A series of drawings for ads commissioned by the Massachusetts Mutual Life Insurance Company invited Rockwell to prove himself as a genre painter: the object was not a joke or even a smile but close observation of life as it was lived in the homes and backyards of the company's customers.*

while. But that's deadly now—nobody wants it." But the truth was that Rockwell knew what it meant to please an audience and was willing not to do so. "I couldn't paint [the Four Freedoms] today," he added. "I just don't believe it. I was doing this best of [all] possible worlds. And I liked it, but now I'm sick of it." He told of being invited down to the Marine base at Quantico, Virginia, and commissioned to do a portrait of a Marine in Vietnam kneeling over to help a wounded villager. A very big picture. He thought about it a lot. And turned the job down.

There were occasional bright spots in an America that otherwise seemed cruel and false. The Kennedy administration raised Rockwell's hopes for the future. He admired the Peace Corps and the space program. In 1967, using a simulated lunar landscape at the Manned Space Flight Center in Houston, he painted what the world would soon see in fuzzy television images when Neil Armstrong set foot on the moon. The old artist saw tomorrow more clearly than the cameras and the networks did: the landing vehicle, with an American flag emblazoned on its hull, gleamed in a eerie sunlight untempered by earthly air or weather. The future was bright and crisp, like the flag that flew over the landscape of the moon.

But the promises of the sixties evaporated with the decade. People liked the old Rockwell covers now, the old gags, the kids, the dogs. People longed for the security of the past. "These days everyone is a little frightened and they want those good-natured human pictures again," he told *Good Housekeeping* in 1976, the nation's bicentennial year. Were the good old days really better? "Yes, I would say so," Rockwell replied. "We laughed a lot more in the old days. . . ."

Man on the Moon

1967. Oil on canvas, 71 x 46" (180 x 117 cm). National Air and Space Museum, Smithsonian Institution, Washington, D.C. (*Look* illustration, January 10, 1967)

The last frontier—John F. Kennedy's "New Frontier"—space travel was an adventure that moved Rockwell deeply. In some of his earliest Post *covers, Rockwell had poked fun at the first automobilists; now, in his old age, Americans were about to fly to the moon. Rockwell made the trip to the Manned Space Flight Center in Houston to see the equipment and study how the astronauts trained. Departing from the massed portrait format used in many of his late "big" pictures, Rockwell concentrates here on the alien splendor of the lunar landscape. He worked with scientific illustrator Pierre Mion to get the topography of the moon right, but the use of hyperreal detail to establish a bond with the viewer, even when the scene is unfamiliar, is one of Rockwell's oldest tricks. The insistent frontality of the composition lends weight and conviction to a view of the moon painted before Armstrong actually landed there.*

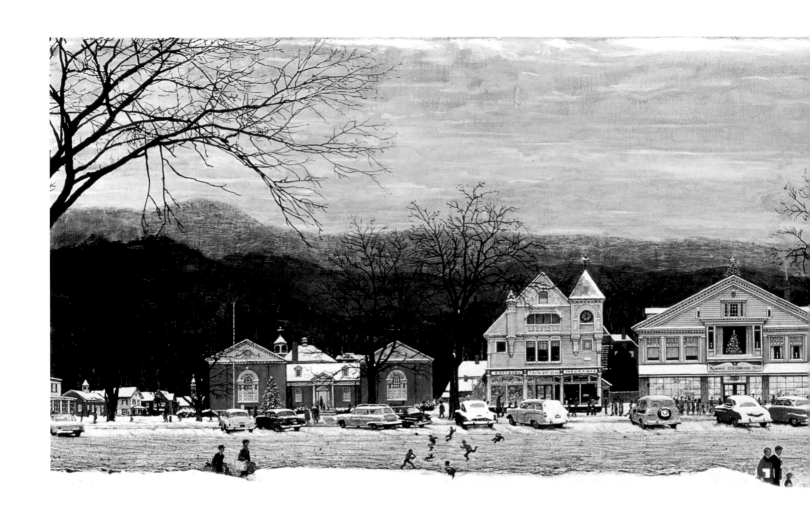

Postscript: Winter in Stockbridge

In 1967, for the December issue of *McCall's* magazine, Norman Rockwell painted a long, narrow picture of Stockbridge, Massachusetts, in the snow. A topographical view, in the manner of nineteenth-century prints that aimed to make every small town into a new Rome or Athens, Rockwell's picture was unlike anything he had done before. It was almost six feet long, for one thing. His *Look* pictures were equally detailed, but they dealt with important national and world events; the east side of Main Street seemed pretty ordinary fare.

At the right stood the Red Lion Inn, closed for the winter, and beyond it, the junction with South Street, Route 7. Next to the inn on the other side was the bank, all columns and classicism; the old town hall, which looked like a church; the barbershop; Williams & Sons Country Store; and the grocery. An antique shop. The library. And finally, Elm Street with the Old Corner House at the turning. A car skidded down the snowy street with a tree lashed to the roof. In the big, triple-pane window over the grocery store, a Christmas tree decorated with lights and ornaments winked season's greetings at the street below. Rockwell called the scene *Home for Christmas*.

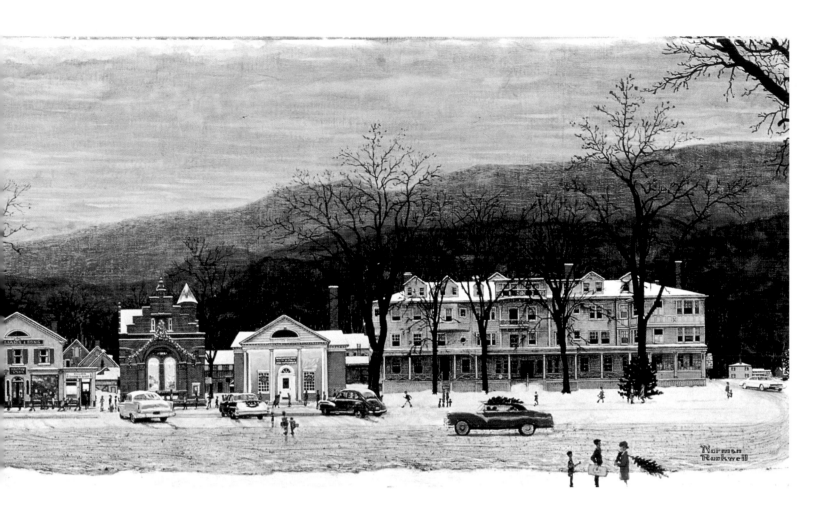

A year after the picture was painted, Rockwell and some friends concluded negotiations to buy the Old Corner House, intending to turn it into a museum of Stockbridge history. The exhibits proved uninteresting to the tourist traffic that crowded New England's ancient Main Streets every year from Memorial Day until the leaves finally fell. So Norman lent his paintings instead—and the venture prospered. Route 7 was where he rode his bike every day for exercise, in the company of Molly Punderson, a retired schoolteacher who became the third Mrs. Rockwell in 1961; local motorists had learned to slow down and steer carefully around the old couple. At the very edge of the picture, past the Red Lion Inn, was the Rockwells' driveway and at the end of the drive, their white house and Norman's little red studio. The upstairs window in the grocery store, where the Christmas tree beamed down on Main Street, was Rockwell's doing, too: the room had been his first studio in Stockbridge. In a sense, *Home for Christmas* is another self-portrait of Norman Rockwell, the leading citizen of Stockbridge—an autobiography written in architectural landmarks.

In 1967, Stockbridge and Norman Rockwell became a single entity, an embodiment of some ineffable something America pined for. Warmth. Antiqui-

Home for Christmas

1967. Oil on canvas, 26½ x 95½' (67.5 x 242.5 cm). The Norman Rockwell Museum at Stockbridge, Massachusetts. (*McCall's* illustration, December 1967)

Autobiography disguised as topography, this painting shows local landmarks important to Norman Rockwell. His house and studio are at the extreme right. The big second-floor window framing the Christmas tree marks Rockwell's first Stockbridge studio: he had had the window installed himself. In the 1960s and early 1970s, the peaceful old New England town came to define home for a nation that seemed to have lost its way in the hot pursuit of anything new. The venerable Norman Rockwell sang a chorus of "Yankee Doodle" in counterpoint to the raucous anthems of the Woodstock generation.

ty. Changeless, timeless rightness. Or, as *McCall's* put it, in the written introduction to Rockwell's painting, "the feeling of coming home for Christmas." The horizontality of the scene, sheltered in the embrace of the Berkshires, exuded a quiet, contented peace. And peace was in short supply elsewhere that year. War protesters marched on Washington. Race riots broke out in Cleveland, Detroit, and Boston. Three astronauts burned to death on the ground when fire swept through their Saturn rocket. But in Stockbridge, the snow fell, the wreaths and lights went up, and Christmas came right on schedule, wrapped in a blanket of heavenly peace.

Throughout the early seventies, filmmakers, reporters, and tourists came to Stockbridge to see the nation's past in the flesh, to visit the old man who still went to work in his studio every day in a town as venerable as himself. Norman Rockwell and Stockbridge: they both seemed to be preserved in the crisp New England air, living relics of a simpler time. In Rockwell's seventy-eighth spring, *Look* came calling and found him less interested in "big" idea pictures now, although he still talked over the events of the day with Erik Erikson and another neighbor, Reinhold Niebuhr. But his biggest canvases were reserved for Stockbridge scenes, the places along his bicycle route.

Back in business again, the *Saturday Evening Post* came calling that summer with a freckle-faced newsboy in tow, in search of a cover. They didn't get a Rockwell painting but they did put his photograph on the front of the new *Post* in 1971, sitting before his easel, talking to a kid out of his own past. As long as Norman Rockwell sat at the easel, it was possible to pretend that nothing had changed in the fifty-odd years since he did his first *Post* cover for George Horace Lorimer. Stockbridge felt that way, too: oddly familiar and reassuring. "Like most Americans suddenly arrived in New England, even if they have never been there before," wrote the new editors from the Midwest, "[we] feel as if [we] were back home at last."

At Thanksgiving, the *Ladies' Home Journal* came to call and persuaded the Rockwell family to pose as *Freedom from Want,* with the same huge turkey and celery tray. The dinner was prepared at the Red Lion Inn from traditional recipes, shared with the readers. The picture reminded the *Journal* that a War on Poverty was still raging—but not here, not in this eternal American Eden where a courtly, white-haired old gentleman helped his wife serve the Thanksgiving dinner the way it had been done since Pilgrim days. Jonathan Edwards, Oliver Wendell Holmes, and Nathaniel Hawthorne all had Stockbridge connections. Five American presidents had signed the register at the Red Lion Inn since it opened in 1773. Rockwell and his turkey looked like a tableau vivant from some great pageant of American history, suddenly come to life for the camera in a century not their own.

Norman Rockwell had become the nation's kindly grandfather. Despite a long life and a wide range of pictorial interests, Rockwell got stuck in his own old age, thanks to the esteem in which he was held by his countrymen. This was his defining moment, this tumultuous and bitter period when conservatism was often mistaken for patriotism, a president of the United States resigned in dis-

grace, and liking Norman Rockwell was tantamount to thinking Lawrence Welk was a great musician. As a cultural phenomenon, Rockwell wound up in the corner of the national memory that also contained hot pants, tie-dyed T-shirts, Twiggy, and the poetry of Rod McKuen. His own popularity made him something bigger than an artist and so condemned him, for a little while at least, to the mortality of mere fame.

"Norman Rockwell Day," celebrated in Stockbridge in 1976, paid tribute to the eighty-two-year-old artist with a special Bicentennial parade. The floats were based on famous Rockwell covers: the Four Freedoms, Lucky Lindy, and a bevy of Rockwell kids rolled by for two solid hours, as a crowd of ten thousand cheered Norman and Molly. "I'm tired but proud," he said at the end of a long day. For many years, it had seemed that he would never grow tired. In 1965, he tried his hand at movie acting for the first time during a 20th Century-Fox remake of *Stagecoach*. Throughout the decade, he traveled the world on assignment. He wrote a children's book. He even joined an art class. Although he only ventured out of his studio to paint portraits of presidents, the famous flocked to Stockbridge to sit for him: John Wayne, Frank Sinatra, Colonel Sanders. But he was slowing down. "I work from fatigue to fatigue, " he said in 1971. "At my age there's only so much daylight left."

In the year of his country's Bicentennial, he went to the easel almost every day and tried, but his color sense had deserted him and he could no longer execute the painstaking detail built into his style. His work was looser not by choice or by inclination but because Rockwell was failing. He could still draw but he sometimes forgot why he was sitting there, in front of the easel. Norman Rockwell died at home in Stockbridge in the fall of 1978, just before the Christmas lights went up again.

Rockwell will always point the way home for Christmas. He will make us feel, as a nation, a little better than we are: kinder, funnier, more resourceful. He will always look for happy endings. But there is more to Rockwell than that. There is a light that sanctifies an ordinary day and reminds us how strange and sweet this life can be. There is a view of a distant place that winds up being so close that it's almost a feeling, a whisper deep in the heart. There is an angle of vision that stops time in its tracks, suddenly, without warning: an inkling of immortality. A relentless search to find out what a person's work means. A belief that democracy must work, that all of us have been created equal.

Chronology

1894 Norman Percevel Rockwell is born at 2 A.M. on February 3 in the back bedroom of a brownstone at 103rd Street and Amsterdam Avenue, New York City. Norman is the second child of Jarvis Waring Rockwell and Nancy Hill Rockwell. The family summers in rural New Jersey and in upstate New York.

1899 Young Norman attends Admiral Dewey's triumphal parade and then makes drawings of American battleships.

1903 The family moves to Mamaroneck, New York, in Westchester County. Rockwell is raised in a succession of boarding houses.

1908–9 Early in his high school years, Norman decides to be an illustrator; he commutes to the city to attend the Chase School of Fine and Applied Art.

1909 At age fifteen, Norman quits high school and enrolls at the National Academy School in New York, where he copies plaster casts.

1910 Impressed by the fact that his hero, author-illustrator Howard Pyle, was one of the founders of the school, Norman transfers to the Art Students League, where he studies anatomy under George Bridgman and illustration under Thomas Fogarty.

1911 At seventeen, Rockwell works on his first illustrated book, the *Tell-Me-Why Stories about Mother Nature* by C. H. Claudy (published in 1912).

1912 Rockwell's family moves back to New York City; he rents his first studio in an attic on the Upper West Side. His father, on a visit of inspection, discovers that the studio is in a whorehouse.

1913 In the year of the Armory Show, the teenage Rockwell contributes his first illustrations to *Boy's Life* with the encouragement of Fogarty and is soon named art director of the magazine. He also begins to work for other children's publications: *St. Nicholas, Youth's Companion, Everyland,* and *American Boy.*

1915 The Rockwell family moves to New Rochelle, an illustrators' colony whose famous residents include Joe and Frank Leyendecker, Howard Chandler Christy, and Charles Dana Gibson. With cartoonist Clyde Forsythe, Norman sets up shop in Frederic Remington's old sculpture studio.

1916 With Forsythe's encouragement, the shy Rockwell presents himself at the Philadelphia offices of the *Saturday Evening Post.* The *Post* prints its first Rockwell cover, *Salutation!,* on May 20, 1916. Norman marries schoolteacher Irene O'Connor.

1917–18 World War I: Rockwell joins the Navy. Stationed in Charleston, South Carolina, he continues his work for the *Post, Country Gentleman, Literary Digest,* and *Popular Science* and lucrative ads for consumer products, like Jell-O.

1919 Resumes life in New Rochelle in the social whirl of the artists' colony. Begins a series of Christmas covers for the *Post* (continued until 1943).

1922 Judges Miss America contest with other celebrity-illustrators.

1923 A crisis of confidence inspires a trip to Paris; Norman even enrolls briefly at Colarossi's art school there. Rockwell has his first brush with modern art; editor George Horace Lorimer of the *Post*

encourages him to get over it. In the 1920s, without his wife, Rockwell also travels aimlessly in North Africa and South America.

1924 First of Rockwell's annual Boy Scout calendars published by Brown & Bigelow.

1926 Paints the first *Post* cover ever reproduced in full color.

1927 To Europe again. He joins the country club and plays the part of the sophisticate, parties with F. Scott Fitzgerald in Westport, Connecticut, and gradually finds himself estranged from his wife.

1929 Rockwell moves to the Hotel des Artistes on Central Park West, learns to ride, and suffers a breakdown. Moves back to New Rochelle, to the fashionable Colonial Revival house and studio featured in *Good Housekeeping*.

1930 Divorce. Visits Los Angeles, hobnobs in movie colony, and, in April, marries Mary Barstow, a young schoolteacher.

1932 Another crisis over his art: Rockwell takes Mary and newborn son Jerry (Jarvis) to Paris. Does only a handful of *Post* covers all year.

1933 Birth of second son, Tommy Rockwell.

1935 Commissioned by the Heritage Press to do sixteen illustrations for a new edition of Mark Twain's *Tom Sawyer*, Rockwell does intensive research in Hannibal, Missouri.

1936 Birth of third son, Peter Rockwell. Lorimer, whom Rockwell respects deeply, retires from the *Post*, ending an association that goes back twenty years.

1937 Rockwell starts to use a camera regularly to compose his pictures and to replace the professional models who have all but disappeared from the scene. Commissioned by the *Women's Home Companion* to provide illustrations for a biography of Louisa May Alcott (published in 1937 and 1938), Rockwell does research in Concord, Massachusetts.

1938 Rockwell is restless. He takes his family to Europe.

1939 The Rockwells move to Arlington, Vermont. John Atherton, Mead Schaeffer, and several other members of Rockwell's generation of illustrators already live in the neighborhood.

1941–46 To keep up home front morale during World War II, Rockwell conceives his series of eleven much-loved *Post* covers tracing the adventures of Willie Gillis, an all-American everyman draftee who eventually comes home safe and sound and goes to college on the GI Bill.

1941 Rockwell's first solo exhibition, at the Milwaukee Art Institute.

1942 Rockwell wakes up at 3 A.M. determined to help the war effort with a series of paintings based on President Roosevelt's "Four Freedoms" speech and the Atlantic Charter.

1943 Rebuffed by government bureaucrats to whom he pitches his idea, Rockwell paints the Four Freedoms for the *Post* instead. Reprinted in the millions as war bond posters, the Four Freedoms pictures go on a sixteen-city tour with Rockwell selling bonds at every stop.

 Rockwell's Arlington studio is destroyed by fire. The loss of his large collection of historic costumes turns Rockwell toward more contemporary themes. The family moves into town, to a 1792-vintage house in West Arlington.

1943–44 Ken Stuart takes over as art editor of the *Post* and aims at a literal, collective portrait of the nation. Rockwell's work becomes more detailed.

1945 Two-part profile of Rockwell in the *New Yorker*.

1946 Arthur L. Guptill publishes his classic *Norman Rockwell Illustrator* (reissued 1970), the first monograph on the artist.

1946–48 Rockwell undertakes a crucial documentary series for the *Post*, visiting such locales as the offices of a country doctor and a small-town editor and a one-room schoolhouse.

1948	Rockwell becomes one of the founders of the Famous Artists School of Westport, Connecticut, offering art lessons by correspondence.
1951	Rockwell paints *Thanksgiving (Saying Grace),* his most popular *Post* cover (November 24, 1951).
1952	Rockwell paints Ike for the *Post* and begins the custom of making portraits of presidential candidates and their wives every four years.
1953	The Rockwells move to Stockbridge, Massachusetts, where Mary undertakes a course of treatment for alcoholism at the Austen Riggs Center. Rockwell meets Erik Erikson and begins treatment for the recurring depressions that have affected his work over the years.
1957	Norman and Mary buy a Federal-style house in Stockbridge and remodel the carriage house for use as a studio. Previously, Rockwell had worked in a rented room above Sullivan's Meat Market on Main Street.
	An article in the *Atlantic Monthly* accuses Rockwell of being socially, politically, and artistically irrelevant, and of debasing the taste of the average American by his neglect of recent developments in modern art. Such attacks continue throughout the 1960s.
1959	Mary Rockwell dies unexpectedly of a heart attack.
1960	The *Post* serializes Rockwell's memoirs (as told to his son Tom), published in book form that same year: *My Adventures as an Illustrator* is a best-seller.
1961	Marries for the third time: Molly Punderson, retired from a long career as a teacher at Milton Academy, is a Stockbridge native. Norman publishes a second book, *The Norman Rockwell Album.* Paints pictures in oils, which are not commissioned illustrations, in Peggy Worthington Best's Thursday morning class in Stockbridge.
1962	Rockwell, who admires Jackson Pollock's work, tries his drip technique for a *Post* cover.
1963	After forty-seven years, Rockwell and the *Saturday Evening Post* part company. His last cover for the *Post* appears on December 14.
1964	Begins to paint pointed studies of current events and social issues for *Look.* His first major *Look* picture, *The Problem We All Live With,* concerns school integration and marks the emergence of an activist who will respond pictorially to racism, space exploration, and the Peace Corps in the years to come. He also begins his searching multiple portraits of world leaders.
1967	With a text revised by Molly, Rockwell writes and illustrates a children's book, *Willie Was Different.* Paints *Home for Christmas* for *McCall's.* "Stockbridge is the best of America, the best of New England," he says.
1968	Danenberg Galleries in New York mounts a Rockwell retrospective. Forty paintings are exhibited. *Thanksgiving* hangs in the front window.
1969	The Old Corner House, a historic Stockbridge house converted into a museum, is opened by a local group that includes Rockwell and his wife. His paintings hang in the house.
1972	A sixty-year Rockwell retrospective is held at the Danenberg Galleries and then tours the country; it is roundly panned by critic John Canaday in the *New York Times.*
1973	Rockwell sets up a trust, leaving his work to the museum; in 1976, he adds his studio to the bequest.
1976	Rockwell's last magazine cover is the Bicentennial cover of *American Artist.*
1977	Norman Rockwell is awarded the Presidential Medal of Freedom by Gerald R. Ford.
1978	Norman Rockwell dies on November 8 in Stockbridge at the age of eighty-four.
1993	The Norman Rockwell Museum at Stockbridge opens. It houses the material contained in the Rockwell trust, including the Four Freedoms series. The main building is designed by architect Robert A. M. Stern.

Selected Bibliography

Alexander, Jack. "Norman Rockwell." *Saturday Evening Post* 215 (February 13, 1943): 16–17, 37, 39, 41.

The Best of Norman Rockwell, A Celebration of 100 Years. Philadelphia: Courage Books, 1988.

Bogart, Michele H. *Artists, Advertising, and the Borders of Art.* Chicago: University of Chicago Press, 1995.

Boyle, Ruth. "A House With Real Charm: The House and Studio E. P. Parmelee Built for Norman Rockwell." *Good Housekeeping* 88 (February 1929): 48–49, 172.

Buechner, Thomas S. *Norman Rockwell, A Sixty Year Retrospective.* New York: Harry N. Abrams, 1972.

———. *Norman Rockwell, Artist and Illustrator.* New York: Harry N. Abrams, 1970.

Cohn, Jan. *Covers of the Saturday Evening Post: Seventy Years of Outstanding Illustration from America's Favorite Magazine.* New York: Viking, 1995.

———. *Creating America: George Horace Lorimer and the Saturday Evening Post.* Pittsburgh: University of Pittsburgh Press, 1989.

De Young, Gregg. "Norman Rockwell and American Attitudes Toward Technology." *Journal of American Culture* 13 (Spring 1990): 95–103.

Finch, Christopher. *Norman Rockwell's America.* New York: Harry N. Abrams, 1985.

———. *Norman Rockwell, 332 Magazine Covers.* New York: Abbeville, 1979.

Flythe, Starkey, Jr. *Norman Rockwell and the Saturday Evening Post.* Vol. 1. New York: MJF Books, 1994.

Forsythe, Clyde. "Norman Rockwell." *Saturday Evening Post* 199 (December 18, 1926): 34.

Frese, Penelope Anne. "The American Dream in Form and Conception in Thornton's Wilder's 'Our Town,' Norman Rockwell's 'Saying Grace,' and the Architecture of Hudson, Ohio." Ph.D. diss., Ohio University, 1985.

Glaser, Milton. "The Importance of Being Rockwell." *Columbia Journalism Review* 18 (November/December 1979): 40–42.

Guptill, Arthur L. *Norman Rockwell Illustrator.* New York: Watson-Guptill, 1946.

Hughes, Robert. "The Rembrandt of Punkin Crick." *Time* 112 (November 20, 1978): 110.

"I Like To Please People." *Time* 41 (June 21, 1943): 41–42.

Jarman, Rufus. "U.S. Artist." *New Yorker* 21 (March 17, 1945): 34–38, 41–42, 44–45.

———. "U.S. Artist—II." *New Yorker* 21 (March 24, 1945): 36–40, 43–44, 46–47.

Kataoka, Yoshio. *The Saturday Evening Post: Magazine Covers from 1945 to 1962.* 2 vols. Japan: Treville, 1994.

Kent, Norman. "The Portrait Sketches of Norman Rockwell." *American Artist* 38 (September 1964): 38–43, 75–77.

Mendoza, George. *Norman Rockwell's Patriotic Times.* Foreword by Ronald Reagan. New York: Viking, 1985.

Meyer, Susan E. *America's Great Illustrators.* New York: Galahad Books, 1987.

———. *Norman Rockwell's People.* New York: Harry N. Abrams, 1981.

———. *Norman Rockwell's World War II: Impressions from the Homefront.* Foreword by Robert F. McDermott. N.p.: USAA Foundation, 1991.

Moffatt, Laurie Norton. *Norman Rockwell, A Definitive Catalogue.* 2 vols. Stockbridge, Mass.: The Norman Rockwell Museum at Stockbridge, 1986.

Morris, Wright. "Norman Rockwell's America." *Atlantic Monthly* 200 (December 1957): 133–36, 138.

Murray, Stuart, and James McCabe. *Norman Rockwell's Four Freedoms: Images That Inspire a Nation.* Stockbridge, Mass.: Berkshire House, 1993.

Norman Rockwell, A Centennial Celebration. New York: BDD Illustrated Books, 1993.

The Norman Rockwell Album. Garden City, N.Y.: Doubleday, 1961.

Olson, Lester C. "Portraits in Praise of a People: A Rhetorical Analysis of Norman Rockwell's Icons in Franklin D. Roosevelt's 'Four Freedoms' Campaign." *Quarterly Journal of Speech* 69 (February 1983): 15–24.

Reeves, Richard. "Norman Rockwell is Exactly Like a Norman Rockwell." *New York Times Magazine* (February 28, 1971): 14–15, 36–37, 39, 42.

Rockwell, Norman, as told to Tom Rockwell. *My Adventures as an Illustrator.* Foreword and afterword by Tom Rockwell. New York: Harry N. Abrams, 1994.

Rockwell, Peter. "My Father, Norman Rockwell." *Ladies' Home Journal* 89 (November 1972): 84, 88, 100–101.

Singer, Marshall. "Capitalist Realism by Norman Rockwell." *Ramparts* 11 (November 1972): 45–47.

Sommer, Robin Langley. *Norman Rockwell, A Classic Treasury.* Greenwich, Conn.: Barnes and Noble, 1993.

Stoltz, Donald R., and Marshall L. Stoltz. *Norman Rockwell and the Saturday Evening Post.* Vol. 2. New York: MJF Books, 1994.

———. *Norman Rockwell and the Saturday Evening Post.* Vol. 3. New York: MJF Books, 1994.

Stuart, Kenneth. "The Unforgettable Norman Rockwell." *Reader's Digest* 115 (July 1979): 104–9.

Thomas, Sarah. "America's Most Popular Artist." *Contemporary Review* 264 (May 1994): 259–62.

Updike, John. "An Act of Seeing." *Art and Antiques* 7 (December 1990): 92–97.

Walton, Donald. *A Rockwell Portrait: An Intimate Biography.* Kansas City: Sheed Andrews and McMeel, 1978.

Photograph Credits

The author and the publisher thank the museums, galleries, libraries, and private collectors who permitted the reproduction of works of art in their possession and supplied the necessary photographs. Other sources of photographs (listed by page number) are gratefully acknowledged below.

American Illustrators Gallery, New York, 90; HNA-Archive, New York, 19, 20, 24, 28, 38, 52, 54–55, 57, 67 (left), 68, 75, 76, 81 (top), 89, 92, 93, 94 (left), 98, 104, 105, 106, 110, 115, 116, 120, 123 (top), 144, 145 (right); Norman Rockwell Museum at Stockbridge, Massachusetts, 12, 15, 26, 27, 30, 31, 40, 46, 48, 50, 67 (right), 70 (left), 74, 77 (bottom), 83 (right), 87, 94 (right), 108, 109, 113, 119 (bottom), 123 (bottom), 124, 126 (both), 136, 138, 143 (bottom), 145 (left)

Index